D0162681

Seal: Much Can Be Accomplished in the Decade of the 80s

Cover: Couples (Horse), Collection of Peggy and Jack O'Mara
English Title Calligraphy: Anne Olympius

Inside Cover: Guilin Reflections

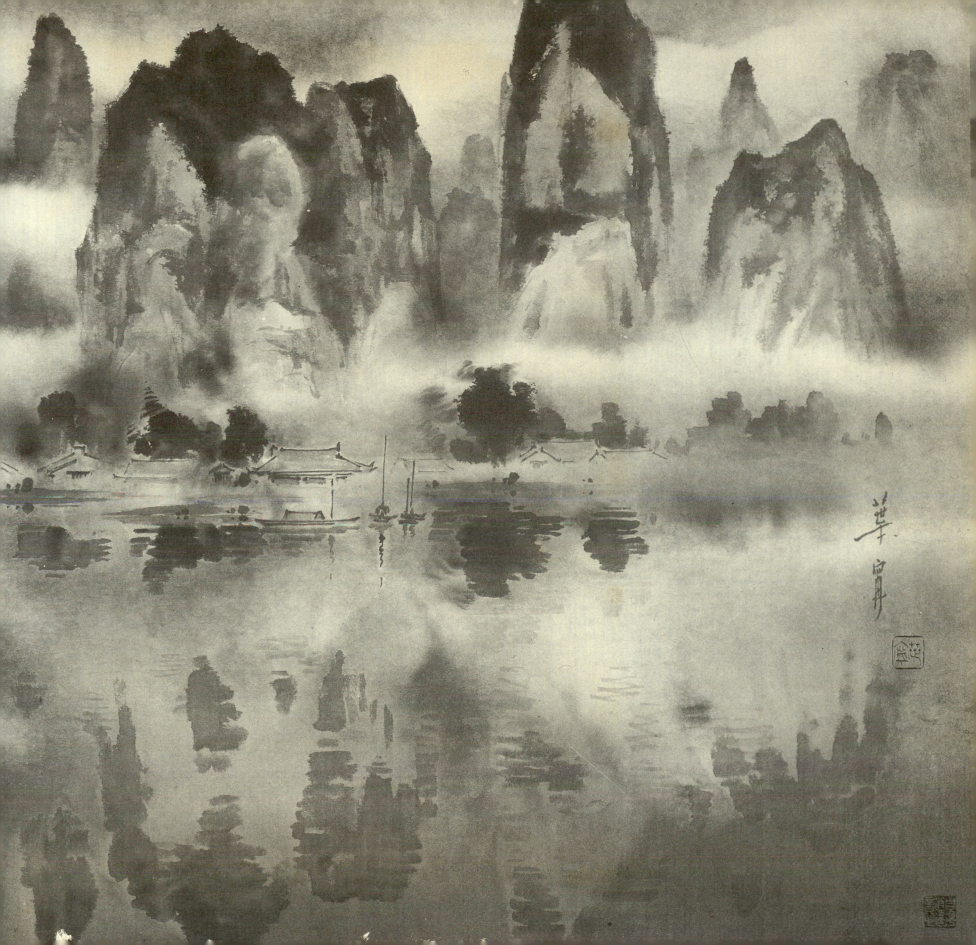

An Album

of Chinese Brush Painting
Eighty Paintings and Ideas

Ning Yeh's Second Art Album

First Edition
Published as the Resource Book
for the television series:
''Chinese Brush Painting with Ning Yeh''

to be used for general purposes or
along with *Chinese Brush Painting:
An Instructional Guide,* the Study Guide
for the television series

by Ning Yeh's Art Studio
10181 Crailet Drive,
Huntington Beach, California 92646

Copyright 1986 by Ning and Lingchi Yeh
Library of Congress Catalog Card Number: 86-091740
ISBN: 0-9618307-0-0

葉寧畫集

Optional Accompanying Materials:

For material and supplies listed in this album

please request the OAS Catalog published

by Ning Yeh's Art Studio

10181 Crailet Drive, Huntington Beach,

California 92646

For detailed, step-by-step instruction,

please follow *Chinese Brush Painting: An Instructional*

Guide for the television series ''Chinese Brush Painting

with Ning Yeh''

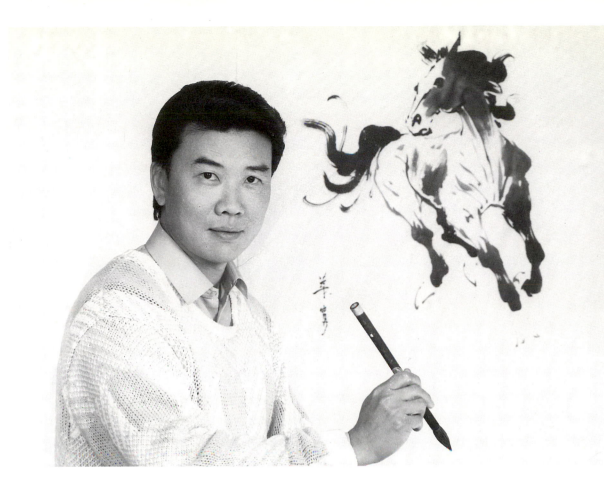

Author's Photo

Ning Yeh
Signature & Personal Seal

Contents

A Resource Book for A Television Series

I want to thank Coastline Community College for inviting me to start the first series of instructional television programs on Chinese Brush Painting in the United States.

I welcome the challenge of working under pressure. A millionaire (the one who risked his own life to bring his employees to safety from Iran) said once that he did not think he was a pearl and he did not care to be a clam. However, he did compare himself to that little particle of sand which irritated the heck out of that clam and forced it to produce the beautiful pearl.

I published my first album in 1981. By the time 1986 came along, there were only a handful of copies left. When Coastline proposed the telecourse, they honored my album as the resource book for the course. However, I found out that my printer had destroyed the plates of my first album! But the largest seal among my collection reminded me, "Much can be accomplished in the decade of the 80's." What better way to start the second half of the 80's than to work on another book, my second art album?

Confucius said, "When one reaches the age of 40, one should no longer be confused." (四十而不惑) There are now just a few months left of the time allowed by the sage. The pressure is mounting. I need to have this book done so later I can tell my critics, "You are right; I was still confused at the time."

I am truly blessed to have had the opportunity to work with a wonderful group of people who are involved with the television production.

Coastline has been a leading force in educational television production. I feel humbled by President Vega's decision to ask me to be the first Coastline faculty member to host a television series. I want to thank Ron Berggren, who asked me to do a "screen test," and Leslie Purdy, who decided to go nationwide with 20 half-hour programs on Chinese brush painting. I thank David Stone, the producer; David Hamilton, the director; and Mickey Jackson, the lady who has become a mirror for my creative existence; they are all Chinese disguised as Americans. Finally, I thank Ted Boehler, our studio manager who is also a Kung Fu master, and his crew. I feel the whole television production staff behaved like a group of excited tourists, sitting around a banquet table in an exquisite restaurant overlooking the Great Wall, and waiting for the waiter to bring out the menu.

An advisory committee consisting of Betty and Warren Freeman, Gwen and Paul Dent, Peggy and Jack O'Mara, Mary and George Butler, Maria and Milton Nathanson, Nancy Knight, and Jan Haring has highlighted the enthusiastic support among my friends. Without their effort and the encouragement from all my students and patrons, the telecourse would never have become a reality.

I wish to thank Mr. Ho Kung-shang (何恭上) of Art Book Company, and Mr. Wong (王俊華) of Ke-Fan Printing (克帆) in Taiwan. They have provided the finest technical assistance in the printing of this resource book. A special thanks to Anne Olympius for her elegant calligraphy, which added a touch of elegance to the title of this book.

Now, let us bring out the main course.

Seal: Painting

1

Seal: The Ancient Moon that Once
Shone on the Glory of the
Chin Dynasty Is Still Hanging
at Dawn on the Peak of the
Emerald Mountain

Preface

Early this year, I went back to the Orient to visit my mother. Wandering through the bookstore in Taipei, I ran across a book entitled Stepping off the Red Carpet, written by a lady. The book described her feelings and experiences after her marriage, and I eagerly bought it.

Twenty years ago, I had bought this lady's first book, Waiting at the Other End of the Red Carpet, which described the feelings of a young girl about to get married. In one of the essays in the book, she talked about her experience on a mountain road, "Slowly I walked, I walked above the green, I walked amid the green, I walked under the green. The green is within me, and I am within the green." I fell in love with the book.

When I read the new book, I found out that the author is the mother of two lovely children and has been honored as one of the "Ten Most Outstanding Young Women" in Taiwan. She is now a professor in a university. Her name is Chang Hsiao Feng (張曉風).

I have never met her, but I do feel I know her as a friend. I feel happy for her, and I feel happy for myself knowing her.

I have many such friends: Su Tung-pao (蘇東坡), Wang Wei (王維), Chen Pan Ch'iao (鄭板橋), Lin Yutang (林語堂) . . . Across time and space, they helped me to grow, just like the folks around me did. Our friendships are based on trust, because in the writings of these people is a true revelation of how they really felt. Although we are thousands of years or miles apart, they have touched my heart.

Someone once said, "Life is like a morning dew." If I should intepret this phrase, I would say that a morning dew is part of water, and water never vanishes. It transcends the boundaries of nations in various forms, always helping things to grow. There is definitely a purpose for that drop of morning dew.

I am fortunate to have received the finest education in two worlds, one blessed with the longest spiritual tradition, the other offering the most advanced modern technology. I can paint; I can write. I was given a teaching assignment, and now I have been given a television show. No matter how slow-witted one claims himself to be, after such experiences it is time to put one's act together. Yes, I can be a friend to a vast number of people I can never dream of meeting face-to-face.

In addition to providing the basic technical information, I decided to tell the stories behind each of the paintings. I do not know the value of these stories; I can only reveal how I truly felt. These stories are centered around the following themes:

Painting as a Window for Chinese Culture

The enchantment of Chinese brush painting is in every phase intertwined with the entire sphere of Chinese culture. Never is a flower merely a flower nor scenery merely a place in China. Each has its legends, romantic stories, volumes of poetry and literature, remarkable deeds recorded by remarkable personalities, and symbolic spirituality. To paint a subject, artists cannot help but immerse themselves into all the fascinating background which is an integral part of the total cultural existence of the Chinese mind. To study a subject without knowing its background, one has only scratched the surface. To enjoy Chinese brush painting is to enjoy the total depth of a splendid civilization.

Unity between Man and Nature

The Hsieh I (寫意 Depicting Idea) painting style, in its "Po-Mo" (潑墨) — or "throw ink" expression, is one of the most dynamic forms of art. Spontaneity, freedom, and honesty are some of the most important principles. The painting is done without a sketch, and the brush movement is completed in a simple, powerful, and speedy way. The artist is allowed no time to think, no chance to pretend, no room to hide, and no way to correct. The art form becomes a direct extension of the artist's mentality; it reveals the personality and experience of the artist in the most earnest way.

Art is a vehicle for people to communicate with nature. As an artist, I like to reveal nature's vitality through personal observations and experiences. I like to absorb as much information as possible about the painting subject. I collect this information in my mind and internalize it as part of me. When I paint, I treat all the subjects as idealistic expressions of my own personality.

Balance

In many ways, I was brought up to see nature through the eyes of the Taoist (道家). In my work, the vitality of nature is presented by the constant interaction of the Yin and the Yang (陰陽) — the two opposite forces forever challenging and adjusting to each other. The outcome, hopefully, is a dramatic presentation of the diversities of the Yin and the Yang in harmony.

3

The Golden Top of Mt. Emei

Collection of Dana and Lorraine Lovejoy

22"x36"
Paper: Jen Ho
Brushes: "Mountain Horse" (texture), "Landscape" (structure and tree), "Big Idea" (color), "Wash" (mist).
Colors: ink, vermillion, burnt sienna, Prussian green mixed with charcoal gray, green mixed by blending yellow and indigo (mountain); vermillion, Winsor violet, Prussian green and charcoal gray (mist); French ultramarine, sky blue (sky). For detailed, step-by-step instruction on landscape, see Lesson 18 in the Study Guide.

Mt. Emei 峨嵋山

The great poet Li Po (李白 701-762) wrote, "the State of Shu (Szechwan or Sichuan 四川) abounds in mountains which share the fairy spirit. None of them matches the beauty of Emei."

Szechwan, "the God-Giving Land," is a basin with fertile soil. Protected by mountains, Szechwan could only be reached before the modern era through the gorges of the mighty Yang-tze (揚子江) by laborers pulling boats upstream.

During the Second World War, China made Chungking (重慶) her wartime capital because invaders never were able to penetrate into this hinterland. This basin was where my parents met and where I spent my first year. The Chinese way of counting age is to begin at the point of conception. In the mother's tummy one is counted as one year old. From then on, each calendar year counts as one more year of age. For example, I was born on New Year's Eve in 1946; by New Year's Day, 1947, I was only two days old but counted as three years old. I grew up really fast.

Mt. Emei, meaning "Mountain of Tall Elegance," was once called the "Court Lady's Eyebrow." Standing 3,099 meters above the Chengtu (成都) Plain, it is constantly surrounded by mist and its two main peaks float above the clouds like the eyebrows of an elegant lady. Mt. Emei is one of the Buddhist's four sacred mountains in China. A temple with a golden roof was built at the main peak, and at sunrise, a ray of gold shines on the mountain top.

Confucius said, "People with kindness appreciate mountains; and people with wisdom enjoy waters." (仁者樂山 , 智者 樂水)
In Southern California, I moved from Claremont to Huntington Beach. I have noticed that the people in the mountains tend to be more introverted and calm; the people by the sea are more outgoing and playful.

I do believe that the majority of Chinese rely more heavily on their mountains as a main source for spiritual inspiration than on the seas. China has a long coastline, but very little literature has been devoted to describing the seas. However, if given their preference, the Chinese would insist on mountains which incorporate the elements of water: rivers, streams, waterfalls, mist, clouds, and snow. A mountain without water is like a man without a woman. The Chinese therefore call their landscape "Shan Shui" (山水) — which translates as "Mountain and Water."

Seal: Notes of Learning in the Misty Mountain

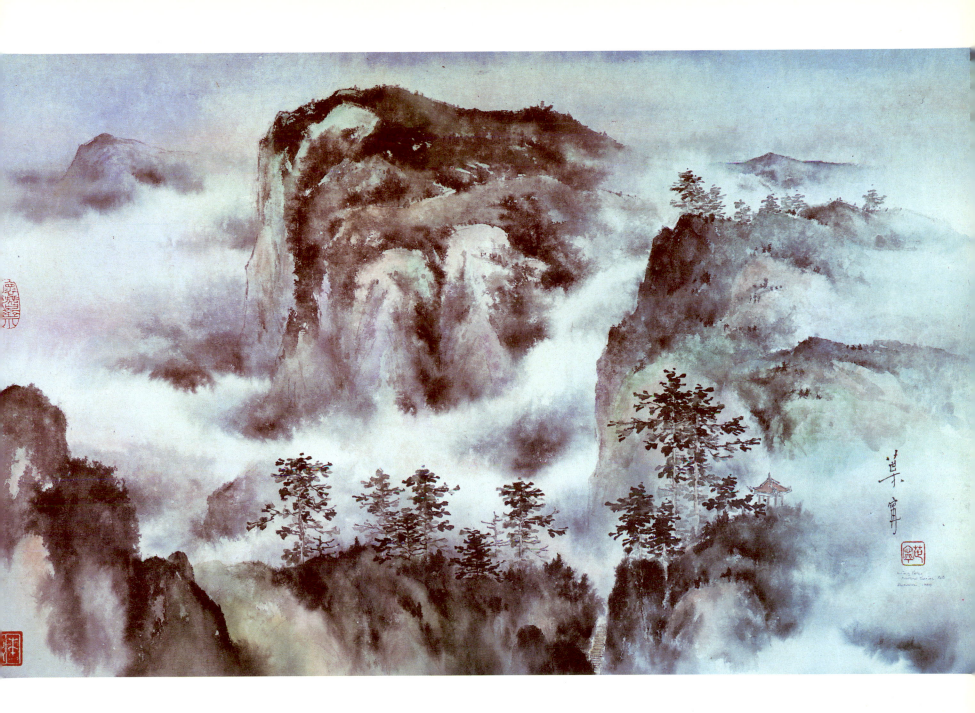

Celebration (Amaryllis)

Collection of Harold and Magda Ness, Jr.

18"x36"
Paper: Double Shuen
Brushes: "Large Flow" (flower, calyx), "Idea" (Stamen, pollen, pistil), "Lan" (stalk, leaf).
Colors: vermillion, red (petal); dark green mixed by blending yellow and indigo (center); poster white (stamen); poster white and yellow (pollen); vermillion with green (calyx); green mixed by blending yellow and indigo (leaf).
For detailed, step-by-step instruction on the amaryllis, see Lesson 11-12 in the Study Guide.

Chu Ding Hong 柱頂紅

The amaryllis has many types and various names. The pink flower is often called "Naked Lady," because when the flower blooms there is no leaf to cover her body and the shy flower turns pink. I like this name a lot.

The scarlet red amaryllis is called "Chu Ding Hong," meaning "Post Top Red." This flower carries doubly cheerful messages. "Climbing to the top of the post" is a great symbol for coming success. Red is also the color of happiness, bountiful land, warm-hearted people, fertility, and prosperity. The flower offers us good wishes for climbing to the highest ladder of success and blossoming into multitudes of red. For people who graduate from school or get a new job, for people who first start doing brush painting, or for a teacher who first offers a televised course, the amaryllis is a must subject.

My friend Betty once brought us a flower bulb, but she did not say what type of flower it was. A few weeks later, the stalk came out. The day when I received the news that I would go nationwide teaching Chinese painting on television, the flowers on the stalk bloomed like fireworks. Usually there are less than five flowers on a stalk, but for an artist in the mood of celebration I do not think Mother Nature minded adding a few more.

I do feel it works both ways. I play tricks on Mother Nature because she constantly embarrasses me. I remember once in class I was stressing to my students not to paint a "chicken foot" on their trees (three branches coming out at one point of the trunk), because it is ugly. During the break, students pointed to the beautiful tree right in front of the classroom. The tree had no other branching pattern except a series of "chicken feet."

At the moment when the amaryllis bloomed, I was working on the study guide for the telecourse. "Establish a dominant tendency, then arrange a host to serve as the focal point and a guest as the supportive element," I wrote, feeling rather proud of these "golden rules." As I looked up, two amaryllis bloomed right in front of me, splitting the tendency in two opposite directions. They looked like twins, blooming at the same time with identical shape, size, and color. They looked absolutely breath-taking. "Dominant tendency? Host and guest? Chicken foot? My foot!" I seemed to hear Mother Nature's voice.

Seal: The Proud Children of Nature

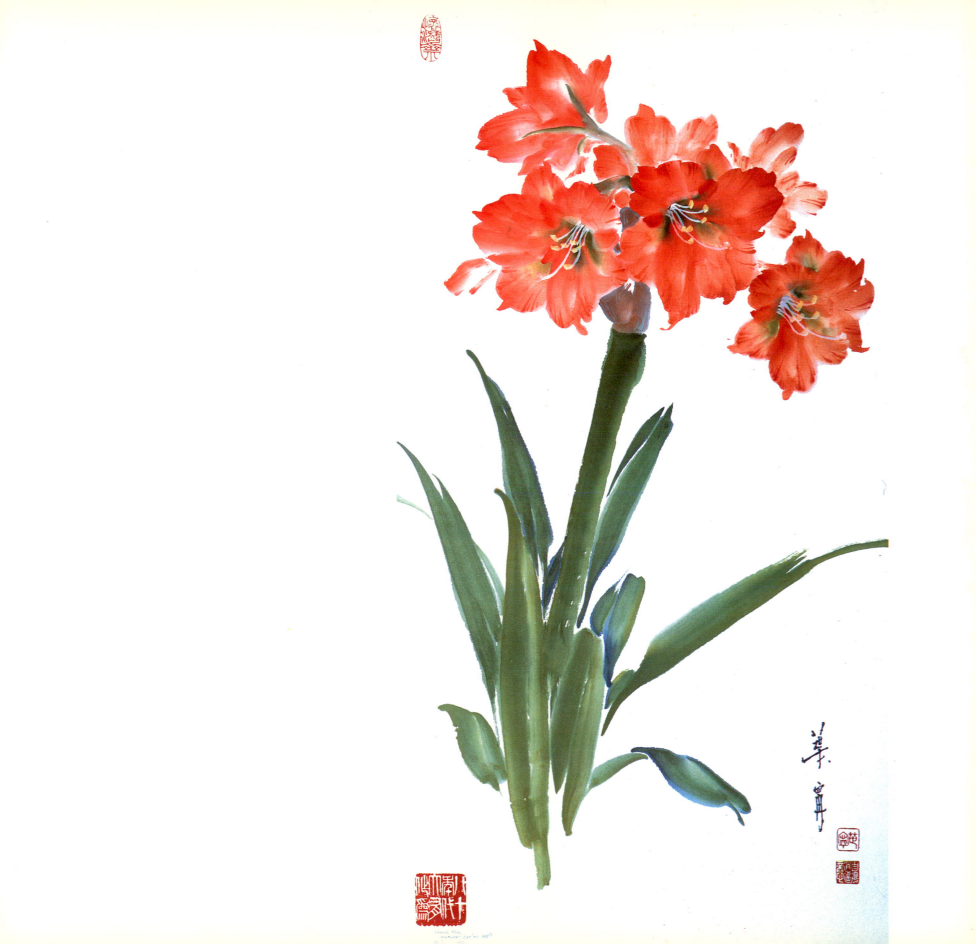

Leaping Forward (Horse)

Permanent Collection, Board of Directors, Los Angeles County Fair

22"x36"
Paper: Double Shuen
Brush: "Large Flow"
Color: ink
For detailed, step-by-step instruction on the horse, see Lesson 16-17 in the Study Guide.

The Spirit of Horse (Ma 馬)

Horse painting is my family tradition. From the very beginning, it has been a subject in which I felt I must excel. It occupies a very special place in my heart. I recall the first time I offered to teach my students this subject, my father, who almost never initiated any contact with me, called me long distance from China. "Are you SURE?" he asked. He was not so much afraid of letting go of the family secret, but rather afraid that people might not learn it right and therefore put our family name to shame. I was holding my breath when I took my students' show to the Orient in 1978. It was quite a relief to hear him say after he visited our exhibition in Taipei (臺北), "You did the right thing."

According to Confucius, "The horse should be complimented not for its strength, but for its virtue." In the horse, the Chinese see a spirit of rendering service without asking recognition, of suffering hardship without complaint, of offering life-and-death friendship and loyalty without seeking material gain in return, of marching humbly with the utmost inner pride. Elevated by these qualities, the horse becomes humanistic.

In Chinese folk legend, the horse was the celestial creature which blessed China with its first set of written language. In the Book of Changes, an authoritative Chinese classic, the strong horse signifies the well-being of the Chinese nation.

Seal: Chi-ling: Imaginary
Creature of Vitality

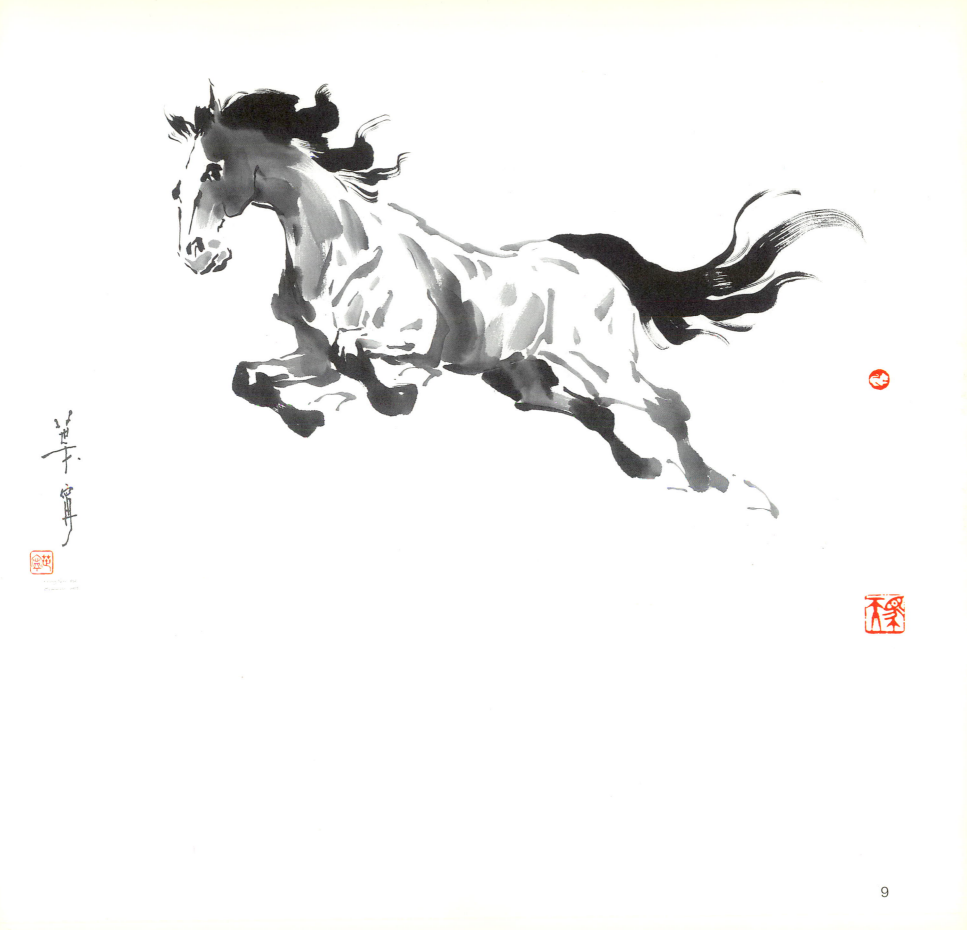

Land of Enchantment

Collection of Louis and Jean Lee

18"x36"
Paper: Jen Ho
Brushes: "Best Detail" (figure, structure), "Big Idea" (color, mountain), "Wash" (shading).
Colors: ink, yellow ochre, burnt sienna, vermillion, red (structure); French ultramarine (clothing), Prussian green with charcoal gray, Winsor emerald (tree, mountain), Winsor violet, manganese blue (sky, water).

Trend of Thoughts

I enjoy demonstrating my art in public. It is quite different from painting alone. It takes a performer's virtue to handle the task, and demonstration also requires sharing. Painting alone in one's studio requires communication with one's inner self and that can be dangerous. When I find I am beginning to talk to myself frequently, I know it is time to do some demonstrations in order to maintain a balanced frame of mind.

In this painting, I placed myself and a friend in the lower left corner to start the exercise. We were painting pots. A girl started to get interested (of course, why else do we want to paint in public?). Her friend in green did not care about us, so I would not paint her face. In fact, only the girl and I had faces in this painting. In order to show that I was painting in public, I placed the figures near a bridge. To make things more interesting, I had the bridge turned with a row of laborers marching inward. A row of buildings went across, with one tilting to lead the viewer further back to the pagoda. All my childhood memories came into the painting: the temple where people could have their fortunes told instantly (Before I came to the States, I did ask for a fortune, and was told the trip was going to be hazardous); the tank top noodle place where my friend

and I took our first cup of wine after class and claimed we were doing homework in school; boatmen selling fresh vegetables; chicken men selling chickens; ducks swimming; and an old man holding a pipe . . . everything worked. But then came the decision whether or not to add some green foliage and mountains to balance all the warm and busy structures and figures. Tension always develops halfway into a good painting. Should one risk ruining the whole thing by adding more? Or leave things well enough alone? In this case, the risk brought ample reward. I love this.

When I paint a scene which has been envisioned in my mind, I feel the ultimate challenge and reward. As the scenery emerges from the blank paper, it engenders a sensation similar to that experienced by a master explorer at the first sight of a natural wonder. However, the satisfaction is much deeper, for the nature the artist discovers is actually his own creation.

Seal: A Journey of Heart

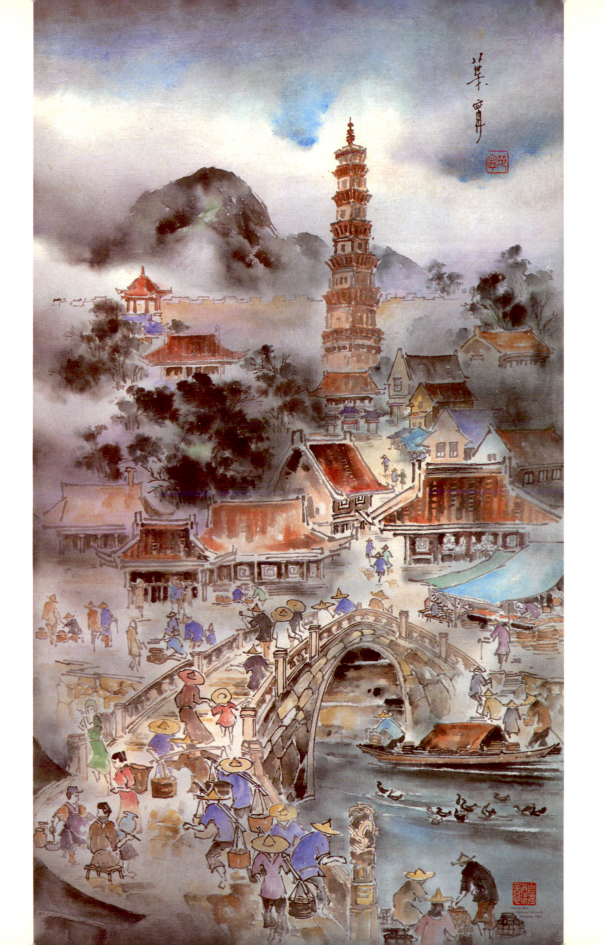

05 春意

Idea of Spring (Roses)

Collection of Janet Quigley

14"x18"
Paper: Double Shuen
Brushes: "Large Flow" (flower), "Idea" (vein, thorn), "Big Idea" (Stem), "Flower & Bird" (leaf).
Colors: poster white, permanent magenta, crimson lake (flower); green mixed by blending yellow and indigo, indigo, ink (leaf); crimson lake (thorn); ink (vein).

Mei Kuei 玫瑰

The Mei Kuei (rose) has been in cultivation since the beginning of Chinese history. Ladies carried rose petals in their "fragrant purses," and gentlemen made wine and herbal medicine with the petals. Along with "Orchid," "Rose" is one of the most popular names for girls in China.

When One Loves Poetry and Literature, One Shall Find Time to Enjoy Flowers

The above is the message of one of my favorite seals. This message provides the best answer to the question of why one should do flower paintings.

How grateful for a Chinese student of painting and literature to realize that as early as the Tang (唐) Dynasty, the artist Wang Wei (王維 699-759) had already completed the fusion of painting and poetry. As a scholar, Wang's poetry depicted the atmosphere of a painting. As a painter, his painting portrayed the spirit of a poem. Through his inspiration, the School of "Hsieh-I" (寫意) or "Depicting Idea" emerged. Chinese painting was elevated from a minute pursuit of detailed accuracy and advanced into one which captured the poetic spirit. Generations of literary giants became master painters, and a unique art-literati, or scholar-painter tradition was born.

It has not been easy for a boy who was born into a family of horse painters to start painting flowers, especially since quite a few master flower painters have been the arch rivals of my family in the art arena.

When I was fourteen, my father had an all-horse art exhibition, with the exception of one painting. It was a couple of turnips done in ink. My father put the painting in the last spot of the showcase. The implication was that after all the fame and glory of the galloping horses, all he really wanted was to have a couple of turnips for a meal — a statement of modesty. A rival, a lady flower painter, came to see the show. "What is that?" her little girl asked, pointing to the turnip painting. "It must be horse pu-pu," she replied.

I decided that if I really wanted to do subjects other than horses, I'd better start early, before the reputation of a horse painter stuck.

Seal: When One Loves Poetry
and Writing, One Shall Find
Time to Enjoy the Flowers

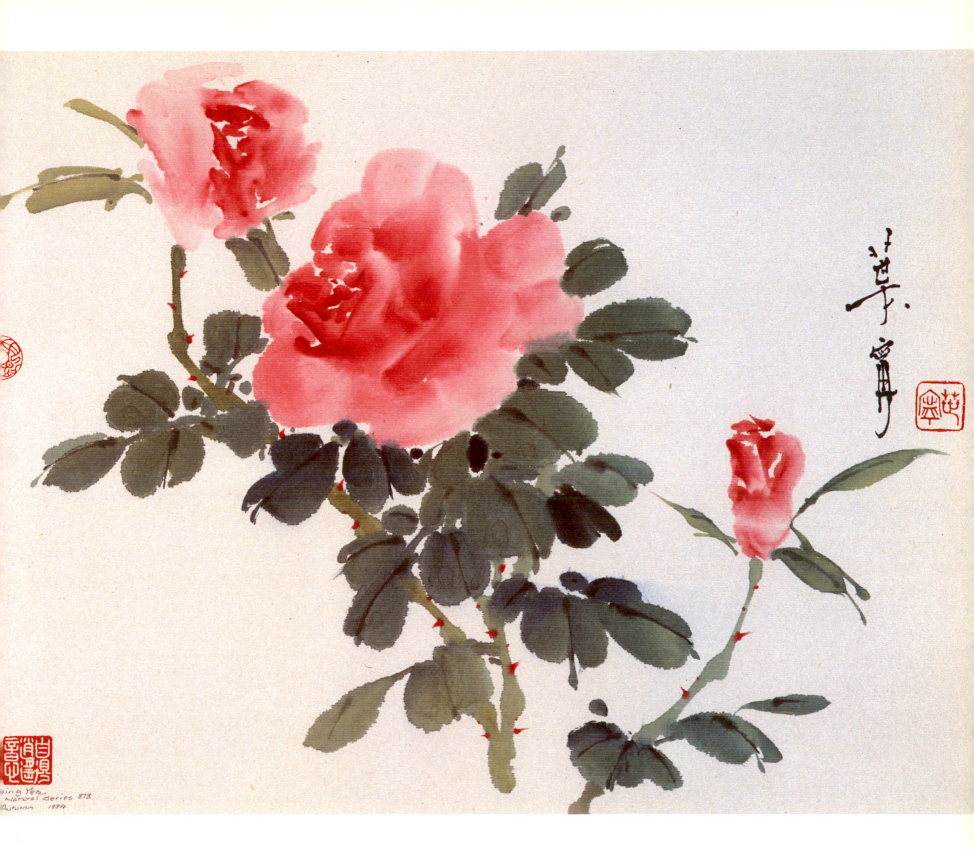

Ming Yen
Natural Series 873
Autumn 1984

Brotherhood

Collection of Mervin and Eleanor Cooper

22"x36"
Paper: Double Shuen
Brush: "Large Flow"
Colors: ink, vermillion
For detailed, step-by-step instruction on the horse, see Lesson 16-17 in the Study Guide.

Seal: Seasoned Memory

The Romance of the Three Kingdoms

I was born in Hunan (湖南), my mother's hometown. She was the youngest daughter of a very well-to-do family and proud to be one of the few college graduates in town.

I have no recollection of Mainland China. Mother told me that during the three years while I was in China, I had travelled in her arms through many provinces. She was travelling to find a cure for my childhood illness, search for my father, and escape war. Some faded pictures of me in a baggy cotton robe, all with different backgrounds, tell the extent of my journey.

My father was an army general. When I was a youngster growing up in Taiwan, our house guests were mostly old soldiers. The after-dinner conversations were centered around reminiscing about the old country. My fascination toward China grew stronger in my fourth year in elementary school, when my math teacher, Mr. Kuan, spent the whole year dissecting the chapters of The Romance of the Three Kingdoms. (三國演義) This story portrays the heroic deeds of the personalities centered around three blood brothers during the time of the Three Kingdoms (220-581), and all the places which the story made famous have become forever dear in my heart. What a fantastic story-teller Mr. Kuan was! There was no math taught, but every pupil looked forward to the "math class" and continuing the journey of imagination through the story. Worrying about my ability to enter junior high school, my mother transferred

me to a school that stressed a fourteen-hour study schedule with "the stuffed-duck" (填鴨) technique: tons of information, no concern for comprehension, forced memorization, corporal punishment, and a lot of math. I recall begging Mr. Kuan to loan me The Romance of the three Kingdoms. Covering my head with thick blankets in the upper bunk bed, I read the story with a flashlight. Tracing the route of battles on my father's old map, I had some of the most inspiring moments and fantasies of my childhood.

Besides The Romance of the Three Kingdoms, written by Lo Kuan-chung (羅貫中), there are three other classical novels which have had profound influence in China:

The Dream of the Red Chambers (紅樓夢) — by Tsao Hsueh-ching (曹雪芹); a story of the hollow life of a gentry family, centered around a young man and his entanglement in a chamber which housed over one hundred ladies. Eventually the young man became a monk;

All Men are Brothers (水滸傳) — by Shin Nai-an (施耐庵), a story of one hundred and eight "Robinhood-type" bandits; and

Pilgrims to the West (西遊記) — a story of the adventures of a Buddhist monk and his three disciples (among them, the famous monkey king) on their way to India to bring back the first set of Buddhist holy books.

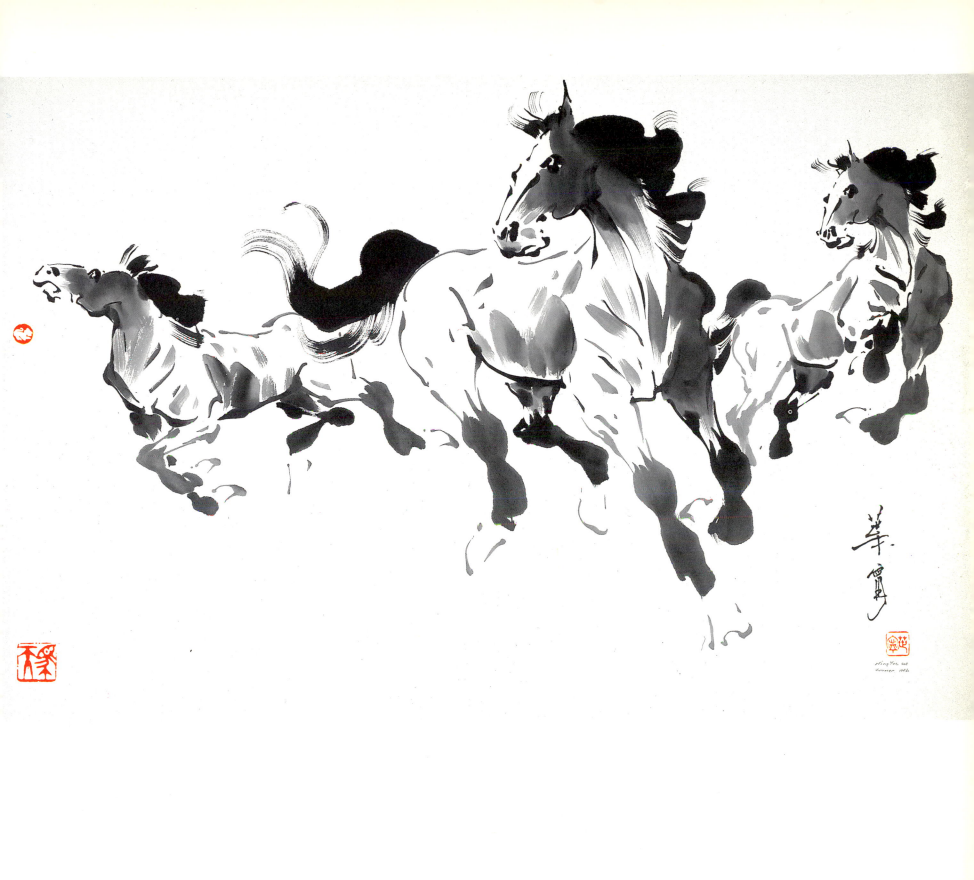

15

Fu-shin (Taiwan)

Collection of John and Donna Frantz

18"x36"
Paper: Jen-ho
Brushes: "Landscape" (line), "Big Idea" (color, texture), "Small Soft" (tree), "Wash" (mist, water).
Colors: vermillion, yellow ochre, burnt sienna, French ultramarine (structure); green mixed by blending yellow and indigo, Winsor emerald (field); Prussian green with charcoal gray (mountain, mist), manganese blue, Winsor violet (sky, water).

Seal: A Mood Like This Shall Be Forever Cherished in My Heart

Taiwan 台灣

Taiwan is beautiful. The island is covered with intense, lustrous green and high mountains embraced by misty clouds. Taiwan has all the graceful charm of southern China, with a touch of tropical scenery.

After several years of unsteadiness, my family settled in the northern border of Taipei in a village called Tatung (大同 Universal Harmony). My father was stationed in Quemoy (金門), an offshore island by Mainland China. My mother taught at an orphanage in Peitou (北投).

Peitou is a beautiful resort town with hot springs along the base of the high mountains. Every morning, my younger brother and I took a train with mother to the orphanage. Along the left side of the railroad, we would see the mysterious Kuan-yin (觀音 Goddess of Mercy) Mountain resting across the silk-belt-like Tamsui (淡水) River. On the right side, the arms of the high Tatun (大屯) mountains rapidly descend into the waving rice fields. Farming villages were surrounded by tall bamboo groves, and little brooks were dotted with water buffalo playing and ducks swimming.

Ten years after I left Taiwan, I made my first homecoming trip with forty of my students. Everything had changed, but along the Cross-Island Highway, there were still places reminiscent of my childhood memories, untouched by Coca-colazation.

I dearly love the scenery along the Cross-Island Highway and the Sun-Moon Lake. The former is full of strength and cuts through the marble canyons; the latter is filled with grace and changes mood and color with every white cloud floating by. On my trip I saw youngsters by the hundreds, hiking along the highway singing with their youthful tunes, and honeymooners on their row boats on the lake, waiting for the sunset.

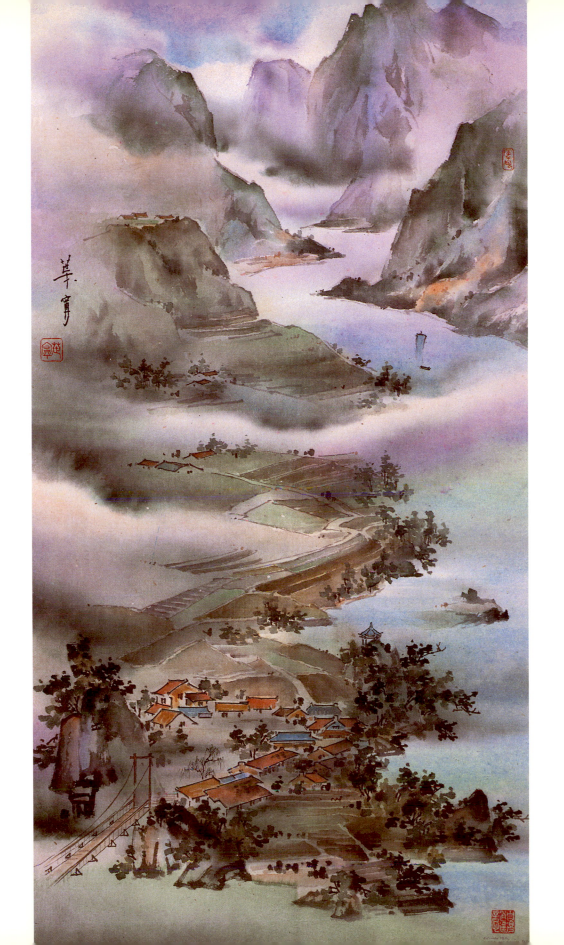

Home Town

Collection of John and Joanna Duffy

18"x36"
Paper: Jen Ho
Brushes: "Idea" (line), "Big Idea" (color, texture), "Wash" (water, sky, mist).
Colors: vermillion, French ultramarine, yellow ochre, Winsor violet, burnt sienna (structure); vermillion with white (bridge); green mixed by blending yellow and indigo, Prussian green with charcoal grey, Winsor emerald, vermillion, Winsor violet (mountain); manganese blue, Winsor violet, Prussian green with charcoal grey (sky, water, mist).

A Studio Seal

Our living quarters in Taiwan were very congested: I lived in an attic. When my work was chosen the "Best of Show" in a youth art festival, a well-known sculptor decided to carve a studio seal for me. "I will visit your place to find a suitable name," he said. I was very humbled to have to show my room to him, especially when I found out that he was a man who studied the connection between one's fortune and one's environment (a Feng-shui 風水 master). "Don't be ashamed of where you live," he said as he pointed to my painting table. "Where you are sitting is the place which will produce Chun-yuan (狀元 the name for the one who came out first in the Imperial Examination in the old days). "Out of your window stood the tallest peak of the Tatun Mountain," he proceeded to explain. "The trash dump which your village was built upon was a burying ground for gold. All the items of trash were at one time things of value. Now, they are all stuck up under your seat." He also explained, "The slaughter house next door provides constant fresh offerings . . . the three tall chimneys of the factory across the street are like incense burning. All these were at one time sacred items which people brought to

Seal: Studio Blessed with Potential

a temple for worship. The goddess of the mountain will bless you." He called my room "The Studio with Potential."

After school in those days, I would take my brother for a bike ride from the Confucian Temple, across the suspension bridge, passing the Orchid Mountain Rock, climbing up to the Martyr's Shrine, and ending behind the Grand Hotel to watch the sunset. This daily ritual continued into my college days, where I found another companion. A girl who liked me because I "smelled like her favorite tea" moved into the neighborhood across the river. All these happy moments of escaping the noise which came with the modern, metropolitan city and the ecstasy of teenage romance have made these sceneries particularly dear to my heart.

In my high school days, the study of Chinese geography, history, and literature became my focal interest. At the time, Taiwan was so eager to modernize that its youngsters were oriented mostly toward careers in the fields of science or commerce. The study of humanities was secondary. Yet I took tremendous pride in knowing every trivia of information which had to do with the Chinese land and people. My effort was rewarded by my recruitment into the finest university specializing in humanities studies. I received the highest honor for the high school graduates, which was to acquire the Pao Sung (保送) status, being able to enter the university as its first draft choice without going through the dreadful college entrance examination. To this day, it has remained one of the highlights in my life.

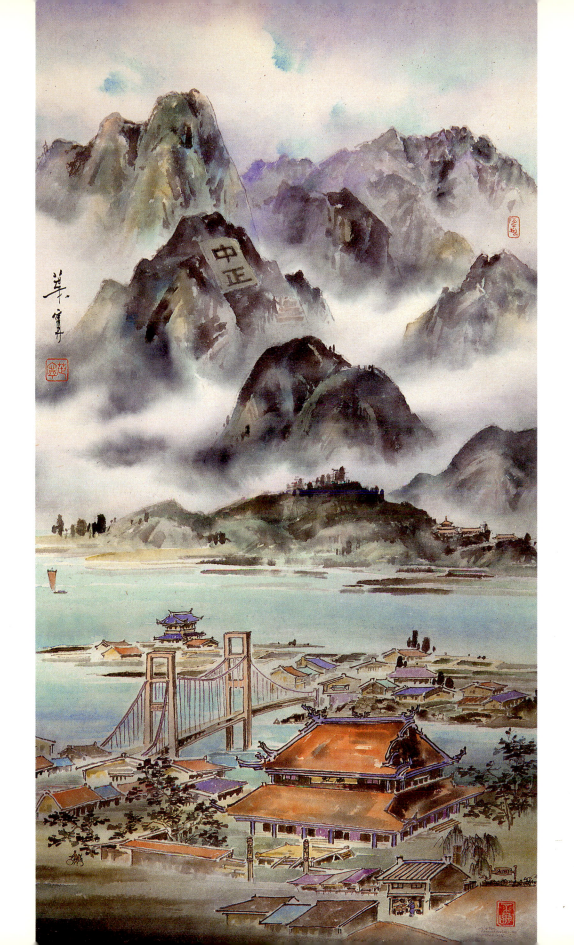

09 王者之香

Royal Presence (Peony)

Collection of Amy Hsu

18"x26"
Paper: Double Shuen
Brushes: "Flower and Bird" (small petal), "Large Flow" (large petal, leaf), "Idea" (pollen, seed pod, vein), "Orchid Bamboo" (branch).
Colors: poster white, permanent magenta, crimson lake (petal); green mixed by blending yellow and indigo, indigo and ink (leaf); burnt sienna and ink (branch); light green (seed pod); poster white with yellow (pollen); crimson lake and ink (new growth and branch dot).
For detailed, step-by-step instruction on the peony, see Lesson 13-15 in the Study Guide.

Muh Dan 牡丹

The tree peony is native to China and is called Muh Dan. The flower symbolizes good fortune and material well-being. It is the king among all flowers.

The fame of the peony reached its height during the Tang Dynasty (A.D. 618-906). The Emperor compared the flower to his favorite Court Lady, Yang (楊貴妃). A palace in the center of the peony garden was named "Subdued by Fragrance." The Emperor was particularly intrigued by the poem, "When the red peony poised in its shining crimson glow, its face flourished with romantic ecstasy, like a lady enjoying her wine." The Emperor invited Court Lady Yang to drink in front of a mirror to emulate the meaning depicted in the poem. While Lady Yang was practicing, the Emperor went to another lady, and Lady Yang got drunk. The tale has since been staged as one of the classic favorites in Chinese opera.

The best peony is cultivated in Loyang (洛陽). The legend for this particular peony city goes back to the days of the Empress Wu Zetian (武則天), the first woman sovereign in Chinese history (690-701 A.D.)

One cold winter day, the Empress was drinking in her chamber and enjoying the snowy scene outside. As she opened her window, she was greeted by the sweet smell of the winter plum blossoms. Her appetite for the fragrance of the flower aroused, she issued the following order to God:

> Tomorrow I shall walk about my garden;
> I bid you to make
> All the flowers blossom in the night,
> Before the morning wind has time to blow.

Because of her name, which means "Disciplining Heaven," and her absolute power as a ruler ordained by heaven, Zetian believed that the plants dared not disobey her. Indeed, all the plants began to bud and blossom that night, but the tree peony remained bare. Too proud to flatter the Empress, it did not put forth even one leaf. In utter rage, the Empress ordered all the peonies in the capital city of Xian (西安) to be banished to the town of Loyang. Once these peonies arrived at Loyang, they all blossomed with hundreds of new varieties of flowers.

Seal: Pleasing Thoughts of Beauty

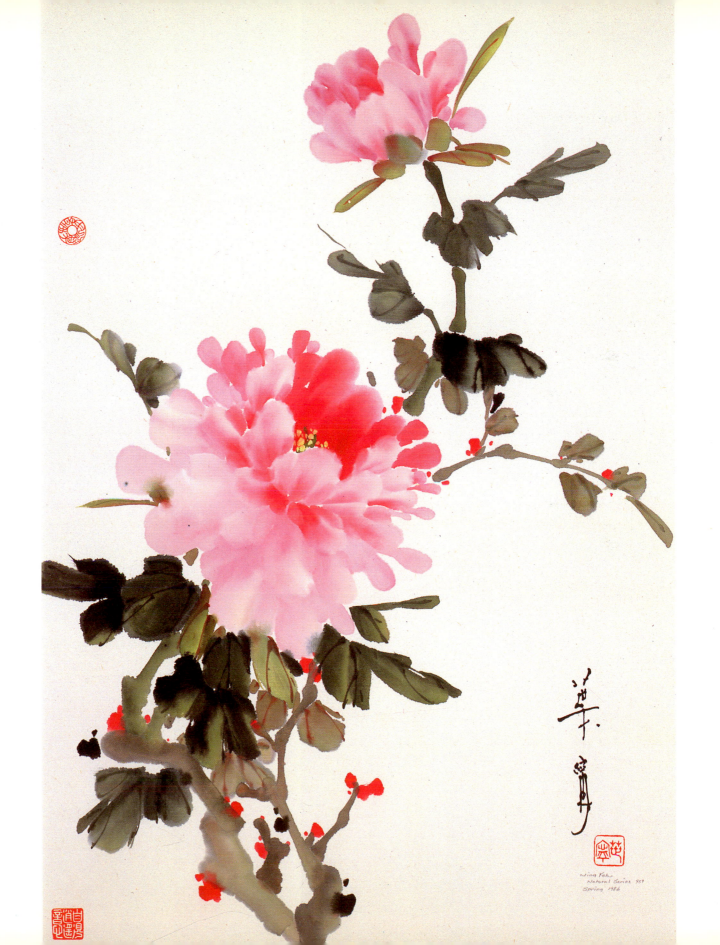

Ning Yeh
Natural Series 957
Spring 1986

Spring Comes to the Great Wall

Collection of Mary Lou Zoglin

18"x36"
Paper: Jen Ho
Brushes: "Idea" (line, dot), "Big Idea" (color, texture), and "Wash" (mist), "Flow" (tree dot).
Colors: yellow ochre, burnt sienna, Winsor violet (wall); green mixed by blending yellow and indigo, burnt sienna (mountain); poster white, permanent magenta (flower); dark green, Winsor violet, vermillion (mist).

The Great Wall 長城

The Great Wall twists and turns, rises and descends along the ridges of mountain chains, and stretches for six thousand kilometers across northern China. Construction of the wall began during the Warring States Period (戰國) in fifth century B.C., and was advanced by the Chin emperor (秦始皇 221-210 B.C.) — the number one tyrant in the history of China. Three hundred thousand forced laborers were involved in the construction. Little did the Chinese know that they were building the only man-made structure visible from the moon. They were, instead, preoccupied with the worries of stopping the barbarians' invasion from the north. Two thousand years later, the Wall has become the number one tourist attraction and the Chinese still have the same worries.

The Chinese compare the spirit of the Great Wall to that of the Imperial Dragon. It moves across the deserts, plateaus, meadow plains, and mountain ridges and eventually reaches the sea. It represents the crystallization of wisdom, along with the blood, sweat, and tears, of a glorious civilization. Many touching stories of romance, triumph, and tragedy were witnessed by these silent walls.

As mentioned earlier, landscape painting is referred to as Shan Shui (山水) in China. Shan is the mountain; it represents the constancy of nature. Shui is the water; it represents the change of nature. The most inspirational scenery is where the mountain meets water, or the Shan unites with the Shui.

I do not paint scenery totally from my mind. I feel very fortunate to be among the first generation to view the aerial photos and films of the scenery of China. It is indeed a privilege to paint some of the actual scenic wonders that offer so much background in the total cultural makeup of the Chinese nation. But I do not allow myself to be conditioned by what I see in the photos or films. For instance, the Great Wall rarely is visted by rows of cheerful mists. But in painting, the artist can send in the clouds.

Seal: I Like to Spend My Entire
Life Preparing Ink

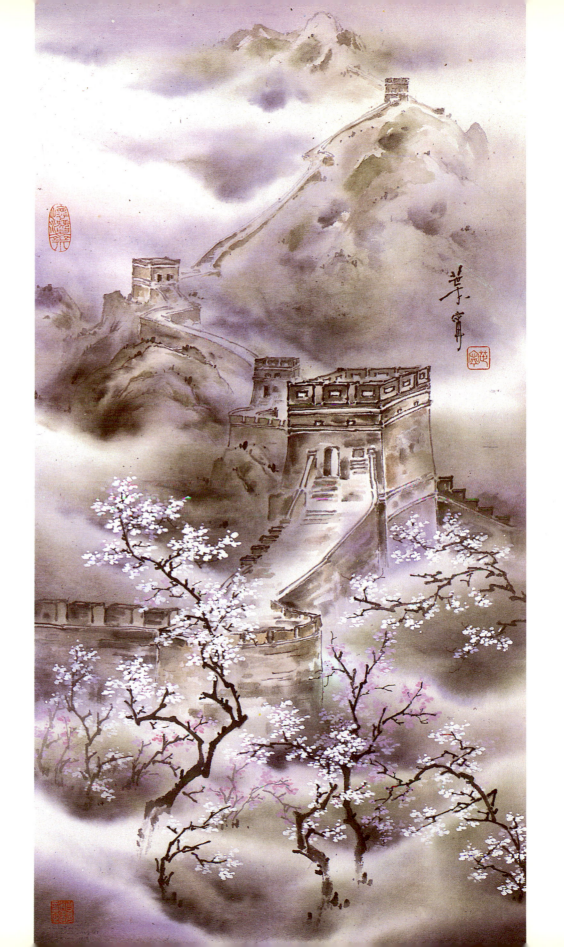

The Silent Watcher

Collection of Paul and Gwen Dent

18"x36"
Paper: Jen Ho
Brushes: "Idea" (line), "Big Idea" (color, texture), "Flow" (tree dot), "Wash" (mist).
Colors: yellow ochre, burnt sienna, vermillion, Winsor violet (wall); green mixed by blending yellow and indigo, burnt sienna (mountain); green, ink (tree); vermillion, Winsor violet, dark green (mist).

Chao Chun North Bound

Among the stories about the Great Wall, I was especially moved by the experience of Wong Chao Chun (王昭君) during the Han Dynasty (漢 206 B.C. to 220 A.D.).

Wong was a native of the Szechwan province, an exceptionally beautiful girl with a gift in music and poetry. At the age of seventeen, she was selected to enter the Court to be a candidate for the emperor's favor. Under the Han system, all the ladies were to have their portraits painted to be viewed by the emperor before a personal audience could be made. Wong's portrait was painted by Mao Yenshou (毛延壽), a court painter reputed for his talent but considered to be greedy and petty in character. In order for him to paint a portrait which could catch the eye of the emperor, Mao solicited bribery from the ladies, and most of them paid dearly. Wong, feeling confident about her own beauty and despising the mean nature of the painter, refused to oblige. Her portrait was done with deliberate malice by Mao, and she was kept in the back court without any prospect of being seen by the emperor.

The Han Empire was constantly raided and looted by the nomad hordes from the north. The Han emperor attempted to buy off his enemy by offering his court ladies, along with their sumptuous dowries to the chieftain of the northern tribes. When the Hsiung-nu (匈奴) tribal chief came to call, he requested a court lady from Han. The Han emperor looked through all the portraits and selected the least attractive one, figuring the barbarian did not know any better anyway. It was the portrait of Wong.

When Wong's appearance graced the emperor's court, the Han emperor was stunned to see her beauty, but it was too late for him to go back on his promise. Outraged, he executed portrait painter Mao and with regret he watched the court lady Wong, holding her favorite musical instrument, the pi pa (琵琶), disappear northward beyond the walls.

However, the above story appeared only in fiction. According to the real history, Wong volunteered in writing for marriage to the tribal chief, had many children, and lived happily ever after. She kept peace in the north for many years and was considered a great lady "diplomat."

I hesitated for a long time before telling you this truth. It really spoiled the fun of the tragedy. It is the Yin and Yang again.

Many years from now, people in China may spread the story of how Ning was forced to come to America to spread brush painting to those strange looking folks. I'll have them know, I volunteered to be here.

Seal: Hidden Beauty

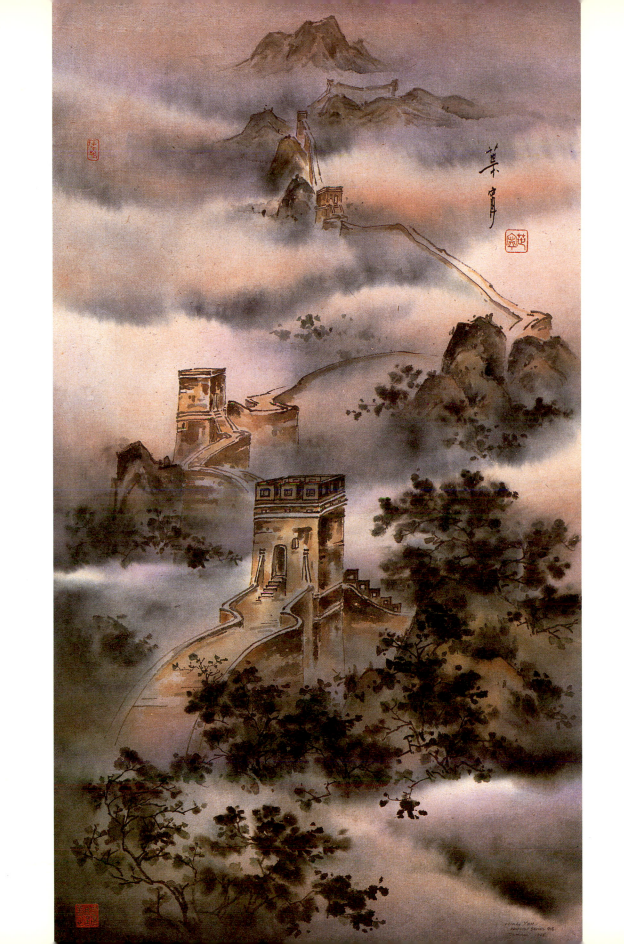

Panda

14"x26"
Paper: Double Shuen
Brushes: "Idea" (line), "Large Flow" (ink).
Colors: ink, vermillion.
For detailed, step-by-step instruction on the panda, see Lesson 7 in the Study Guide.

Da Hsiung Mao 大熊猫

The Chinese name for panda is "Da Hsiung Mao," which means "Big Bear Cat."

No animal, not even the imaginary dragon, has enjoyed such enormous popularity in the past decade as the panda. This large, stuffed-animal-like creature, has an irresistible, winning personality which charms the child-like spirit in all of us.

The panda is a native of Szechwan, in southeast China. The home of the panda is destined to become China's most beautiful national park area in the future. It sits high above the Szechwan basin, on top of the Min (岷) Mountains, with the Min River cascading through the dense bamboo forests. Jade blue lakes with multiple-colored petrified woods resting on their beds are located on different levels and connected by millions of waterfalls. In this "Land of the Fairies," the panda lives a solitary life, away from the madding crowd.

The panda is called a bear because of its size and its heavy limbs, but the zoologist places it in the raccoon family. To the Chinese, the panda is the panda.

The panda is heavy-bodied; it grows up to six feet in height and a weight of more than 250 to 300 pounds. Compared to a bear, its head is rounder and its nose and lips shorter. It has a very short tail (about eight inches).

The face of the panda is incredibly cute. The eyes are encircled by tilted black patches. On the underside of the large white nose, near the nostril, is a black triangle. The forehead takes up one half the length of the face. (To the Chinese, the length of one's forehead indicates one's intelligence.) At the top of the head stands a pair of "Mickey Mouse" dark ears.

The body of the panda is black and white and marked in sharply demarcated areas. The legs are black. The black of the front legs continues up over the shoulders, providing a strip of dark arch across its back. Some of the front leg dark hair comes into the chest area, but the rest of the body is white. The panda has long, sturdy claws which can carry the weight of the whole body in tree climbing.

The mother panda takes very good care of her baby but usually limits her attention to only one offspring.

I have recently started to teach panda painting in my beginners' class, in order to change the all-too-serious mood into a delightful, casual pursuit of fun — which is why most of us paint to begin with. Because of its use of minimum shapes and lines, the panda exercise will help to turn the artist loose, using cheerful dots and a blending of ink to present a clever suggestion of a playful spirit. Through this exercise, may many artists discover the true meaning of spontaneity.

Seal: A Gift of Love

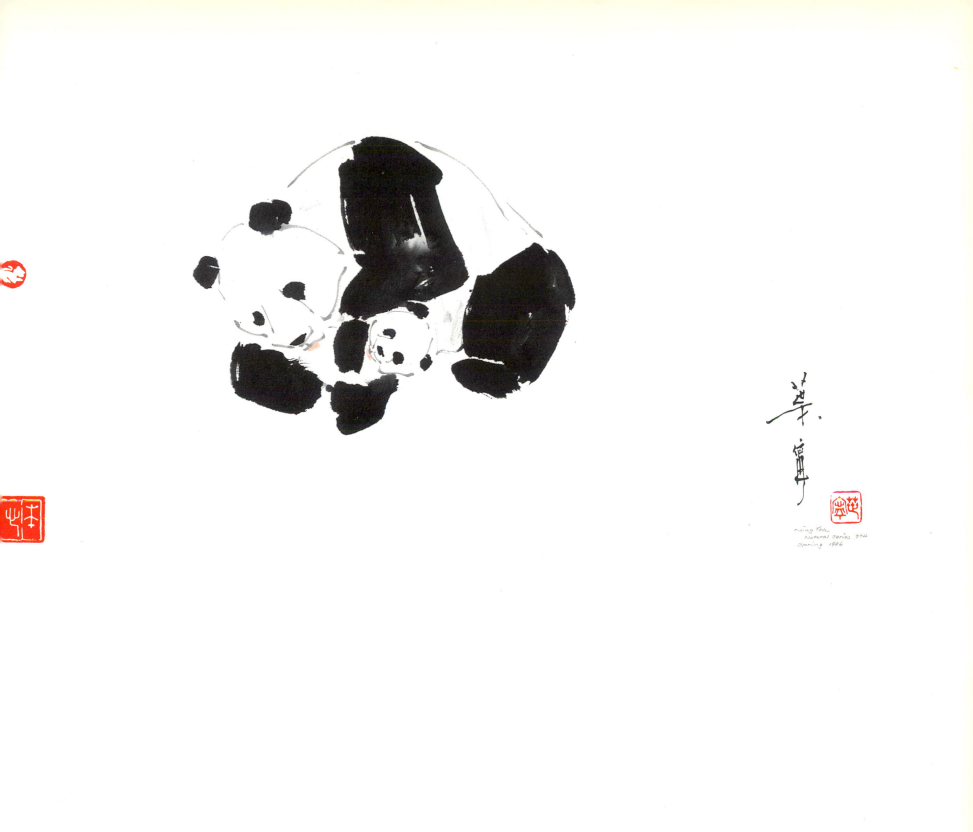

Ning Yeh
Natural Series #26
Spring 1986

The Goddess of Mercy

Private Collection

18"x36"
Paper: "Double Ma"
Brush: "Idea" (line), "Flower & Bird" (color, shade), "Wash" (background).
Color: poster white with vermillion, burnt sienna with ink (statue); Winsor violet, neutral tint, ink (shade, backround).

Seal: Pure

Kuan Yin 觀音

I love the Buddhist gods and goddesses. Among them, I am partial to Kuan Yin, the Goddess of Mercy.

The Kuan Yin Mountain, located along the northwestern edge of metropolitan Taipei, is a mountain of enchanting grace. Every sunset, the golden rays highlight the contour of the sleeping goddess, resting so calmly across the Tamsui River (淡水河). For years I longed to find a rendition which could bring the true spirit of Kuan Yin to life. Sadly, most temple goddess statues lack the graceful elegance needed to reveal the true personality of this great lady.

Then I had a chance to see a documentary series about the Yangtze River. When the film took the viewers to Szechwan, there was a section on Dai Chu's (大足) statues. It began by showing the statues along the mountain surface. Many of the scenes depicted some of the most gruesome punishments one receives upon entering hell. For one who knows he has many sins, I really did not need to see these. However, as I was just about to leave the film, it began taking the viewers into a grotto inside the mountain. There I saw the perfect rendition of the Kuan Yin from my dreams.

This statue of Kuan Yin sits with twenty or so other statues in a cave called "The Carrier of the Spirit." This Kuan Yin's face is a little fuller than all the other Kuan Yin I have seen, and it reveals more kindness. Her eyes are closed and the corner of her lips tightened. It is as if she is at the very moment of acquiring the true meaning of life in her deep thoughts and about to smile. She does not have the cold, out-of-this-world, godly presence; rather, she possesses a personal dignity which inspires the good and forces the bad to repent in shame. The moment I saw her face, I exclaimed from my heart with rejoicing, "My thirty years of waiting is over, I now have my perfect Kuan Yin."

The stone carvings of Dai Chu have not achieved the same fame as have places in northern China. I love them even more because of their less-known quality. The statues, numbering over 5,000, were started during the Tang Dynasty (唐 892 A.D.) and their creation continued for over 250 years. The cave which houses the Kuan Yin was completed during the Southern Sung period (南宋 1142-1146). When I think of these artisans who came into remote southwest China and spent generations of efforts to preserve their cultural heritage, I salute them with my utmost admiration.

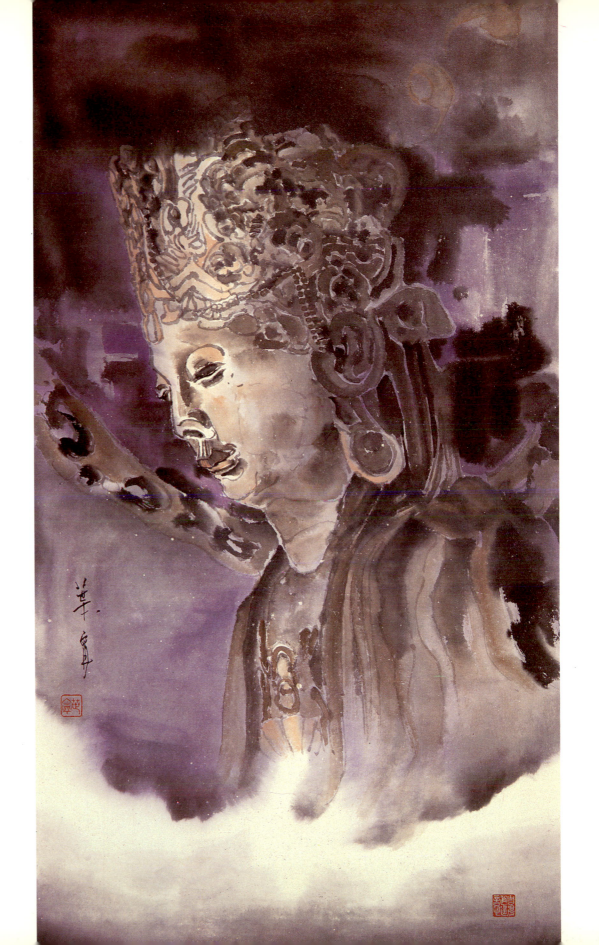

Ji Chang Garden

Collection of Paul and Gwen Dent

Seal: A Journey into Art

24"x36"
Paper: Jen Ho
Brushes: "Idea" (line), "Big Idea" (leaf, color, shade), "Wash" (water, sky, mist).
Colors: burnt sienna with ink, vermillion, red with brown madder, Winsor violet, poster white with vermillion (structure); green mixed by blending yellow and indigo, Winsor green with sepia, ink (leaf); yellow ochre, burnt sienna (trunk); burnt sienna, vermillion, Winsor green with sepia (rock); manganese blue, Winsor violet, Winsor green with sepia (sky, water).

Wuxi 無錫

Besides Hanchow (杭州) and Soochow (蘇州), there are many ancient and beautiful cities in the lower Yangtze valley. Wuxi, in Jiangsu (江蘇) province by the Lake Taihu (太湖), is where the beautiful Hsi-shih (西施) chose to retire.

During the late "Spring-Autumn Period" (春秋 722-481 B.C.), the Chou (周) Emperor was weak, and many feudal lords developed their own kingdoms and competed for power. In the struggles among the states, the King of Wu (吳) defeated the King of Yueh (越) and took him prisoner.

When the King of Yueh was released to return to his home state, he vowed revenge. Feeling comfort had caused his downfall, he slept on chopped wood and hung an object, which is too distasteful to mention in this book, over his head so that he could taste it every day and be reminded of his humiliating defeat. He knew that the King of Wu liked beautiful women (Who doesn't?), so he sent his minister named Feng (范蠡) to search the whole country to find a beauty to occupy the King of Wu's attention. Feng came across a wood chopper's daughter named Hsi-shih.

According to the historical record, Hsi-shih possessed such beauty that in her presence the moon would hide in the clouds and the flowers wither because of their shame over their unfavorable comparison with her beauty. Whenever she came out to wash yarn along the stream, the birds would stop flying and the fishes stop swimming so they could stare at her. (Wow! But seriously, I find my tropical fish does that to me sometimes too.)

Feng was enchanted with Hsi-shih, and he took her back to the king's court and taught her music and dance for three years. He fell deeply in love with her, but for the sake of his country, he had to let her go to the King of Wu. When Hsi-shih arived at Wu on a boat decorated with silk ribbons, the King of Wu built a special palace for her and became completely possessed with her charm.

After ten years of preparation, the King of Yueh staged his counterattack, with Feng leading the troops. The capitol of Wu was captured. With mixed emotions, Hsi-shih attempted to kill herself. She was stopped by Feng, who revealed his long cherished love for her and proposed to give up his high post and accompany her into seclusion.

While the capital of Wu was burning in flames, the two lovers got on a boat and sailed into the mist of Lake Taihu.

Among the many exquisite scenic gardens in Wuxi, the Ji Chang Garden cleverly incorporates the surrounding sceneries in its design. The garden was built between 1506-1521. The Chien-lung Emperor (乾隆 1735-1795) was so impressed with the garden that he ordered the Xie Qu Garden (諧趣園) in the Summer Palace in Beijing (北京) to be built following the blueprint of the Ji Chang Garden.

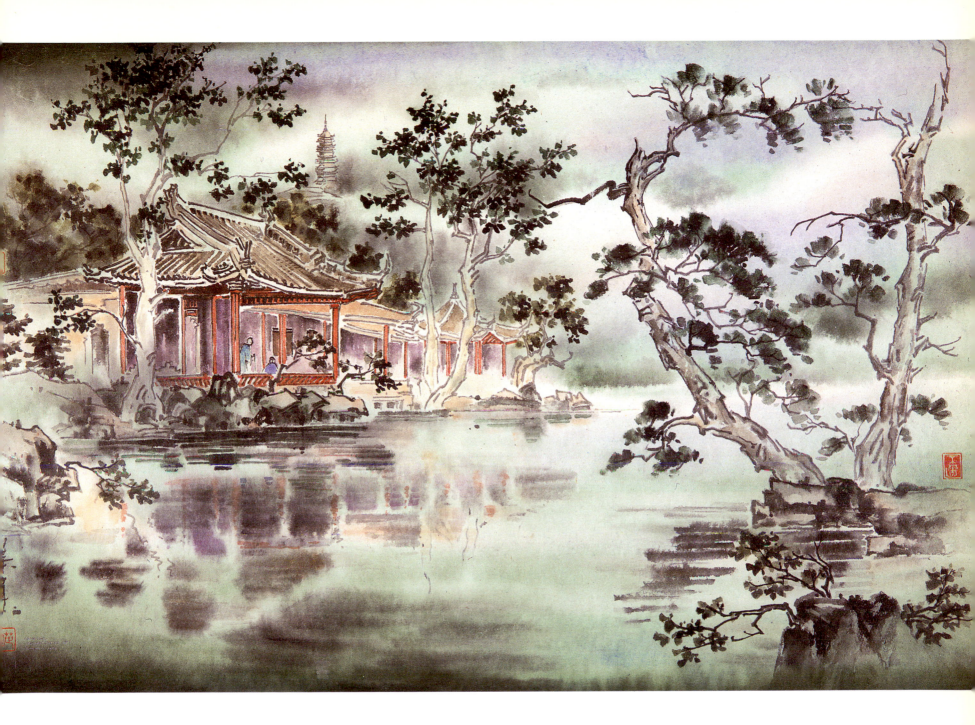

15 月梅

Plum Blossom in the Moonlight

Collection of Clay Marcus

Paper: Ma
Brushes: "Large Flow" (trunk), "Big Idea" (blossom), "Best Detail" (pollen, stamen), "Wash" (background).
Colors: poster white (blossom, stamen); white with dark green (flower center); white with yellow (pollen); ink and burnt sienna (trunk); pasty ink (calyx); Winsor violet and neutral tint (background). The painting is done by doing the branch and trunk first. When these parts are dry, apply the background wash. Then while the wash is still slightly wet, add the blossoms.

Mei Hwa 梅花

The plum, Mei Hwa, is the Chinese national flower. The spirit of the plum lies in its perseverance and resiliency; a symbol of life's vitality during harsh winter days, it demonstrates the will to survive and blossom during hard times.

As the leader of the "Four Gentlemen," the plum blossom study is designed to provide an intensive study of dots.

Related to the study of dots is this story: The most famous father and son calligraphers in China were the Wongs — Wong Hsi-tze (王羲之), the father, and Wong Shin-tze (王獻之), the son.

When the son was little, he began to follow in his celebrated father's footsteps and started learning to become a calligrapher. One day, after he completed his exercise of the "one thousand characters essay," he was so proud of his work that he took it to his father for praise. The old Wong studied the son's writing and without saying a word, he picked up his brush and added a dot to one of the characters. "Take your work to mother for a critique," the old Wong said.

When the mother glanced through the writing, she singled out the dot done by the old Wong immediately. "This dot is good," she said to her boy.

The young Wong swore that he would use up the water in the fish pond nearby to grind ink to continue his studies. A few years later, his mother could no longer tell the difference between his dots and his father's.

Few are born geniuses; the rest of us have to work hard. Good artists come with constant practice.

Seal: Fragrant Shadow

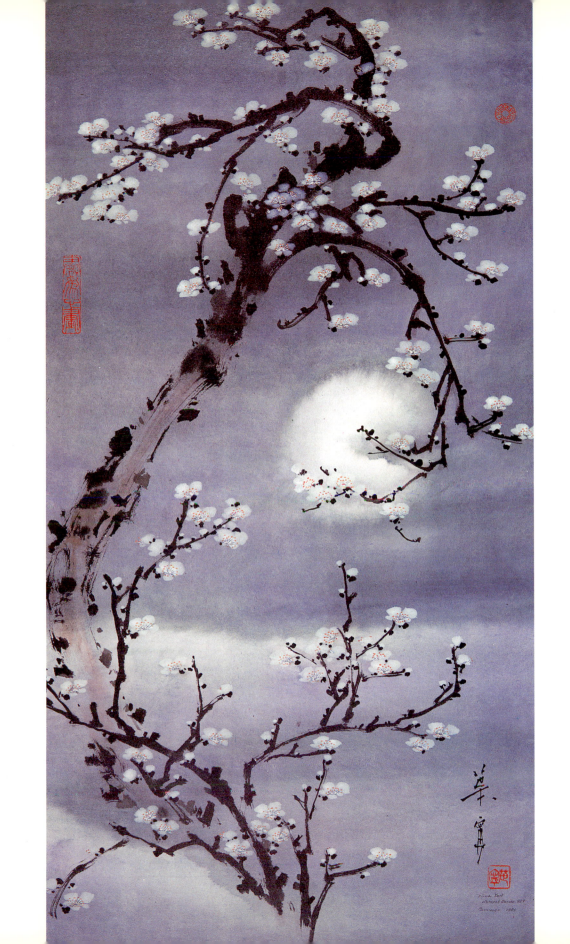

Misty Mountain Impressions

Collection of Bert and Bobbie Lou Heidelbach

22"x36"
Paper: Jen Ho
Brushes: "Mountain Horse" (texture), "Big Idea" (color),
"Landscape" (detail), "Wash" (mist).
Colors: ink, vermillion, manganese blue, Winsor emerald.

Serendipity

I longed to see a demonstration of the Cantonese landscape techniques, but the masters of that school rarely reveal their techniques in public. In the summer of 1983, Cantonese artist Koo Mei (顧媚) was invited by Professor Lindstrom to visit Utah State University. Wading literally through floods, my wife Lingchi accompanied me to Utah and had a great time while I observed Koo Mei.

Several months after the Utah trip, I finally had some success in injecting the type of energy Koo had, through using a bold splash of ink and the incandescent use of color. Furthermore, I managed to stay away from the figurative statement to tell an exact story. I was really happy to see my results.

When the famous artist, Wong Lan (王藍), the chairman of the Chinese Watercolor Society, came to visit, I put my new painting in a frame and hung it in haste. Wong was impressed, and made some most insightful comments. After he left, I returned to enjoy the painting in quiet solitude. It was then I discovered that I had hung the painting upside down.

Good work makes sense in all directions.

Seal: Acquiring the Idea
beyond the Image

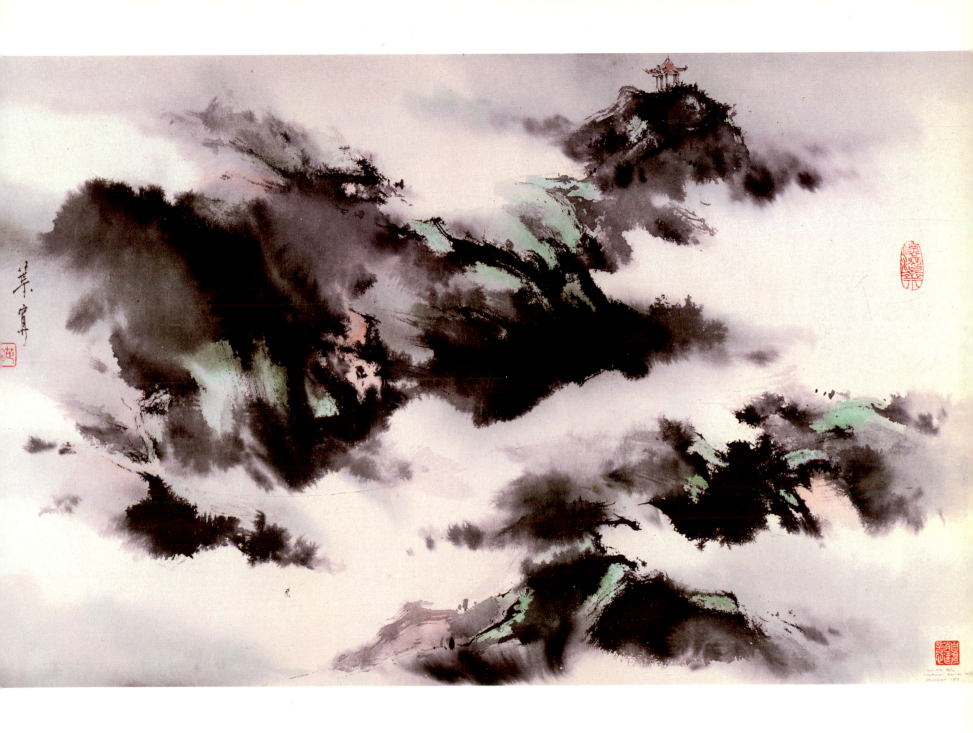

35

Good Companions (Peony)

Collection of Jack and Peggy O'Mara

Paper: Double Shuen
Brushes: "Flower & Bird" (small petal), "Large Flow" (large petal, leaf), "Idea" (seed pod, stamen, vein), "Orchid Bamboo" (branch).
Colors: poster white, permanent magenta, crimson lake (petal); green mixed by blending yellow and indigo (seed pod); white with yellow (pollen); green, indigo, vermillion (leaf); burnt sienna, ink (branch); crimson lake, ink (young leaf, dot); crimson lake (vein).
For detailed, step-by-step instruction on the peony, see Lesson 13-15 in the Study Guide.

A Family of Painters

I came from a family of four generations of brush painters. My father is internationally renowned for his horse paintings. Due to certain circumstances, my parents lived in separation and I grew up with my mother. During my high school days, though, my father lived in a studio not too far from our home. After school, I would go to his place to help him prepare ink and to watch him paint. My mother forced me to practice and constantly urged me to visit other masters' studios. But out of respect for my father, I never formally studied under any other master.

My father is a genius, one of those rare individuals who in their lifetimes are allowed a self-awareness of their place in history. I, on the other hand, was forced to paint to begin with, and only after discovering how much joy it brought me did I paint just for the fun of it. This is why, perhaps, that my father was a general and I only made second lieutenant. After one year of forced ROTC training, I hastily made my exit and flew over the Pacific Ocean.

The second most frequently asked question during my art demonstrations is "Does your son paint?" Both my children, my son Evan and daughter Jashin, paint; however, neither has been pushed as I was. One day I overheard my son talking to his friends: "My folks have this Chinese thing . . ." Alas, I am the father of two Americans, as pure as they come.

What is the first most frequently asked question during my art demonstrations?

"What are you going to do with your demonstration piece?"

Seal: The Yeh Family from Ching-tien, Chekiang

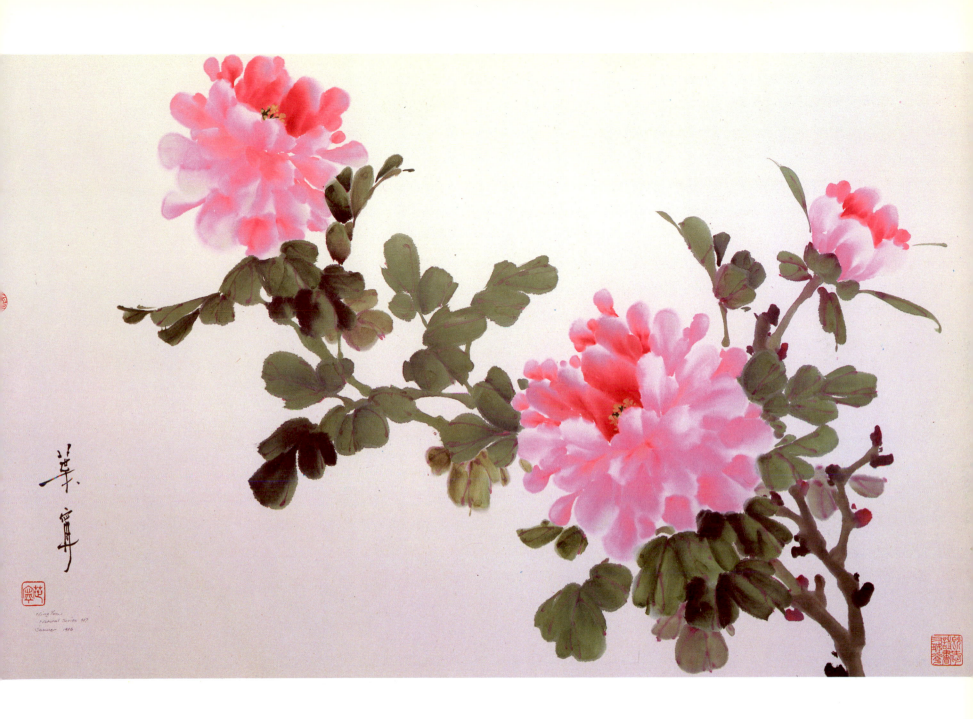

Tung Yuen
Floral Series #7
Summer 1986

Elegance (Horse)

Private Collection

22"x36"
Paper: Double Shuen
Brush: "Large Flow"
Color: Brown Bottled Ink
For detailed, step-by-step instruction on the horse, see Lesson 16-17 in the Study Guide.

Seal: Elegance

Good Equipment

I consider the "Large Flow" brush to be the best brush for my animal studies.

Master painter Hung Chun-pi (黃君璧) once said, "It is the good hand, not the good brush, that makes good painting." When I visited his studio, he was using the finest equipment. A good hand still likes a good brush.

When I was fifteen, my mother gave me an "Orchid Bamboo" brush which she had kept for many years. I could not believe the difference it made on my bamboo leaves. After I boasted of its miraculous power to my non-painter friend, he could not help but try it. Nothing happened. A good brush still needs a trained hand.

In 1949, my mother left Shanghai (上海) and took me to Taiwan. Because of our haste, the only valuable things we took were the brushes and an ink stone which were on the studio table. Later my father transferred four cases of rice paper which had been damaged by water stain. My mother, besides being a great disciplinarian, is a meticulously neat lady and there was a considerable amount of pressure exerted on me to empty these cases of damaged paper by practicing. In many ways, I now feel fortunate to have had the opportunity to use these treasures and acquire the knowledge of differentiating the merits of various painting tools.

When I first started teaching in the United States in 1972, the best equipment was unavailable because of China's dreaded "Cultural Revolution." I wrote to a Hong Kong brush dealer complaining about the wolf hair brush he sold me. The brush had the same label as the ones my family used, but it felt far inferior. He wrote in reply, "Since we could not obtain wolf hair collected in China, we have to use hair from Australia." The implication seemed to be that the Australian wolves were not as artistic as the ones in China.

In 1978, my younger brother came to visit me. To my surprise, he brought the ink stone which my mother had taken from our home in Mainland China. As we were sharing our findings, he began to prepare ink. When I saw his bony fingers holding the ink stick as he started grinding, I was overwhelmed with uncontrollable tears. Yes, the wonderful tradition of Chinese brush painting shall continue and blossom in my family. With many in this country now sharing our enthusiasm, it shall find its roots here in the United States.

China's upheaval has subsided. In the past several years, I have made extensive trips to the Orient, and I now have the best materials for everyone who shares the interest of Chinese brush painting.

The good brush now waits for the good hand.

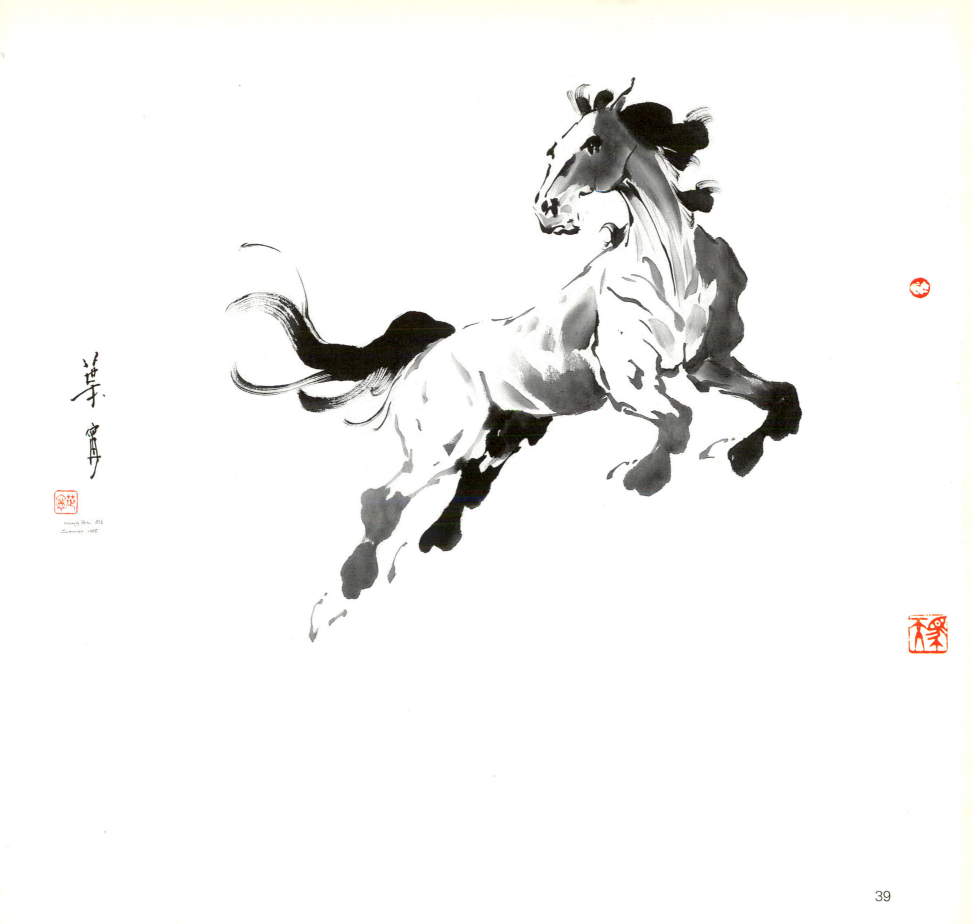

Spring Comes Early in South China

Collection of Mr. and Mrs. Collins
Joyce O'Donnor interior design

16"x24"
Paper: Double Ma
Brushes: "Idea" (line), "Big Idea" (color, dot). "Wash" (shading, mist).
Colors: burnt sienna with ink (tree trunk, boat, bank); Prussian green with charcoal, green mixed by blending yellow with indigo, Winsor emerald (foliage, meadow, water); vermillion, Winsor violet, manganese blue (distant mountain, water, sky).

Seal: The Dawn of Spring

The North and the South

The map of China is shaped like a begonia leaf, with the Shantung (山東) peninsula as its stem and the Chin Mountain Range (秦嶺) cutting across and dividing China into two parts, the north and the south.

Northern China centers around the activities of the Yellow River; southern China, the Yangtze. Northern China's sceneries are grand and somewhat monotonous: the yellow plateau, the Gobi desert, and a massive plain formed by the wash of several rivers. Big industrial cities have a similar outlook. Southern China is marked by grace and variety. Networks of waterways thread through layers of emerald green mountains, and the people of the numerous settled farming villages speak dialects virtually incommunicable to the people in other villages.

Northern Chinese eat foods made of wheat if it is available. These people are taller and physically stronger than southerners. Many northerners used to be good horsemen. Their temperament is straightforward, raw, and rugged. When angry, they reach out with their fists, wrestling into

a pile before any word is exchanged in argument. Afterwards, they smile at each other and remain good friends. Their ladies are big-footed and do not clean house (just a personal observation). When there was not enough to eat, they came south to take from the southerners. All the Emperors came from northern China.

The southern Chinese eat rice. Their attitudes are "laid back" and "at ease." Culturally sophisticated, they engage in wine and poetry. When they disagree, they exchange words which humiliate up to generations of ancestors, but they retreat away from each other physically (Folks from Canton, Hunan, and Szechwan are notable exceptions). And the sweet, soft southern ladies with their musical sounds can bring any man to heaven.

I guess you know where I came from.

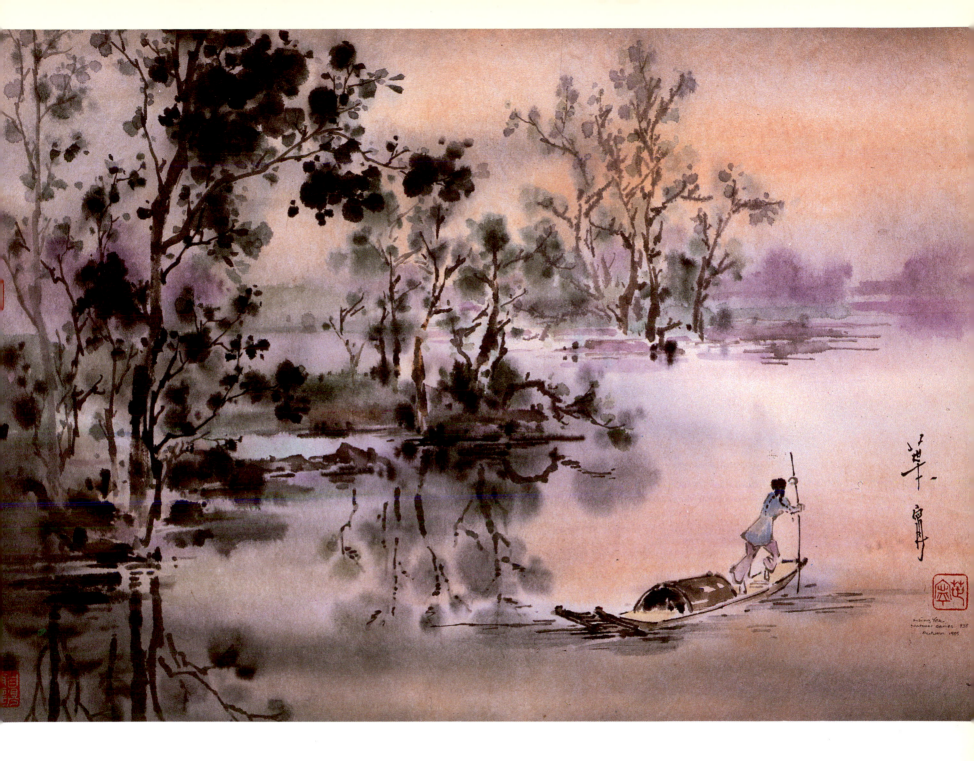

41

Swinging (Grass Orchid)

Collection of Clay Marcus

14"x18"
Paper: Double Shuen
Brushes: "Orchid Bamboo" (leaf), "Idea" (petal, stamen, stem).
Colors: green mixed by blending yellow and indigo, indigo, ink (leaf), green with crimson lake (petal, stem), crimson lake (stamen).
For detailed, step-by-step instruction on the orchid, see Lesson 2-3 in the Study Guide.

Seal: Every Blade of Grass,
 Every Branch of Tree, Shares
 the Essence of the Vital
 Spirit of the Universe

Lan 蘭

The grass orchid (Lan) is admired for its subtle beauty. Its fragrance is intimately enticing but never overpowering. It usually chooses its hermitage in the most spiritual places in nature, where the mountain is embraced by mists or rocks by the roaring streams. To sit with the orchid is a scholarly pursuit with a long tradition. It inspires purity and simplicity.

Ch'u Yuan (屈原), the most commemorated poet of the ancient Chu (楚 about 300 B.C.) always wore an orchid on his robe to set himself apart from the corrupted ministers. In the year 278 B.C., on the fifth day of the fifth moon, he drowned himself in protest against in ill-advised Emperor who ruled his country. The local people raced down the river by boat, in vain trying to salvage his body, beating gongs and drums to scare off the "evil spirits" in the water and throwing rice wrapped with bamboo leaves to calm the creatures in the waters. This day has since marked the celebration of the Dragon-boat Festival. Many orchid societies hold shows in memory of Ch'u Yuan.

A beautiful painting should be beautifully executed. It is a symphony of continuous movements. The motions in the air are just as vital as the strokes and washes on the paper. When the artist is well trained, everything is delivered without labor. The intuition from the heart takes over, and the mind is left unconscious. The artist takes initiative, rather than passively reacting or pondering alternatives.

The grass orchid is a happy spirit; its petals and leaves are ecstatic with joy. The artist should be in the happiest state of mind when painting the grass orchid. It has the simplest form, blessed with ample possibilities for capturing spontaneity of movement. Yet perhaps because of its simplicity, it is one of the most difficult subjects to paint. I like to begin my first class by asking the aspiring "baby" brush painters to paint the orchid. They usually do a good job, because they know nothing and therefore are the happiest painters.

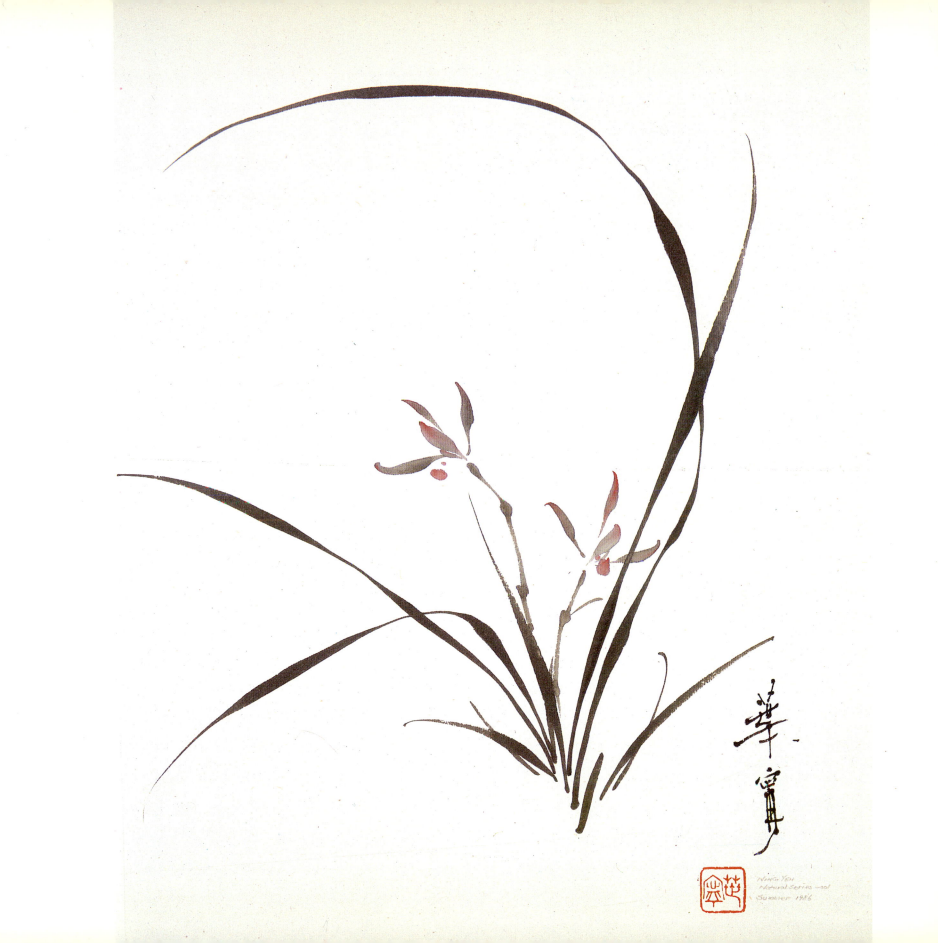

Nature's Brush (Magnolia)

18"x26"
Paper: Colored Shuen (Brown)
Brushes: "Big Idea" (petal outside), "Flower & Bird" (petal inside), "Idea" (flower center, leaf vein), "Large Flow" (leaf), "Orchid Bamboo" (branch).
Colors: poster white (petal outside); poster white, yellow, vermillion (petal inside); purple madder (center); yellow with white (center dot); green mixed by blending yellow and indigo, indigo, ink (leaf); burnt sienna with ink (branch).

Yu Lan 玉蘭

In early spring, hundreds of magnolia buds appear on the tips of bare branches. Like hundreds of brushes prepared by nature, they remind every painter to begin his new year's work.

The white magnolia is known as Yu Lan (Jade Orchid) in China. The flower has the color of jade and the fragrance of the orchid.

The love of Yu Lan is widespread throughout China. Standing proudly in front of the Happy Longevity Hall in Peking's famed Summer Palace is a tall magnolia tree planted by the Ching (清) Emperor in 1750. In early spring, the Emperor called his garden "the Ocean of the Fragrant Jade," in honor of the blooming magnolia. Along the Nanking (南京) Bridge across the mighty Yangtze River, lamps shaped like magnolias light up the sky at night. In their poems, literary giants have compared the flower to the fairy princess descending from heaven. The street vendors fry the flower petals with flour and sugar and sell them by the railroad station as "Jade Orchid Cakes."

The magnolia blossom resembles the shape of the lotus. In some regions of southern China, the flower is called the tree lotus. The legend has it that a lotus flower disliked being rooted in the water and yearned to play with fire. Her wish was granted when she was blown to the top of the tall tree nearby. She dropped her seed pod and held at her center a flaming torch in replacement.

Seal: In Harmony with the Spring Breeze

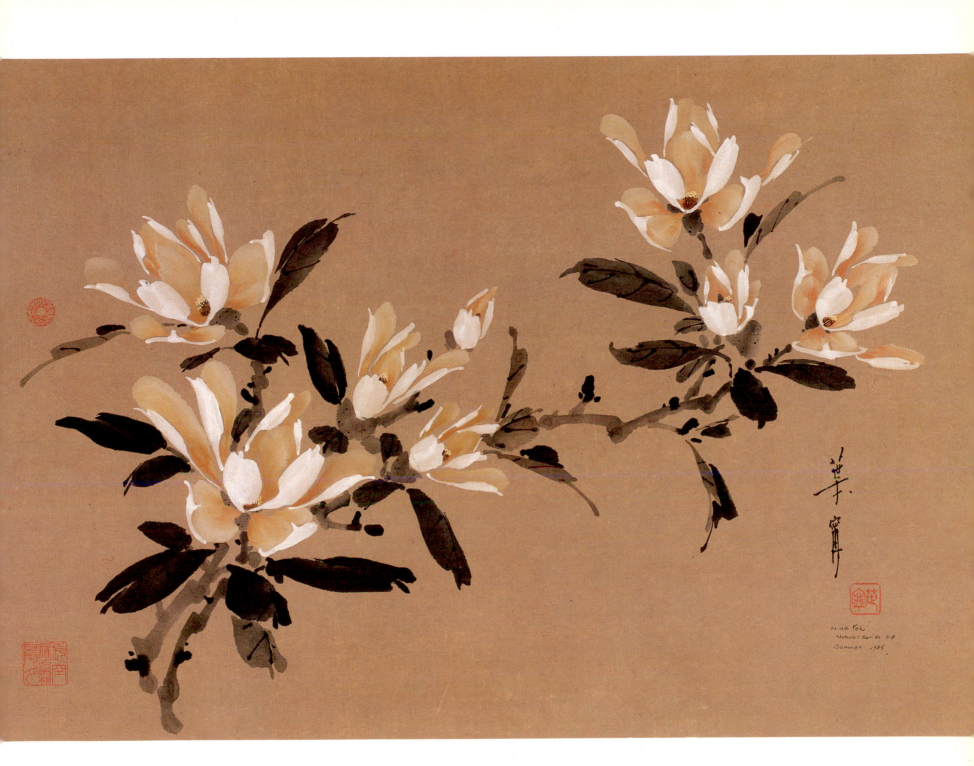

NING YEH
Natural Series 4-8
Summer 1985

22 晨操

Morning Exercise

22"x36"
Paper: Jen Ho
Brushes: "Idea" (line), "Big Idea" (color, shade), "Wash" (mist, sky).
Colors: yellow ochre, vermillion, red, crimson lake, brown madder, burnt sienna, sepia, Winsor violet, Winsor green, Prussian green, charcoal gray, yellow, indigo, French ultramarine, manganese blue, ink. Incredible, isn't it? I forgot which color is used where!

Wu Dang 武當

A unique curse, or blessing, for a boy growing up in China is the unavoidable addiction to the reading of martial arts novels. Nothing in the West is the equivalent, except maybe a combination of western, science fiction, adventure, romance, and horror stories. Long before the coming of Bruce Lee (李小龍) Chinese youth were victims of these martial arts stories. I was no exception.

In school I took pride in being the best friend of two types of people: the ones who studied hard and the ones who played hard. In my senior year, in the National Normal High School (師大附中), all the students who intended to study the humanities were grouped in one class: "the Class 90." (九十班) This class consisted of all the unruly, anti-establishment elements from all the other "regular" classes. I was elected as the class president. Among the first priorities of my presidential decisions was to start a book club to provide my classmates with the officially banned martial art novels written by Jin Yung (金庸). Jin Yung was a fantastic novelist who linked his stories to historical events and who had made many of the bandits in Chinese history look good. Since the novels looked identical to the textbook, the book club served a vital purpose, to help everyone in my class sit through the much dreaded period of "good citizenship."

The two main schools of Chinese martial arts are the Buddhist's Shao Lin (少林) and the Toaist's Wu Dang. The Shao Lin Temple was the base for Chinese martial arts. Wu Dang was founded by Cheng Shai Feng (張三豐), a one-time Shao Lin disciple. He left the Shao Lin Temple, and between 1368-1399, he took hermitage in the Wu Dang Mountain in Hupei (湖北) province. The phenomena of nature and the activity of the animals inspired him to develop the "Tai-chi" (太極) movement. These movements stress an inner tranquility which results from the union between the body and the mind. As the founder of the Wu Dang school, Cheng Shai Feng must feel very proud that his Tai-chi movements are now practiced all over the world.

The third Emperor of Ming (明) took away the throne from his nephew, Hui Ti (惠帝). Hui Ti went into the Wu Dang Mountain to become a Taoist priest, and many of his loyal followers went with him. The Emperor eventually attacked the mountain. Hui Ti committed suicide. In order to ease his own guilt, in 1412 the Emperor began to build a series of temples in the mountain to honor his nephew and other Taoist deities. These temples had some of the most unusual combination of bright colors.

I had thoughts of choosing Jin Yung's novels as the topic for my Ph. D. dissertation. Eventually, however, I chose "Brush Art as a Unique Propensity in the Subculture of the Gentry Elite in Traditional China" as my topic. Getting a Ph. D. degree in the United States in the humanities was considered very hard for a Chinese overseas student. I think it is a piece of cake. The trick is to choose a topic which none of the professors in your dissertation committee knows anything about. They have to agree with you.

Seal: Ascending to Another Level

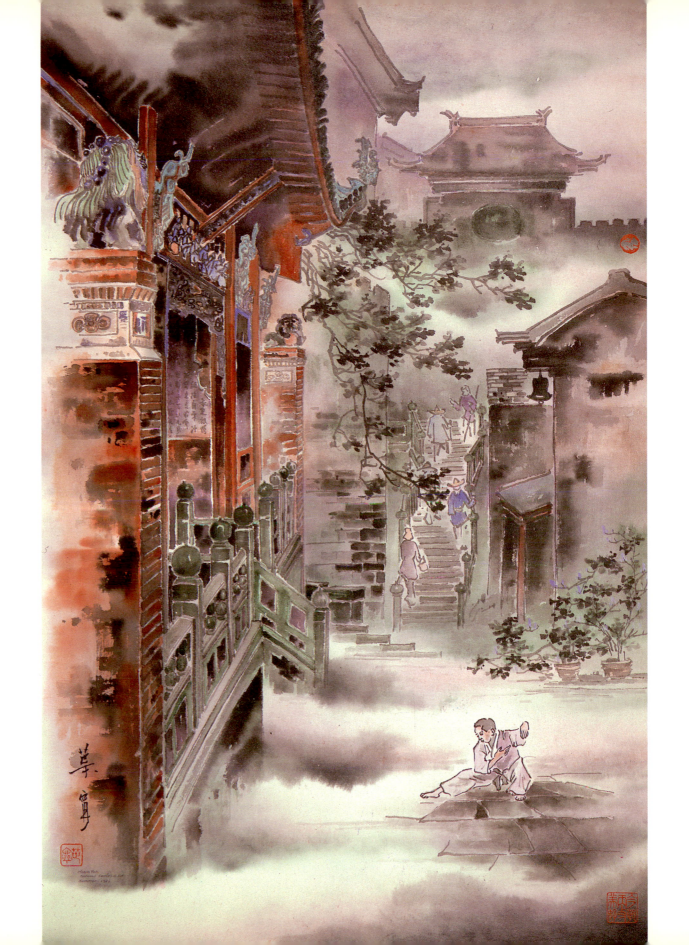

23 舞姿

Dancing Poise (Poppy)

Private Collection

18"x26"
Paper: Double Shuen
Brushes: "Large Flow" (petal, bud), "Big Idea" (leaf, stem), "Idea" (seed pod, pollen), "Best Detail" (fine hair).
Colors: yellow, vermillion (petal backside); yellow, vermillion, red (petal front side); light green (seed pod); poster white with yellow (pollen); green mixed by blending yellow and indigo (leaf, hair, stem).

Yee Mai-jen 虞美人

The name Yee Mai-jen, or Lady Yee, was given to the poppy to commemorate Yee Chi (虞姬), the beautiful and courageous wife of Hsiang Yu (項羽 about 200 B.C.)

Hsiang Yu, the "Chinese Hercules," was endowed with mighty strength and stature. His horse, Wu-tsui (烏睢), an awesome dark creature, was also renowned for its daring and vital spirit. The two shared many victories together.

When the Chin Dynasty (秦 221-210 B.C.) fell, Hsiang Yu took his troops across the Yangtze River into the battlegrounds of Northern China. Lady Yee chose to follow him and stood by his side in every battle. Eventually, the struggle for power became a rivalry between Hsiang Yu and Liu Pang (劉邦 the founder of the Han Dynasty). Hsiang's physical strength proved to be no match for Liu's cleverness. After a long and arduous war, Hsiang's army was surrounded by Liu's troops.

At nightfall, Liu ordered his soldiers to sing the folk songs of Hsiang's homeland to the homesick stricken troops who were trapped in desperation. Lady Yee tried to boost Hsiang's fighting spirit by dancing with his sword. But, too strong was his sense of impending doom; Hsiang sang, with tears, to her:

Once fortune shone on me
With the strength that uprooted mountains
My spirit overwhelmed the earth.

Now fortune has forsaken me
Although Wu-tsui still stands by my side,
Together we cannot prevail.

Alas, a man cannot alter the path of his destiny.
Yee Chi, Yee Chi,
What is to become of you and me?

Lady Yee responded:

The soldiers of Han surround our last stand.
They haunt us with songs from home
And the spirit of my lord is near its end.

Alas, I cannot stand idly by
And, forsaking honor, watch you die.

With this, she turned the sword to herself and committed suicide.

Gathering what strength he had, Hsiang broke through the enemy's encirclement. When he reached Wu River (烏江), he could see the light of his home state on the other side. He recalled that initially tens of thousands of young soldiers had crossed the river with him. "Even if the home folks still want me to lead them, I have no courage to face them," he sighed, and he turned the sword to himself.

Lady Yee was buried in Anhwei (安徽), a town which now bears her name. The legend states that immediately after she was buried, a cluster of poppies sprang in full bloom from her grave site. Poised, the flowers seemed to reflect the spirit of Lady Yee in her silk dress, dancing with sword to the wind.

In China, the poppy has come to represent the loyalty and faith between lovers.

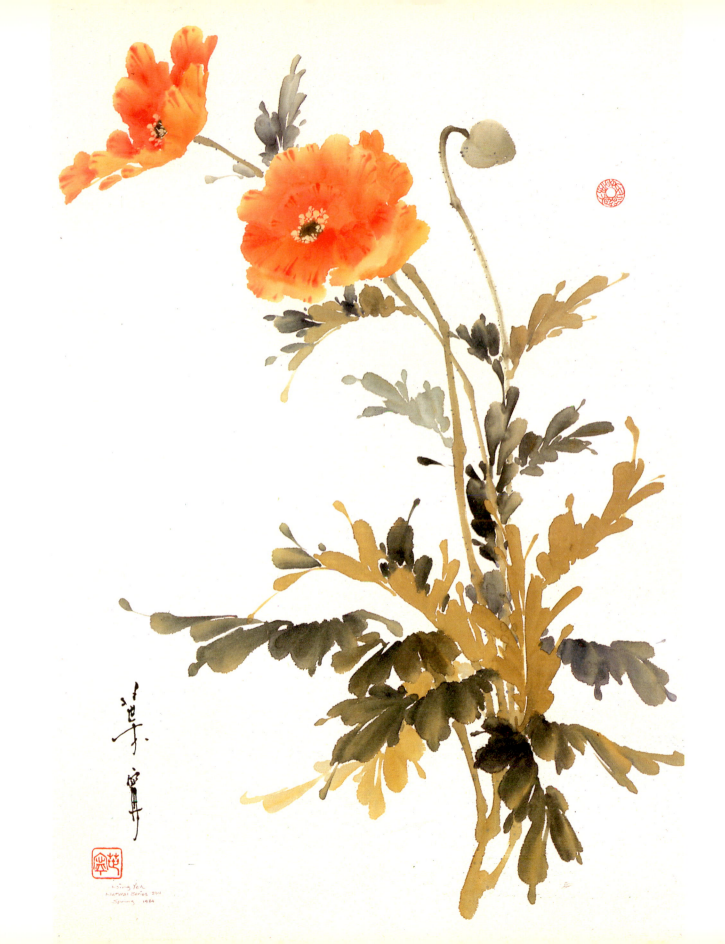

Dancing Posie

Seals: Dancing Poise (top),
Lady Yee (Below)

Grand Prospective (Horse)

Collection of Jeff and Valerie Swain

18"x26"
Paper: Double Shuen
Brush: "Extra Large Long Flow"
Color: Brown Bottled Ink
For detailed, step-by-step instruction on the horse, see Lesson 16-17 in the Study Guide.

Left Hand and Right Hand

The Chinese make no bones about discriminating against left-handed people: "This should be corrected, as early as possible." It is conceivable that when a crowded family gets together at a congested round table, there could be a chopstick war if one should be left-handed.

The Chinese print their words vertically in a line. Each line starts to the left of the last. I have observed that when the Chinese read, they nod, and when the Americans read, they shake their heads. Here lies the fundamental reason why Chinese tend to agree with what they read, and the Americans do not. The American book starts from the back page as opposed to the Chinese book which starts from the front. I tell you all this so that when you travel in the Orient, you will know how to act when people pass you a book . . . provided that you know which end is up!

Although the Chinese read from right to left, they write most of the strokes of their characters from left to right like Americans do. This practice greatly favors right-handed people.

I am right-handed, and all my strokes favor right-handed considerations. I do admire the left-handed artists I have come to know in my classes. They have to reverse all my instructions, and frequently this results in more dynamic movement.

My family paints horses right-handed. We usually begin with the eye. The natural tendency is to have a horse running westward. I remember a Chinese general who had his first show of horse paintings in Taiwan. When the show was hung, everyone realized that every horse was moving to the west. A reporter asked the general to explain why. Without hesitation, his genius staff officer dashed forward and exclaimed, "The general wishes to go back to the mainland." (Mainland china is to the west of Taiwan). Next day, a big article appeared in the newspapers stating "The horse paintings showed the general's determination to lead troops back to the mainland." Stunned but relieved, the general smiled.

God bless the staff officer. He was a second lieutenant, but he must be a general by now.

Seal: Grand Prospective

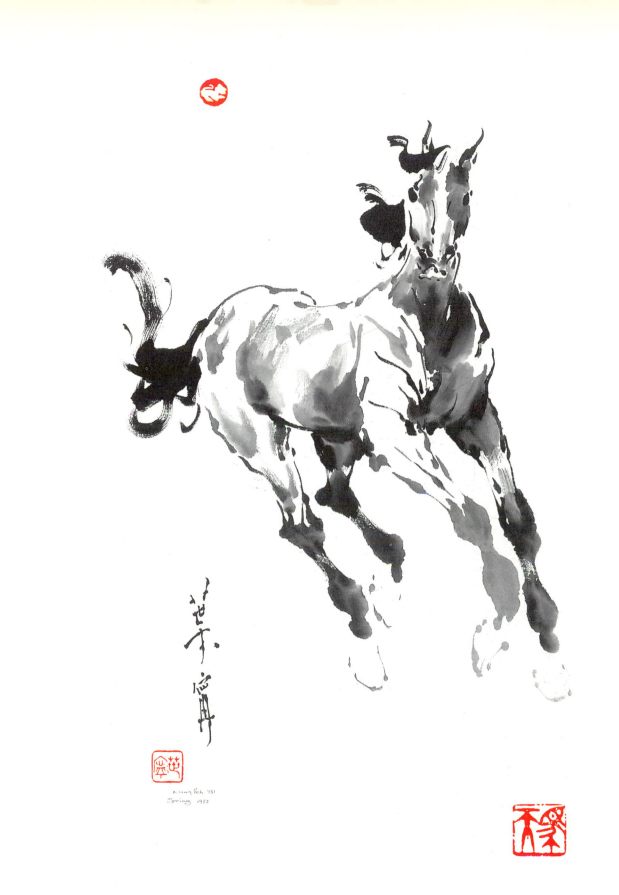

Kung Yeh 751
Spring 1982

51

25 龍之門

Dragon Gate

Collection of Walter and Rose Ann Peters

18"x36"
Paper: Jen Ho
Brushes: "Mountain Horse" (texture), "Landscape" (line, dot), "Big Idea" (color); "Wash" (sky, water, mist).
Colors: ink; vermillion, Winsor violet, light green mixed by blending yellow and indigo (light side mountain); Prussian green mixed with charcoal gray (dark mountain); vermillion, yellow ochre, manganese blue (structure, boat, path); manganese blue, Winsor violet, vermillion, Prussian green with charcoal gray (sky, water, mist).

Lung Men 龍門

Kun-ming (昆明), the capital of southwest China's Yun-nan (雲南) province, is the "City of Perpetual Spring." With its high mountains and big surrounding lake, the city offers the best climate of China.

Southwest of Kun-ming stands the West Hill. Its steep cliff faces the Kun-ming Lake and its peak, named Lo Han (羅漢), has long become the favorite place for poets to seek inspiration.

In the middle of the Ching (清) Dynasty, a family of sculptors spent seventy-two years (from 1781 to 1853) carving into the sheer rocky cliff and creating a series of stone chambers known as the Dai-tien Pavilion (達天閣 the Pavilion Leading to Heaven). The structure begins with a stone arch called Lung Men (the Dragon Gate). The most remarkable feature is that all the statues, figures, animals, and settings were chiseled out from the original rock with their roots remaining connected to the rock. Along with the drifting clouds, singing cranes, and the other ornamental designs above the ceiling, it is a total one-piece sculpture.

Since the Pavilion was built at the spot poets favored, the sculptors decided the main statue of the chamber should be Kui-shing (魁星), the muse of literature. The legend has it that when the Pavilion was nearly completed, the third generation sculptor, named Chu Ja-Kao (朱家閣), put the finishing touches on the statue of Kui-shing. As the muse of literature, Kui-shing was to be holding a brush in his hand. At the news that generations of work was about to be completed, a crowd gathered to witness the grand event, and the anxiety-stricken sculptor accidentally chiseled off the tip of the brush held by Kui-shing. Since every detail of the sculpture was carved from the original rock, the devastating mistake had no remedy. Utterly frustrated, Chu jumped off the rocky cliff.

The tip of the brush was later added by using material taken from another part of the rock.

So, you want perfection?

Whenever I push myself into a corner, frustrated with undesirable results, I ask myself: "Do you really want to jump off the cliff?"

Let's live and learn.

Seal: There is No End to Learning

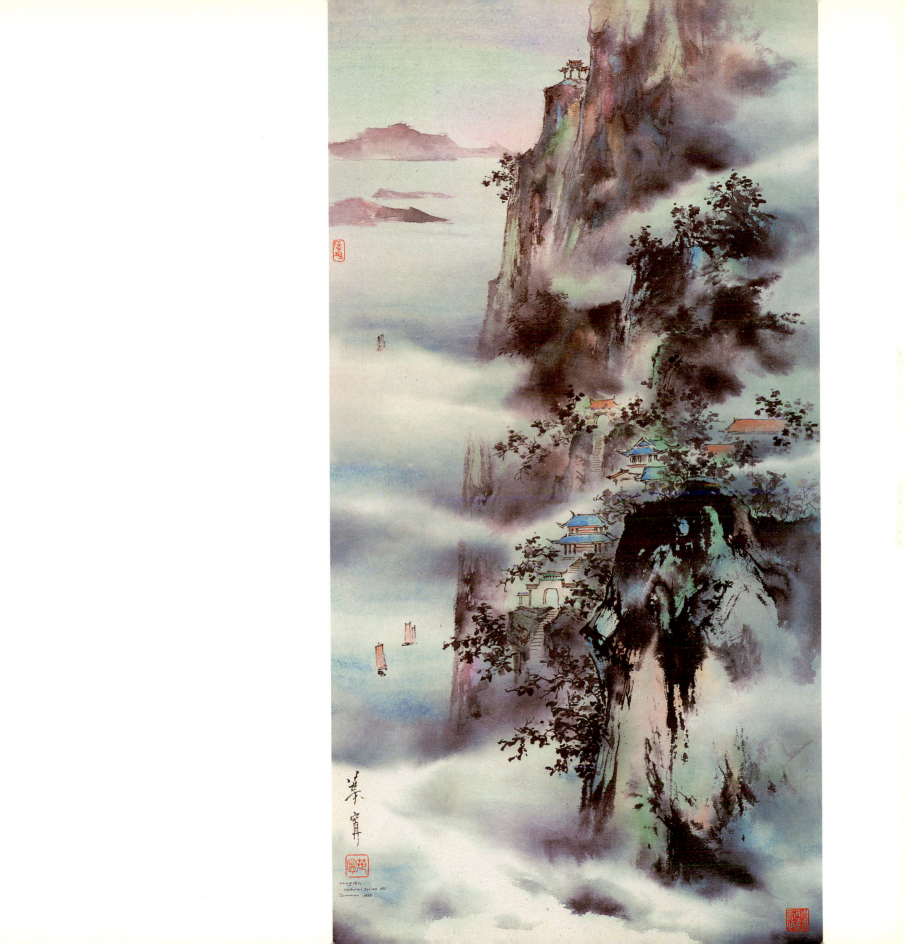

Emperor Sui's Embankment

Collection of Rosalie Traversion

18"x26"
Paper: Double Shuen
Brushes: "Orchid Bamboo" (branch, leaf, structure), "Wash" (background).
Colors: green mixed by blending yellow and indigo, ink (willow); green, burnt sienna with ink (branch); vermillion with ink (structure); vermillion, Winsor green with sepia (background).

Poetic Thoughts under the Bed

> Slender fingers gently peeling a fresh orange,
> The silk covering just starting to get warm,
> Exotic animal fragrance lingering,
> Sitting face-to-face playing the musical string,
> Asking, soft and low . . .
> Where are you staying?
> The gate's time keeper had already struck three,
> It is hard to ride the horse on the slippery snowy road,
> And the fog is getting thicker,
> Why not stay?

The above is a portion of the lyrics for a song written by Chou Pang-yen (周邦彦 1056-1121), the secretary of the Emperor Hui Tsung (澂宗 1101-1125) of the Northern Sung (北宋 960-1127).

"The silk covering just starting to get warm" usually applies to a well-to-do family's lady, who had a maid to warm the bed for her before she went under the covers. In this case, the occasion was different.

When Chou was visiting the well-known "society" girl named Lee shih-shih (李師師) one night, the Emperor showed up unexpectedly, right after Chou settled on Lee's bed to pay patronage to Lee. In a hurry, Chou hid under the bed and thus witnessed the romantic episode described in the song.

Hui Tsung did stay, and Chou spent the long night excogitating poetry under the bed.

When Chou composed the song, he instructed Lee Shih-shih to sing it to the Emperor. The Emperor got angry at Chou and ordered him out of the capital. When Hui Tsung learned that Lee Shih-shih went to Chou to say farewell, his jealousy heightened. "Did he write another song for you?" he asked. Lee Shih-shih nodded with grief and began to sing Chou's farewell tune:

> Willow's shadow straight up,
> Hanging threads branch out, a mist of green.
> Along Emperor Sui's embankment
> How many times have I seen them
> Caress the water, let fall the catkins,
> While sending off a departing guest?
> . . .
> Sad and forlorn!
> Sorrow on top of sorrow —
> Now the banks of the river wind and turn,
> The ferry station silent and empty.
>
> The setting sun lingers, spring never ends.
> I remember how we held hands in a moonlit pavilion,
> Or listened to a flute on a dew-moistened bridge,
>
> Pondering on past affairs —
> Everything is like a dream —
> I shed secret tears.

(translated by Irving Y. Lo, in Sunflower Splendor: Three Thousand Years of Chinese Poetry. Co-edited by Wu-chi Liu and Irving Yucheng Lo, Anchor Books, New York)

Hui Tsung was moved. He ordered Chou back and gave him a new post.

The embankment of Sui has long since vanished. In this painting, I borrowed the corner building of the Forbidden City and the Jade Belt Bridge from the Summer Palace to form the composition.

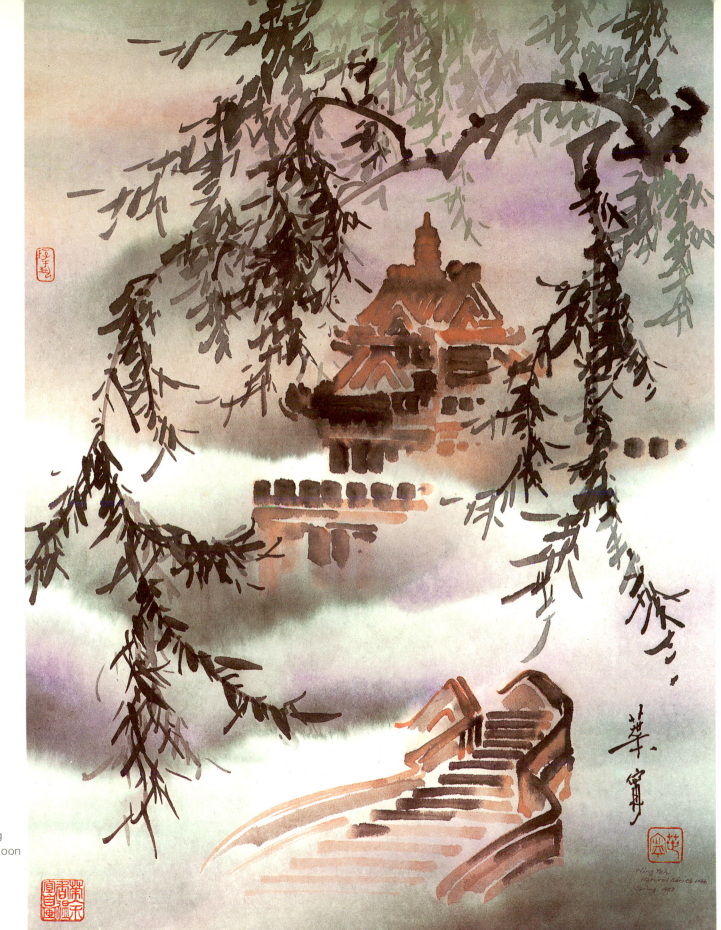

eal: A Mood of Cool Elegance
as Soaring Geese Sing along
with the Frosty Morning Moon

27 綠孔雀

Green Peacock

Collection of Betty and Warren Freeman

22"x35"
Paper: Double Shuen
Brushes: "Idea" (beak, eye, feather), "Big Idea" (crown), "Flower & Bird" (neck, back, wing, scissors below the pendant-like circle), "Big Orchid Bamboo" (maple leaf, branch, trunk).
Colors: Prussian green, French ultramarine, ink (dark feather and body); yellow, vermillion, burnt sienna (light area of body); yellow, vermillion, burnt sienna, ink (maple).

The Emperor's Examination

Hui Tsung was the greatest Emperor-painter of China. He created high positions in his court for painters and personally conducted examinations.

Once he ordered the court painters to draw the peacock in the palace garden. When the works were completed, Hui Tsung was not happy with any of them. "Study the peacock carefully, then paint," he ordered. This time the court painters examined the peacock for two days and then did their paintings. "You have only seen the form; none of you studied the motion," the emperor sighed. "When climbing the stairs, this peacock always reaches with its left foot first. You all painted with the right foot lifting." When the painters observed the peacock again, they saw that the emperor was right.

The best way to handle this test, of course, is not to show the legs at all. I should have been there.

The peacock roams in the wild country of Yunnan in southern China. The splendor of nature is everywhere evident in the body of a peacock. There is a spirit of regal elegance in the creature, as if it should be well kept in a palace.

Seal: Calligraphy: Painting
from the Heart

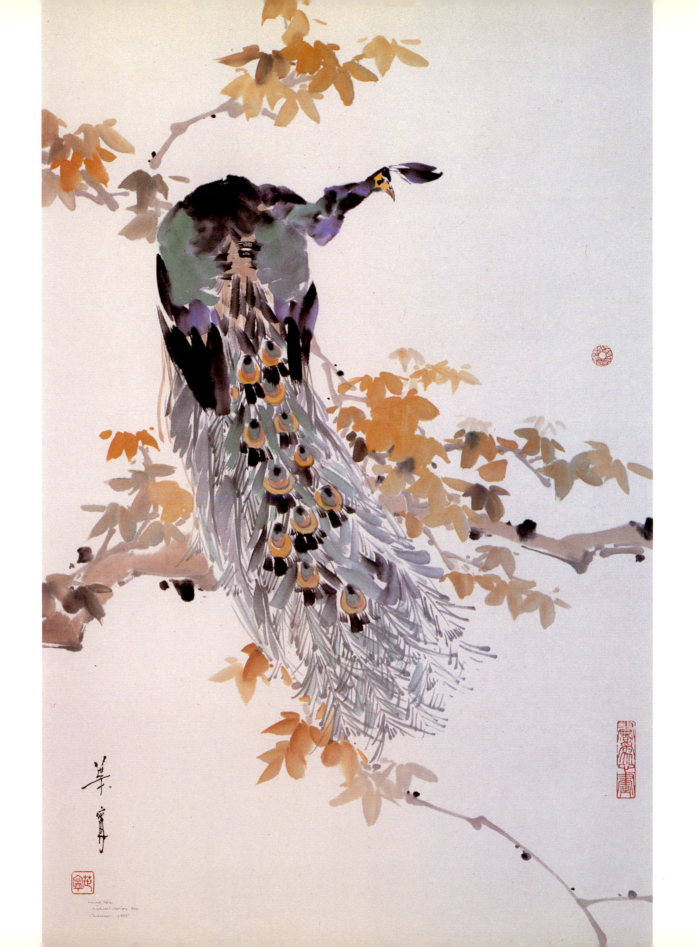

Perfect Gentleman (Bamboo)

23"x36"
Paper: Double Shuen
Brushes: "Flow" (ring, branch), "Orchid Bamboo" (leaf, trunk).
Colors: green mixed by blending yellow and indigo, indigo, ink.
For detailed, step-by-step instruction on the bamboo, see Lesson 4-6 in the Study Guide.

The Spirit of Bamboo (Jwu 竹)

The bamboo is the most popular plant in China. Every village in Southern China is surrounded by bamboo groves. To be Chinese is to feel at home with bamboo. The drooping bamboo leaves cross one another, as if they are composing the Chinese character "An" (安 tranquility). For the wandering traveller writing letters back home, to include a bamboo leaf is to say, "I am fine, I hope that everyone in the family is enjoying peace."

In the order of the Four Gentlemen, the bamboo represents the spirit of summer. But since the bamboo lasts through all seasons, it is frequently associated with pine and plum as the "Three Winter Friends."

The bamboo is considered a gentleman with perfect virtues. It combines upright integrity with accommodating flexibility; it has the perfect balance of grace and strength, or the Yin and the Yang. When the storm comes, the bamboo bends with the wind. When the storm ceases, it resumes its upright position. Its ability to cope with adversity and still stand firmly without losing its original ground is inspirational to a nation which has constantly suffered calamities.

Bamboo is used in every phase of Chinese living, yet it needs very little care to grow and flourish. It is well-sectioned with a polished "skin" and sturdy texture. Like a self-cultivated scholar in hermitage, it is ready to render services when called upon.

Bamboo personifies the life of simplicity. It produces neither flowers nor fruit. Chen Pan Ch'iao (鄭板橋) compared himself to bamboo, saying "I will not grow flowers, so that I avoid tempting the butterflies and bees to disturb me".

The hollow trunk reminds the Chinese of humility. One artist had this praise "Bamboo, who understands humility by emptying his heart, (without stuffing it with arrogance) is my teacher."

The young branches at the top of the bamboo trunk will not grow at the same angle as the older branches below, in order to allow sunlight for their elders. When the young shoots emerge from the roots, they are under the shade of the older bamboo branches. Such a spirit reflects the young respecting the old as well as the old protecting the young.

Seal: Integrity through Humility

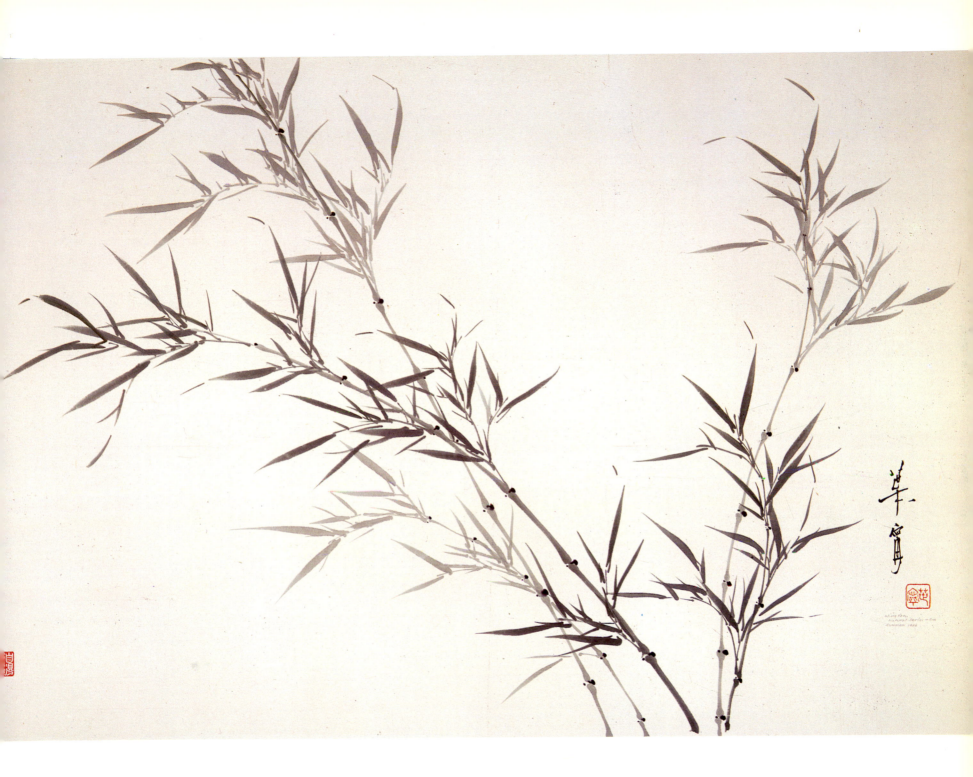

59

29 紅妝

Crimson Glow (Hibiscus)

Collection of Allison Reeder

18"x27"
Paper: Double Shuen
Brushes: "Large Flow" (petal, leaf), "Idea" (pistil, stamen, pollen, calyx, vein), "Big Idea" (branch).
Colors: red, crimson lake (petal); purple madder (center); poster white (pistil stamen); white with yellow (pollen); green mixed by blending yellow and indigo, indigo, ink (leaf, calyx); burnt sienna, ink (branch).

Fu Sang 扶桑

Fu Sang is the Chinese name for hibiscus. It also implies the phrase, "where the sun rises." Its long flowering season, from May until mid-winter, has prompted the Chinese people to consider hibiscus a hardy flower which reveals the spirit of perseverance. Yet my neighbors in Southern California tell me that their hibiscus cannot resist frost. "That is why the hibiscus looks so happy in Hawaii," they say. After a period of confusion, I come up with this conclusion: Flowers in Southern California do not count; they are confused. They simply do not behave normally.

I had thoughts of calling this book "Chinese Brush Painting: the Art for All Seasons." I decided to wait until later. For the past fifteen years, I have lived in Southern California. How can I possibly experience all seasons? As a painter, I am still in my budding spring. Maybe occasionally I have stepped into a few mid-summer night dreams, but I have no concept of what mature autumn and harsh winter can bring to a creative mind.

My floral studies are attempts to portray God's "happy accident." No matter what flowers I do, they are a joyful celebration of life. Yet the hibiscus can serve as a vivid reminder each day. No matter how glorious the flower blooms in the morning, it withers by nightfall.

. . .

If you ask, Where are the flowers?
Last night, amid wind and rain,
The beautiful ladies of the Ch'u Palace were buried.
Where their filigreed ornaments fell,
They left fragrance behind,
As they dotted the peach paths at random,
And lightly fluttered above the willowy roads.
Who is there so loving as to pity their fall?
Only the matchmaker-bees and messenger-butterflies
Knock on the window from time to time.

The eastern garden lies quiet,
Gradually overgrown with dark green.
A silent stroll beneath the precious clusters
Turns into a sigh.
The long twigs purposely entangle the passer-by,
As if pulling his clothes, about to speak,
.With endless parting sorrow.
A tiny remaining bloom . . .

— Chou Pang-yen (1056-1121), translated by James J. Y. Liu (Sunflower Splendor.)

Enjoy the blooming season, but with compassion and understanding . . . this may have been the best lesson I have learned in the study of hibiscus.

Seal: Everything is Even More Beautiful This Morning

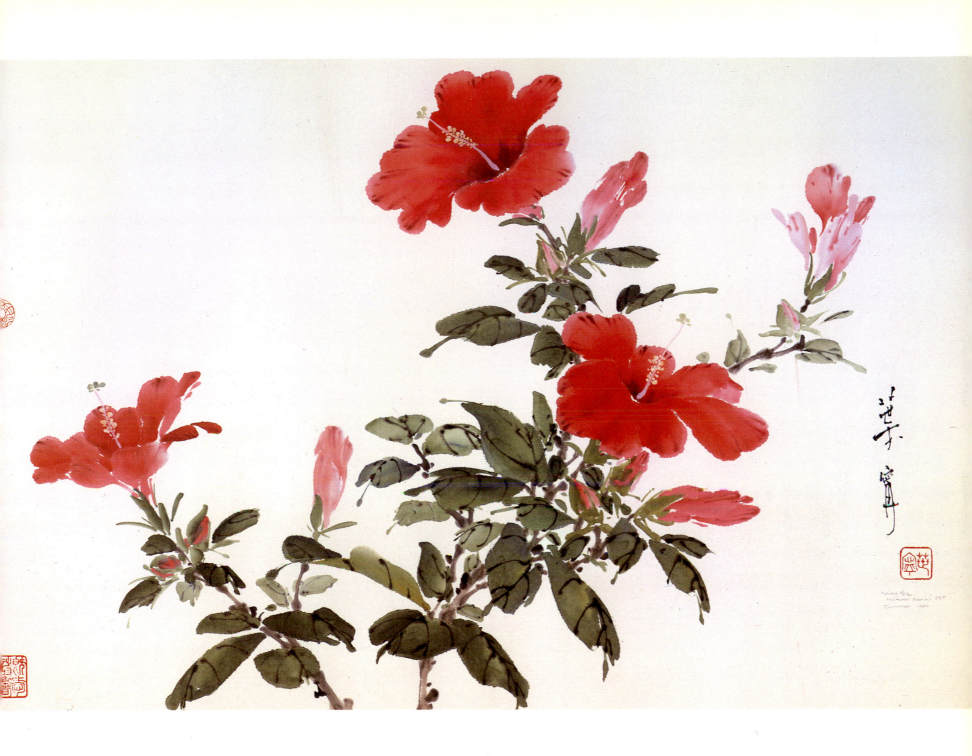

The Caves of a Thousand Buddhas

Collection of Maria and Milton Nathanson

18"x36"
Paper: Jen Ho
Brushes: "Landscape" (line), "Big Idea" (texture, color),
"Wash" (mist, background).
Colors: vermillion, red, burnt sienna, purple madder, gold
(structure); vermillion, burnt sienna, Winsor violet, neutral
tint (mountain, mist); poster yellow, vermillion (background).
After completing the line work, texture, color, and the
background wash, then add gold.

Dun Huang 敦煌

Seal: Everlasting Treasure

China developed her communications with the West as early
as the Han Dynasty (滇 206 B.C. to A.D. 220) through the
"Silk Road" (絲路). From the Capital Xian (西安), past
the Great Wall, the Silk Road went across the desert into
central Asia. One branch of the road went north, through
Russia to Europe; another passed Persia and reached Turkey;
another branch went south, through Tibet, and reached
India. It was through these routes that the West received
silk and china, along with knowledge of the use of gun-
powder, paper and print-making. It was through the "Silk
Road" that the great traveller Maco Polo came East.

Buddhism was introduced to China from India during the
reign of Emperor Ming (漢明帝 A.D. 58-75) of the Han.
During the following years, Buddhism flourished in China,
and many monasteries, shrines, and grottos were constructed.

The journey back and forth along the "Silk Road" was trea-
cherous yet rewarding. The caravans would make an offering
to the temple, commissioning artisans to paint a mural or
to sculpt a statue to bless the journey. Upon returning
with fortunes, they would make further offerings.

Located at the beginning of the old Silk Road, in the city
of Dun Huang (Gansu or Kansu 甘肅 Province), hewn in
the steep cliff by a small tree-lined oasis, are the Mogao
Grottos (莫高窟), or the "Caves of a Thousand Buddhas."
The Caves contain a complete collection of Buddhist art
from the Tsin Dynasty (晉 265-420), through Sui (隋 581-
618), Tang (唐 618-907), Five Dynasties Period (五代 907-
960), Sung (宋 960-1279), to Yuan (元 1234-1368). Over
one thousand years of history are chronologically recorded
by brilliantly colored paintings which cover the cave walls
and ceilings. Forty-five thousand square meters of murals
and 2,300 painted statues remain intact in a network of
caves dotting the hillside.

I am not a Buddhist, and I come from southern China, I
do not appreciate many of the figure paintings in the Caves.
But the sheer fact of knowing the Caves are there, picturing
the glorious journeys my ancestors made through the Silk
Road, makes me shiver with emotion. The pride of Dun
Huang is as deeply imprinted in the minds of Chinese as
the Great Wall.

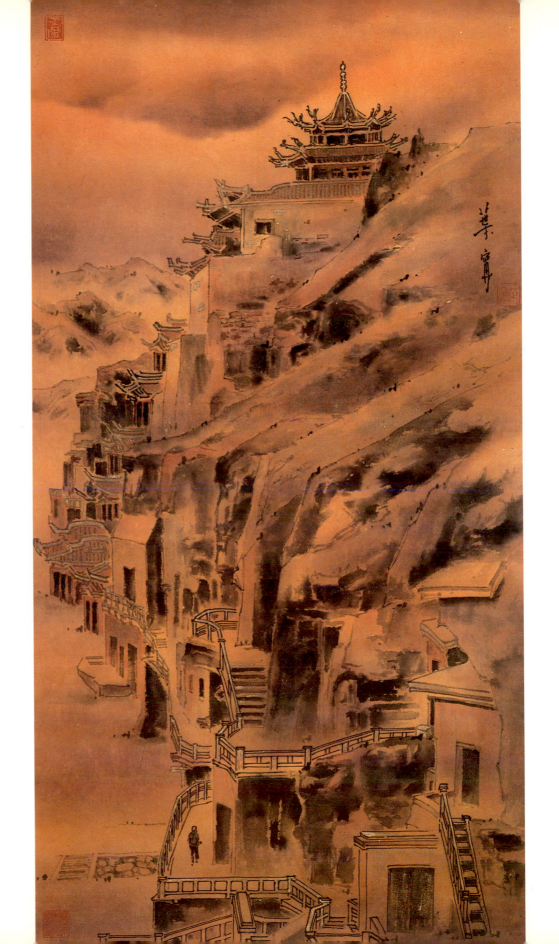

Descending (Horse)

Private Collection

22"x35"
Paper: Double Shuen
Brush: "Extra Large Long Flow"
Color: Brown Bottled Ink (Finest)
For detailed, step-by-step instruction on the horse, see Lesson 16-17 in the <u>Study Guide</u>.

Painting from the Heart

Western artists usually start with the study and sketching of a painting subject; the aim is to present a realistic rendition of the subject. Artists usually have the studied subject in front of them while painting. Chinese artists do these things also, but only as an initial preparation for their painting. They internalize these studies and translate them into their own intepretation. When they begin to paint, they are free from the exact forms of the subject and its specific surrounding environment. They do not have the subject in the sight, but in the mind. The outcome, therefore, reflects the individual personality and spirit of the artist.

Chinese brush painting stresses "I-jean" (意境), or the realm of ideas or imagination. "I-jean" represents the union of the characteristics of the subject and the spirit of the artist. The artist may have learned the subject through objective observation, but when he expresses the subject it is with his thoughts, emotions, feelings, and attitudes, and his expression is based on his experiences and personality. The artist paints the subject not to show the subject, but to show his thoughts, feelings, or emotions through the subject.

During the height of the Tang Dynasty (A.D. 618-907), the Emperor was reminiscing about the beautiful scenery of the Ja-lin river in Szechwan. He sent two of his best painters to study the scenery and asked them to paint him their findings. Two artists, General Li (李思訓) and Wu-tao-tze (吳道子), were chosen. Li sketched each section of the river on site and spent three months putting his drafts together. Wu travelled with wine and companions, up and down the river, without touching his brush. He came back to the Capital (Xian) and completed his rendition of the river in one day. When the Emperor asked Wu for his draft, he replied, "There was no draft. I felt the mountains in my heart."

In this painting, I had no idea where the horse wanted to go. I placed the head of the horse in an impossible position to challenge myself. During the exercise, I actually found myself trying to turn with the horse to stay in the picture, and we succeeded.

Seal: Essence of Heart

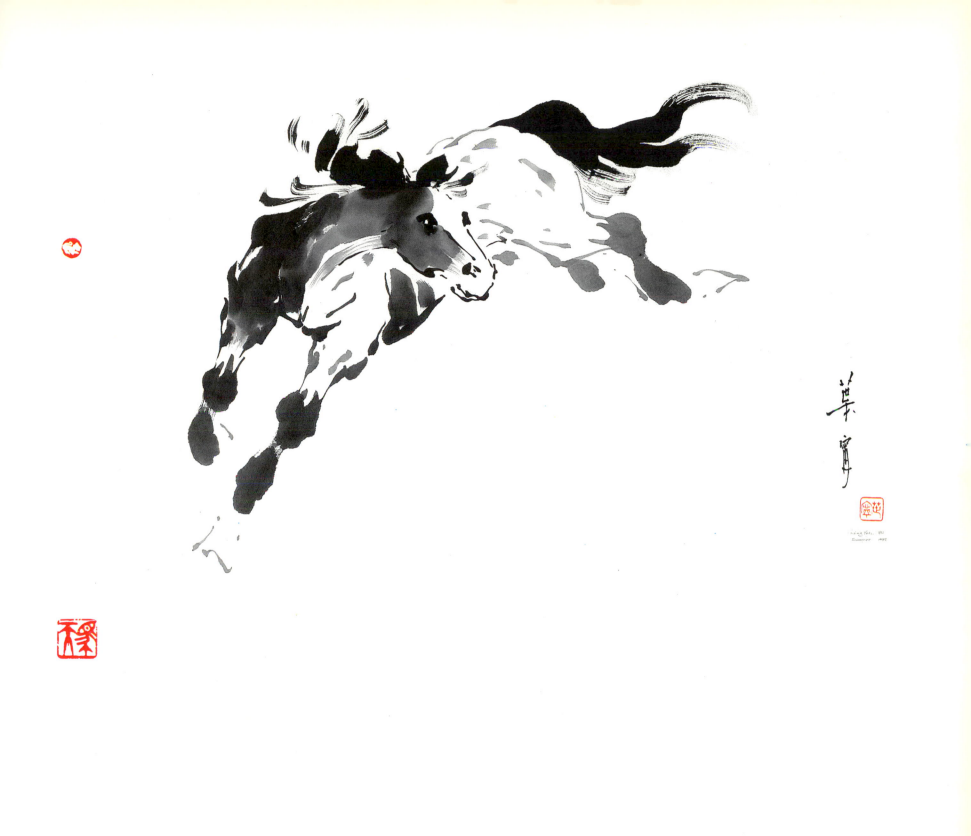

65

Ballerinas (Fuchsia)

Collection of Ann and Aran Vaznaian

17"x26"
Paper: Double Shuen
Brushes: "Large Flow" (leaf), "Big Idea" (branch, bud, flower), "Idea" (stem, stamen, pistil, pollen, vein).
Colors: green mixed by blending yellow and indigo, indigo, ink (topside leaf); green with crimson lake (underside leaf, stem, calyx); ink (vein); burnt sienna with ink (branch); crimson lake with purple madder (hat petal, bud, pollen); poster white with vermillion (skirt petal); purple madder (stamen, pistil); vermillion (pistil dot).

Teng Lung Hua 燈籠花

The Chinese celebrate the conclusion of the lunar New Year on the fifteenth day of the first moon. On the night of "Yuan Hsiao," (元霄) or the first full moon, all children parade in the streets carrying lanterns. All of the temples host contests for the best lanterns. Besides creative and artistic design and colors, each lantern has a riddle written in calligraphy to fancy the mind of the viewer. This calligraphy is an integral part of the contest.

One of my favorite riddles has become the lyrics of Hung Tze's famous tune entitled "Flower, Not Flower," adapted from a poem composed by Po Chu-yi (白居易 772-846)

Flower, not flower;
Mist, not mist.

It comes at midnight,
And is gone by the dawn of the day.

Like a romantic dream,
It comes only for a while.

Like morning fog,
Once disappeared, it can never be found.

This song has been a part of my life for more than thirty years. I sing the lyrics all the time, and I have a special feeling when I do. I never know what "it" is. But I do feel it, when it is there.

I think it has to do with inspiration. But I am not going to say it is.

Maybe you know.
But you do not have to tell me what it is.
So long as I know that you know.

The shape of the fuchsia resembles a typical Chinese lantern. Overhanging from a branch, with decorative arms streching to all sides and tassels swinging underneath, the flowers remind the Chinese of the sight of parading children holding lanterns. "Teng-lung Hua," meaning "Lantern Flower," is the Chinese name for fuchsia.

Chang Dai-chien (張大千), a master painter, onced commented that "the use of the colors was easy, it was the use of water that was hard." It is the successful control of the moisture and the blending of colors, together with dynamic delivery of a variety of strokes, that captures the dancing, celebrative mood of the flower. A petal can be rich and sturdy at its root then become transparent and fragile near its tip. Often within one stroke, the extremes of value, texture, and hue are blended in extraordinary harmony.

Through my floral studies, I hope to bring the viewer a delightful sensation. I hope to express nature's rhythmical poetry in motion. Filled with joy and excitement, the flowers are a celebration of life.

Seal: Flower, Not Flower

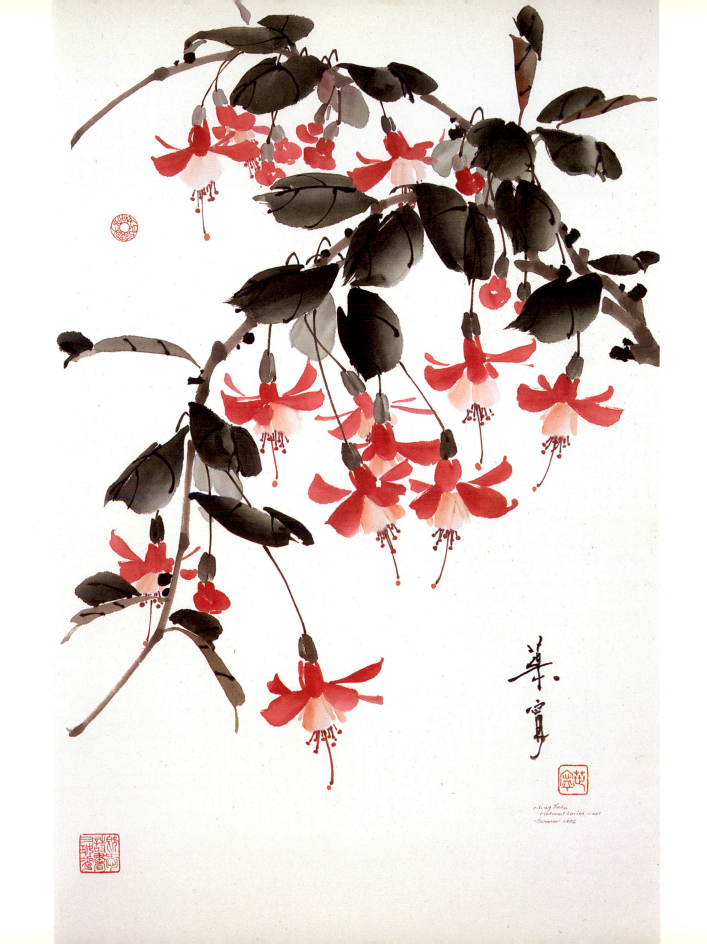

Ning Yeh
Natural series — 021
Summer 1986

Autumn's Greeting (Chrysanthemum)

Collection of Linda and Charles Robinson

17"x26"
Paper: Colored Shuen
Brushes: "Idea" or "Orchid Bamboo" (petal, calyx, stem, vein), "Flower & Bird" (leaf).
Colors: poster white (petal); Winsor violet (center shade); green mixed by blending yellow and indigo, indigo, ink (positive leaf); green with vermillion (negative leaf); ink (vein).

Chu 菊

Chinese people call their chrysanthemum "Chu" and honor the flower as one of the Four Gentlemen, representing the spirit of autumn.

What a perfect word, "Chu," as the name of the chrysanthemum. Chu implies a multitude of virtues which personify the spirit of the Chinese nation.

Chu means "to bow, or to let go with respect." The chrysanthemum never fights with the peony or rose for the glory of spring. It is not because the chrysanthemum is weak. On the contrary, it is because it is strong. The chrysanthemum has the longest history of cultivation in China, and is seen in more than 3,000 varieties.

Chu also means "to endure with devotion." The chrysanthemum appears only when other flowers grow tired of competition and when people really need the comfort of companionship to face harsh circumstances. The chrysanthemum blossoms in early Autumn when the earth is blanketed with frost. Because the chrysanthemum strives with defiance against the cold weather, it has become a symbol for fortitude.

Finally, Chu means "to nourish." The Chinese believe that the chrysanthemum is a flower which can promote longevity. Also, chrysanthemum tea is the preferred drink for calming tension and easing the heat in one's body (All the bus drivers during our student tour to China had large glasses of chrysanthemum tea by their sides).

Tao Yuan Ming (陶淵明 365-427), a poet of the Tsin Dynasty (晉 265-420), took an early retirement from his official post after refusing to bribe his superior. He spent the remaining years of his life as a gentleman farmer at the foothills of Mt. Lu Shan (盧山). He was able to lead a simple, leisurely, and rewarding life growing mums and writing poetry about common folks. Among his works, the first version of Chinese Utopia was offered in "The Journey to the Source of Peach Blossom River". He also wrote an unusual amount of poetry on the topic of the happy pursuit of wine drinking.

Seal: Enjoying Nature at Ease
(While Picking Chrysanthemum
by My Fence, I Feel Nan
Mountain's Leisure)

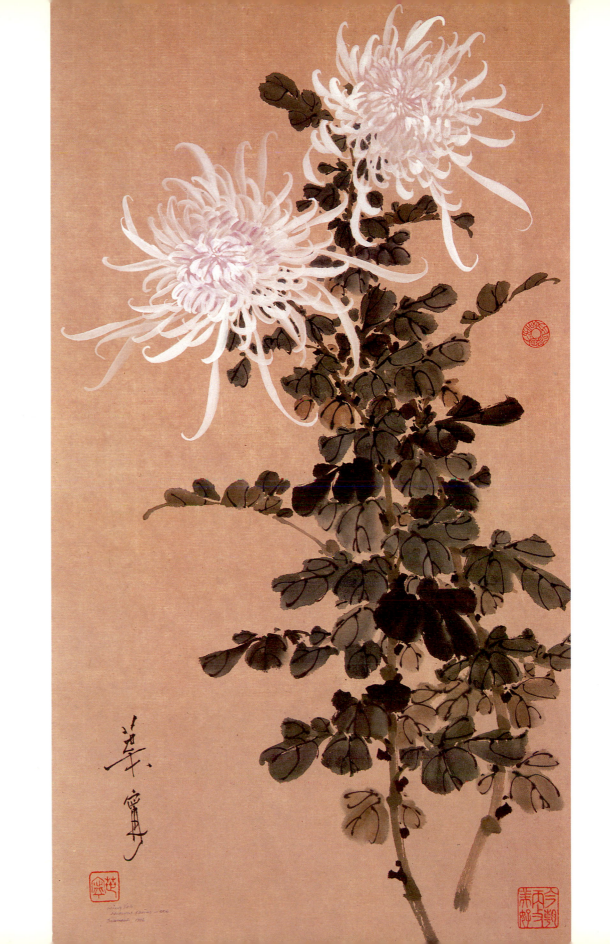

Temple in the Mist

Collection of Bill and Para Horvath

22''x35''
Paper: Jen Ho
Brushes: "Landscape" (line), "Big Idea" (texture, color, tree), "Wash" (mist, sky).
Colors: vermillion with poster white, vermillion, purple madder, yellow ochre (structure); vermillion, green mixed by blending yellow and indigo, prussian green with charcoal gray (tree, mountain, mist); Winsor violet, cerulean blue (sky).
For detailed, step-by-step instruction on landscape, see Lesson 18 in the Study Guide.

Mt. Lu Shan 廬山

The lower Yangtze River is benefited greatly by the lakes adjacent to her body. When she is flooded with water, the lakes take in the excess; when she needs water, the lakes give willingly. The biggest fresh water lake in China, Lake Poyang (鄱陽湖), is one of these good lakes. I say that Lake Poyang is the biggest lake with great reluctance. Even as late as 20 years ago, Lake Dongting (洞庭湖) — near my birthplace in Hunan, was the Number One lake in China. The great Dongting has shrunk considerably because of folks around the lake eager to reach in to take more land.

Mt. Lu Shan stands at the corner where Lake Poyang meets the river. It is surrounded on three sides by water: the masses of water vapor rise from the lake and river, meet the cooler mountain air, and condense into clouds and mists. For more than six months of the year, Mt. Lu Shan is submerged in mist. Poet Su Tung-po (蘇東坡 1037-1101) remarked, "One cannot see the true faces of Mt. Lu Shan if one is in the middle of the mountain." This saying has become widely used by people who find themselves clouded in vision because they are too close to the situation at hand.

I would never admit that the Chinese frequently compare Mt. Lu Shan to a beautiful, moody woman, with unpredictable, everchanging faces which constantly arouse curiosity among men who wish to unveil her mystery.

It is unusual to find such a majestic mountain as Mt. Lu Shan in the lower Yangtze, where fields and waterways are the natural makeup of the scenery. The legend has it that the notorious tyrant (the Chin Emperor), was enraged by one of his court ladies at his palace in Xian, in northern China. He extended his whip to reach her, but he missed badly. Instead, the whip chopped off the top of a nearby mountain and carried it all the way to southern China, where it landed along the south side of the Yangtze River, becoming Mt. Lu Shan.

Mt. Lu Shan's magic is enhanced by her Immortal's Cavern. It is here hat Lu Dongbin (呂洞賓) cultivated himself to become one of the Eight Immortals and displayed his prowess by crossing the sea. Among the various duties Lu Dongbin shared as a Taoist deity was arbitrating family disputes — an endless task in China. Lu Dongbin's Temple is not a suitable place for young lovers who have marriage in mind to visit. I can testify to that.

Seal: The Essence of Misty Mountain

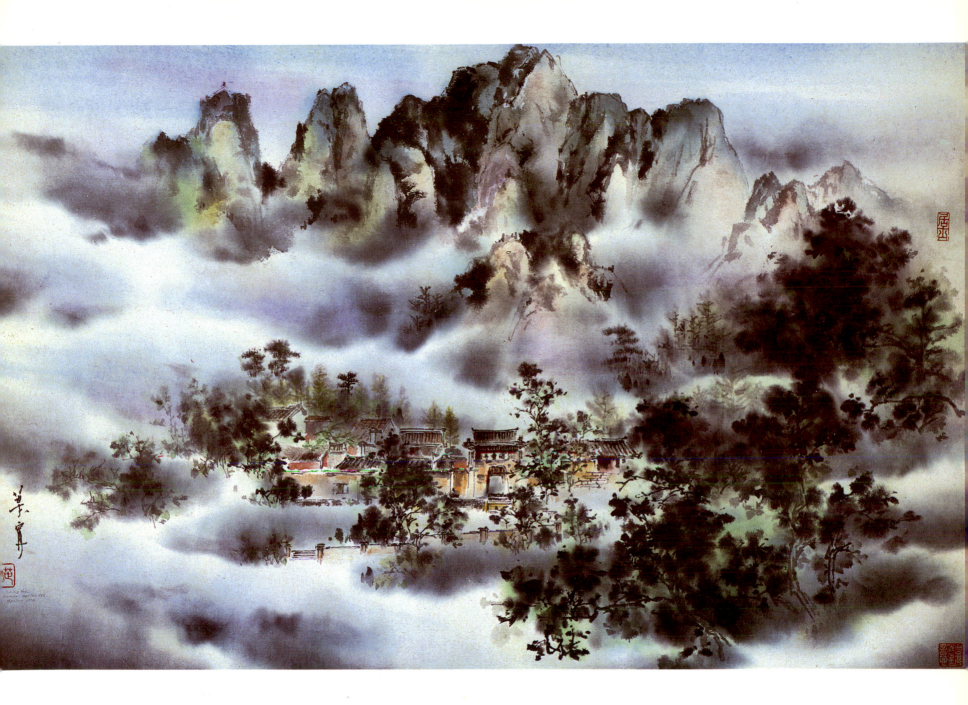

71

Hospitality Hostess (Cyclamen)

Collection of Dr. and Mrs. Lawrence A. De Renne

17"x26"
Paper: Double Shuen
Brushes: "Flower & Bird" (petal), "Large Flow" (leaf), "Big Idea" (calyx, stem).
Colors: poster white, permanent magenta, crimson lake (petal); green mixed by blending yellow and indigo, crimson lake (back side leaf, stem); green, indigo, ink (front side leaf).

Hsien Ke Lei 仙客來

The cyclamen flower reaches out with open hands in greeting. Its Chinese name, "Hsien Ke Lei," means "fairy guest arriving." The flower, appropriately, is a symbol for hospitality.

When the cyclamen blooms, its petals form a crown which turns upward along a bowing stem. The posture resembles that of a prominent official greeting the Emperor. The flower is also called "The Crown of the First Rank" in China, and it is considered a good omen for career advancement.

Recently, in between television filmings, I had an opportunity to take my family to Yellowstone National Park. We joined a tour group by reading an ad in the local Chinese newspaper, and we met a nice group of Chinese folks from various farming communities in Taiwan. Taiwan's economy has experienced an unprecedented boom in the past thirty years. Farmers, being landowners, have all become very well-to-do. After an enjoyable tour of the Park, the tour guide took the whole bus load of us to a tourist trap in a town called Cody. As usual, being the only English-speaking members besides the tour guide, my family was asked to scout the shop before everyone got off the bus. The shop contained the most distasteful skins, horns, and bones of animal remains. I went back to the bus and tried to be as gentle as I could to persuade the group to leave. My attempt was discouraged by the tour guide, and everyone got off the bus. To my utmost surprise, everyone came back carrying huge sets of horns and heads of deer . . . they practically bought the whole store. Embarassed by my inability to share the taste of the majority, I told everybody, "Now I have no need to know your addresses. When I get to your villages, I can just ask which houses have horns from Wyoming and I can find my friends."

In 1968, during the night of the Moon Festival (the fifteenth day of the Eighth month, when the moon is at its brightest), I was serving my military duty as acting company commander (My commander died of a heart attack upon receiving me). The camp was nearly empty, but a few old soldiers were having wine with peanuts, pig's ears, and dried bean cakes out on the lawn. Facing my window, I was trying very hard to put words in my diary to describe how I felt at that moment. Suddenly, I heard the exchange of dirty words among the old soldiers. Soon, the curses became so down-to-earth that they could have caused one's great-grandmother to turn over in her sleep. I dashed out to stop a sure fist fight. As it turned out, the old soldiers were trying their darndest to describe the beauty of the moon. Judging from the satisfaction on their faces, they sure had much better luck in expressing how they felt than I did.

If you ask the farmers or the old soldiers about Hsien Ke Lei, nobody knows. But if you ask about the down-to-earth name for cyclamen — "Tuh Erh Hwa" (兔耳花) — everyone smiles. What is Tuh Erh Hwa? Rabbit Ear Flower.

Seal: Taste of Spring

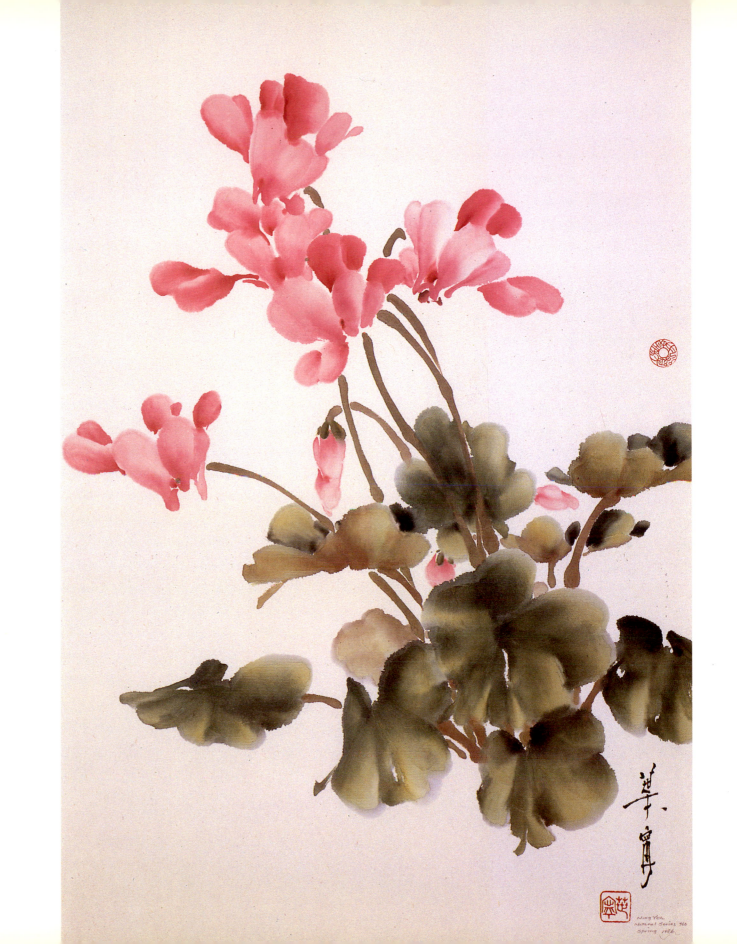

Ning Yeh
Natural Series #6
Spring 1986

Village Near Yangsu

Collection of Dr. and Mrs. Walter Peters

22"x35"
Paper: Jen Ho
Brushes: "Landscape" (line), "Big Idea" (texture, color), "Wash" (sky, water, mist).
Colors: vermillion, yellow ochre, burnt sienna (structure); green mixed by blending yellow and indigo, Winsor emerald, Prussian green with charcoal gray, burnt sienna (field, mountain); vermillion, Winsor violet, Prussian green with charcoal gray, manganese blue (sky, water, mist, distant mountain).
For detailed, step-by-step instruction on landscape, see Lesson 18 in the <u>Study Guide</u>.

Guilin 桂林

Before China opened the floodgate to tourists, one of the most frequently asked questions about my landscape paintings was, "Do you really have mountains that look like that?" But nearly everyone who has been through China these days has visited Guilin (Kweilin). The natural charm and tranquility of Guilin have been replaced by the parade of tourist boats streaming down the Li River.

Guilin is unique. The Li River calmly winds through hundreds of pinnacle-shaped limestone hills whose reflections cast on the mirror-like waters. In a boat ride down the Li River past Xing-ping to Yangsu, one is placed in a Chinese landscape painting scroll with spectacular sceneries surrounding. "Guilin's landscape ranks supreme under Heaven," is a popular saying in China. Folks at Yangsu have taken the saying and added, "Yangsu's scenery is better than Guilin."

Seal: Ten Thousand Layers of
Green Mountains in My
Homeland: Reminiscent of the
Beauty of the Old Country

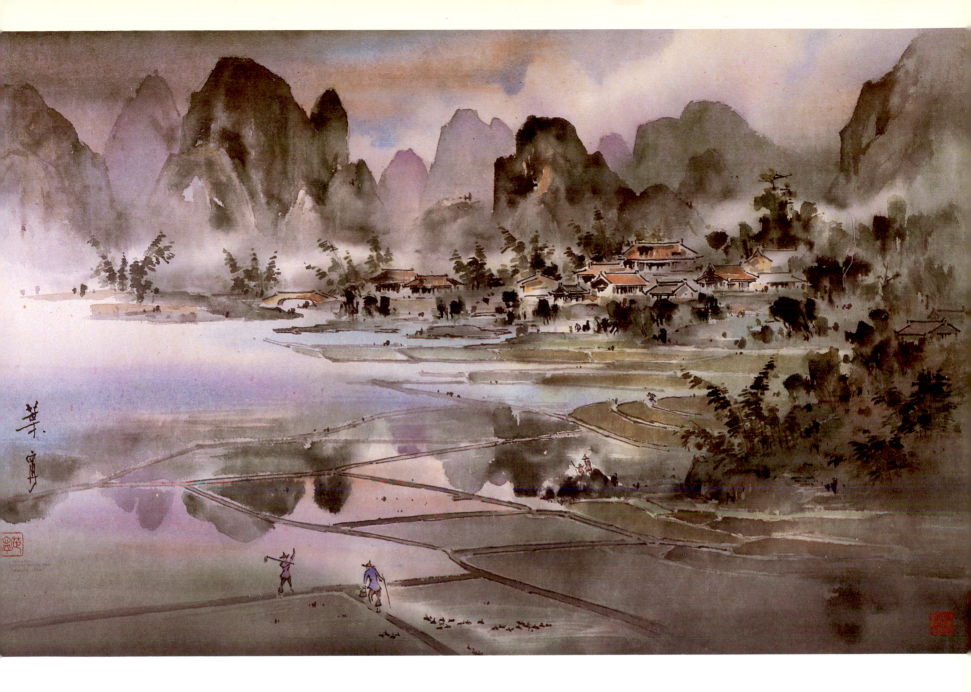

37 慈輝

Paternal Love (Day Lily)

Private Collection

18"x36"
Paper: Double Shuen
Brushes: "Flower & Bird" (flower, bud), "Idea" (stamen, pollen, pistil), "Big Orchid Bamboo" (stem, leaf).
Colors: yellow, vermillion (petal); crimson lake (center); poster white (stamen, pistil); white with yellow (pollen); green mixed by blending yellow and indigo, indigo, ink (stem, leaf).

Wong Yu 忘憂

The day lily has many names in China. When it has a cheerful posture, the flower is called "Wong Yu," meaning "Forgetting Worries." As an omen for expectant mothers who wish for baby boys, the flower is called "I Nan," (宜男) meaning "Suited for A Boy." Since the flower is worn by many mothers, the Chinese also venerate the day lily as a symbol of filial devotion to one's mother.

My mother, Dung Yu Ching (鄧玉珍), has devoted herself completely to her three children: my younger brother Shuen, my younger sister Ming, and myself.

Mother was the athletic director for the First Girl High School in Taipei (北一女) for thirty years before her retirement. In my high school days, I was popular because I could furnish my all-boy school with girls from First Girl High whenever a party was held. Granted, many of the girls were track and field stars (My friends complained that to dance with my girls was like moving tanks); still, they wore green uniforms of the First Girl High — the pride and joy of Taiwan.

I was a good boy and rarely caused my mother to worry about me. I can only recall one incident which nearly caused my mother to lose her job.

The principal of First Girl High was an old maid who, I felt, hated boys. No boys were allowed in the school gate. So the boys in my class decided to challenge her inhumane rule. We learned that she liked Chinese opera, and the plan was to claim that the Chinese Opera Company wished to rent the school auditorum to rehearse their play. But in reality, we planned to show one of Paul Newman's movies. We figured we would flood the school with boys, and when she found out, the rice would have already been cooked, what could she do?

To do this, we needed an official letter from the Chinese Opera Company. My friend, Lin, said that his uncle worked there, and a letter was no problem. Thanks to Lin's uncle, a request letter — complete with the official seal of the Chinese Opera Company — arrived at the principal's office shortly thereafter. The old maid agreed! Tickets sold like hot cakes in my school, and everyone was excited.

The day before the main event, the old maid called the Chinese Opera Company. Nobody there knew anything about the rehearsal. To make the matter worse, Lin had no uncle who worked there. He simply had carved a big "Chinese Opera Company" seal himself. Honestly, I did not know.

"Who was the head of this shameful fraud?" The old maid asked her staff. "Director Dung's nice boy."

Needless to say, our plan to invade the First Girl High never materialized. We were let go by the kind principal without any penalty. But, we had lost credibility among our own schoolmates. Their "remarks" of outrage and disappointment still linger in my mind to this day.

I later acquired the large seal which Lin had made. Whenever a painting has gone to pot and turned into a catastrophic disaster, before throwing it into the waste basket, I stamp the huge "Chinese Opera Company" right in the middle of the painting to remind myself not to make the same mistake.

I hope mother knows that her son is trying to do the right things the right way now.

76

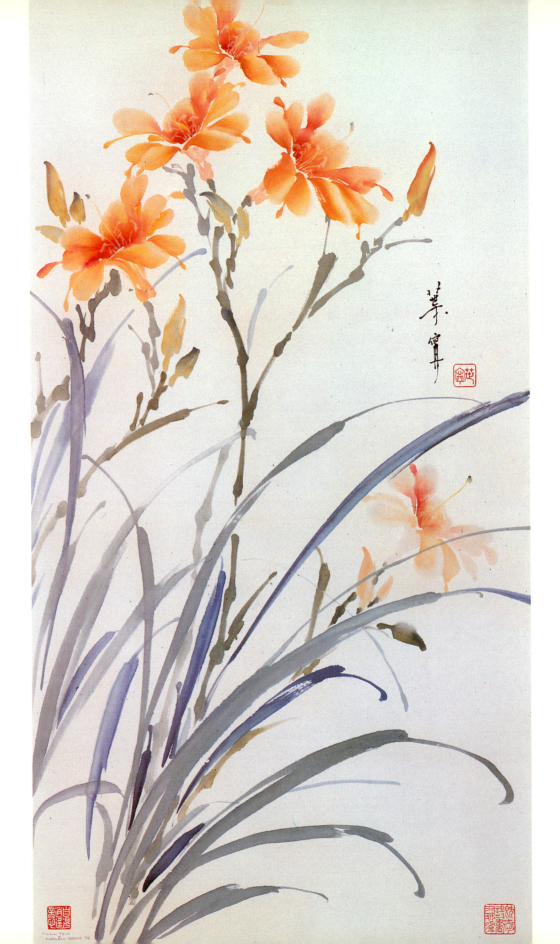

Seal: The Passing Cloud Brings
a Caring Message from Her
Wandering Son

Cascading Falls

Collection of Patricia Hemphill

18"x36"
Paper: Jen Ho
Brushes: "Mountain Horse" (mountain), "Idea" (tree, fall), "Big Idea" (color); "Wash" (mist).
Colors: burnt sienna, Prussian green with charcoal gray (mountain), Winsor violet (mist).

Seal: Warmed with the
 Lingering Fragrance of Tea,
 One Paints for One's Own
 Enjoyment

Painting for Spiritual Attainment

In the traditional view, art was not a profession, but a way of life. Painting was not a career; the finest artists were scholars and officials. Painting was seen as an expressive outlet for leisurely pursuit, a medium for expressing thoughts and feelings which elevate the spirit. It was an extension of literary, poetic pursuits.

Started by Wang Wei (王維 699-759), the art-literati tradition became prominent during the time of Su Shih (1037-1101), and its influence continues even today. Many people in China still feel that painting is a noble pursuit for searching for one's soul and that to sell one's work is a shameful betrayal of purpose. I was trained to feel that way.

Once I came across a cartoon in a local newspaper. An artist was holding his brush and pallet, facing a blank canvas. He was puzzled . . . and still puzzled in following frames as if he were searching for inspiration. Then, a light bulb appeared on top of his head: "I got it!" His brush dashed to the lower right corner, and he wrote down the amount of five thousand dollars.

Indeed, here in the United States, an artist is respected by the predetermined amount which his work can generate, even before the work is done.

It is an ironic contrast.

As for me, I try to put myself into a position where I do not have to rely on painting sales to earn a living. If art patrons collect my work, I hope it is because they can see its spiritual elements, not because it is a good investment. But if they should insist on calling my work a good investment, who am I to argue? I have invested my whole life in it. It has to be good.

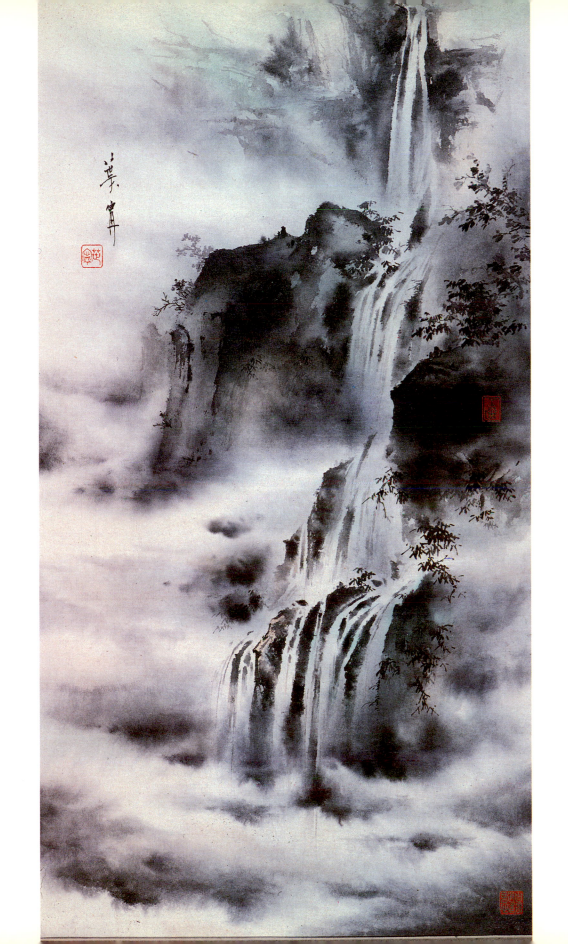

The Green Waves of Summer (Lotus)

Collection of Steven and Julie Barilich

Paper: Double Shuen
Brushes: "Orchid Bamboo" (petal back side, stalk), "Flower & Bird" (petal front side), "Idea" (seed pod, pollen, stalk dot), "Large Flow" (leaf).
Colors: poster white, permanent magenta, crimson lake (petal); green mixed by blending yellow and indigo, indigo, ink (leaf); green (seed pod, stalk); white with yellow (pollen); crimson lake (dot on stalk).

Ho Hua 荷花

Most cities in southern China have large lotus ponds. In summer, the fragrance of the lotus extends for miles around. Instead of using fences, many owners of private retreats by the lakes grow the lotus as a natural barrier from the boating public. Only with precise directions can one guide a boat through the networks of crisscrossing lotus stalks and reach the shore. Collecting lotus seeds on a rowboat is a favorite summer pastime for the young.

The Chinese see the lotus as a symbol for purity. The plant roots in mud but stays undefiled; it grows with elegance and stateliness from the mud. Sometimes reaching four to five feet tall, it blossoms with clean petals and a delightful fragrance.

People here sometimes confused the lotus with the water lily. To the Chinese, the difference could be described by comparing a Court Lady to a street walker. The water lily is much smaller than the lotus, with more symmetrical and monotonous shapes. It chooses to float on water, uncertain about its destination. The lotus has a much more regal presence; it reminds people of a lady raised in the wrong neighborhood who grows up to be Miss America.

Seal: Face to Face
with Words Forgotten

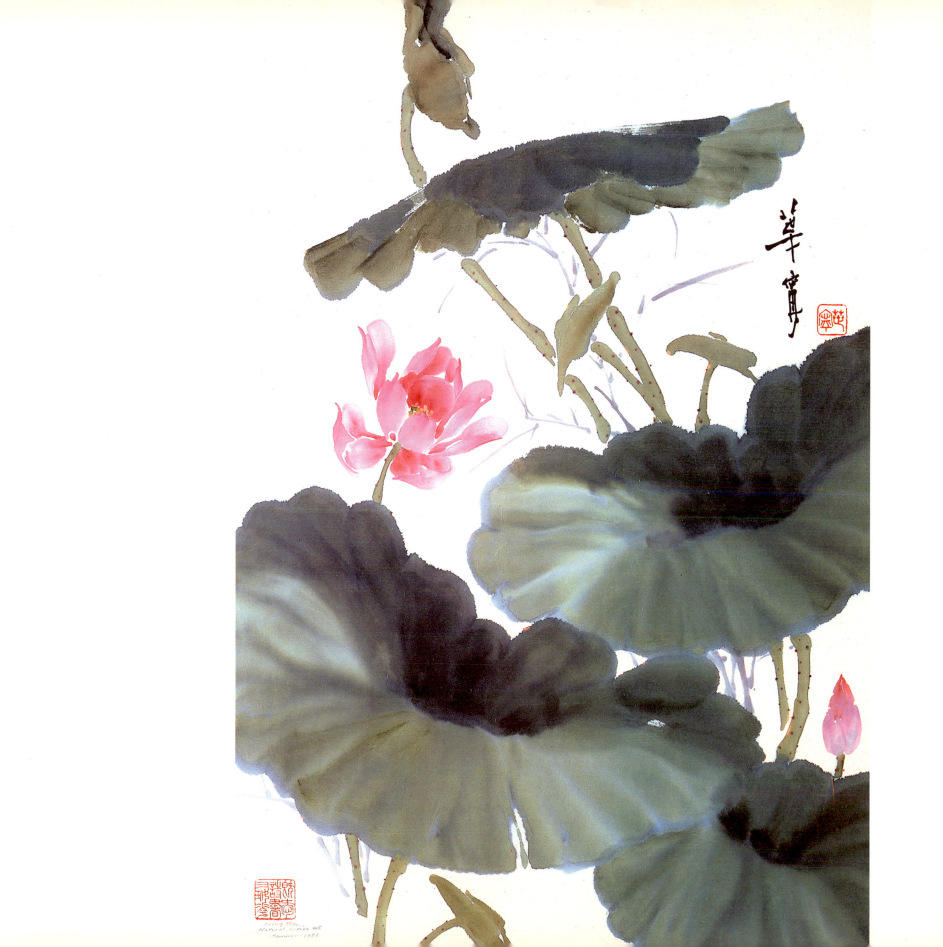

Purple Haze (Myrtle)

Collection of George and Mary Connelly

22"x35"
Paper: Double shuen
Brushes: "Large Flow" (leaf), "Big Idea" (branch, vein), "Idea" (flower, bud, stem), "Best Detail" (stamen, pollen).
Colors: Green mixed by blending yellow and indigo, indigo, ink (leaf); poster white with yellow (leaf vein); green with burnt sienna (branch); pasty ink (dot); diluted white with Winsor violet (petal); neutral tint (flower center); poster white (stamen); white with yellow (pollen); green with brown madder (bud, stem).

Seal: A Multitude of Colors in Celebration

Tze Wei 紫薇

> Under the silky pavillion, tranquility prevails in my study;
> The clock tower strikes, reminding me of the long hours passing . . .
> In this evening of solitude, who shall be my companion?
> Tze Wei flower facing the Tze Wei Long (紫微郎).

Poet Po Chu-yi (白居易 772-846) wrote the above passage in the prime of his career. During the Tang Dynasty, the secretary in charge of the central administration was called the Tze Wei Long. By royal decree, Tze Wei (myrtle) trees were planted in front of the residence of the Secretary. Tze, meaning purple, is the color of the Secretary's robe.

The myrtle tree grows wild in the mountain regions of southern China. Blossoming in mid-summer, the myrtle has a flowering season which lasts several months. The red myrtle is called One-Hundred-Day Red (百日紅), or the Full-House Red (滿堂紅). The branch of the myrtle tree has sensitive skin. When a bird lands on top, the whole branch shakes all the way to its tip. Therefore, the village people call the myrtle "the Fear Itching Tree."

It is used to decribe men who are afraid of their ladies. The smooth texture of the myrtle tree presents a problem for the tree-climbing monkeys. In the mountain regions, the myrtle is known as "the Tree Too Slippery Even for Monkeys."

The official myrtle is purple-colored. When blooming, the clusters of small flowers turn the forest into an ocean of purple.

I have made three trips to the Orient with my students. We have visited the studios of many leading masters. The hospitality extended by these master painters was incredible. I have also noticed that there are subtle hints of competitions among the masters . . . it even got down to what kind of food they served to us. Each master was trying to outdo the other.

Mr. Yu Chung-lin (喻仲林) was one of the master painters we visited. He developed an elegant way of portraying the beauty of the myrtle flower. He passed away last year. How I wish I could ask him how to do this flower right!

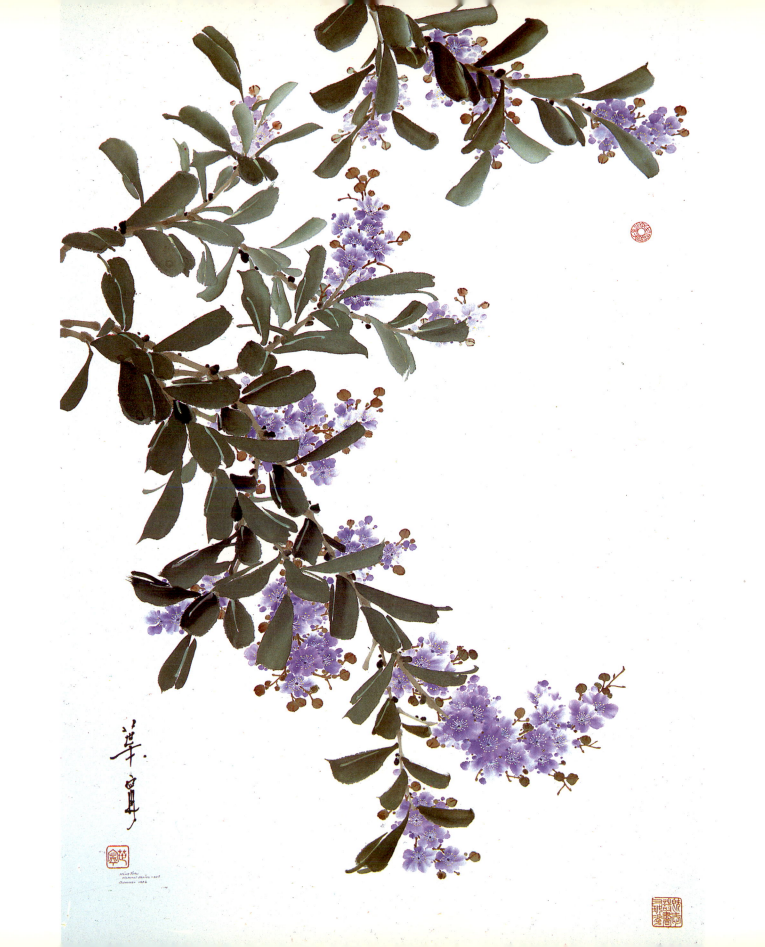

Celestial Imprints (Calla Lily)

Collection of Julie Peterson

15"x26"
Paper: Double Shuen
Brushes: "Large Flow" (flower, leaf), "Big Idea" (center, stalk, dot).
Colors: yellow, vermillion, red (flower); poster white with yellow (center, leaf dot); green mixed by blending yellow and indigo, indigo, ink (leaf, stalk).

Ma Ti Nien 馬蹄蓮

According to the Book of Poems (詩經), there were once ten thousand celestial horses roaming across China. Wherever they went, they left their footprints which later turned into flowers. Those flowers were the original calla lilies.

In another tale, the Yellow Emperor (黃帝), the founder of the Chinese nation (about 2000 B.C.), was praying to God for a better way to communicate with his subjects. In his dream, he saw celestial horses descending from heaven, each carrying a scroll imprinted with the basic characters for the Chinese language. These horses left their footprints along the waterways. They became calla lilies.

Both of these stories were perhaps inspired by the shape of the calla lily. In China, the flower is simply called Ma Ti Nien — "horse-hoof lily." In any event, the Emperor fulfilled his wish; the Chinese had acquired a sacred language. And the calla lily has come to reflect the rejoicing celebration of a nation.

Seal: Fulfillment of An
Everlasting Wish

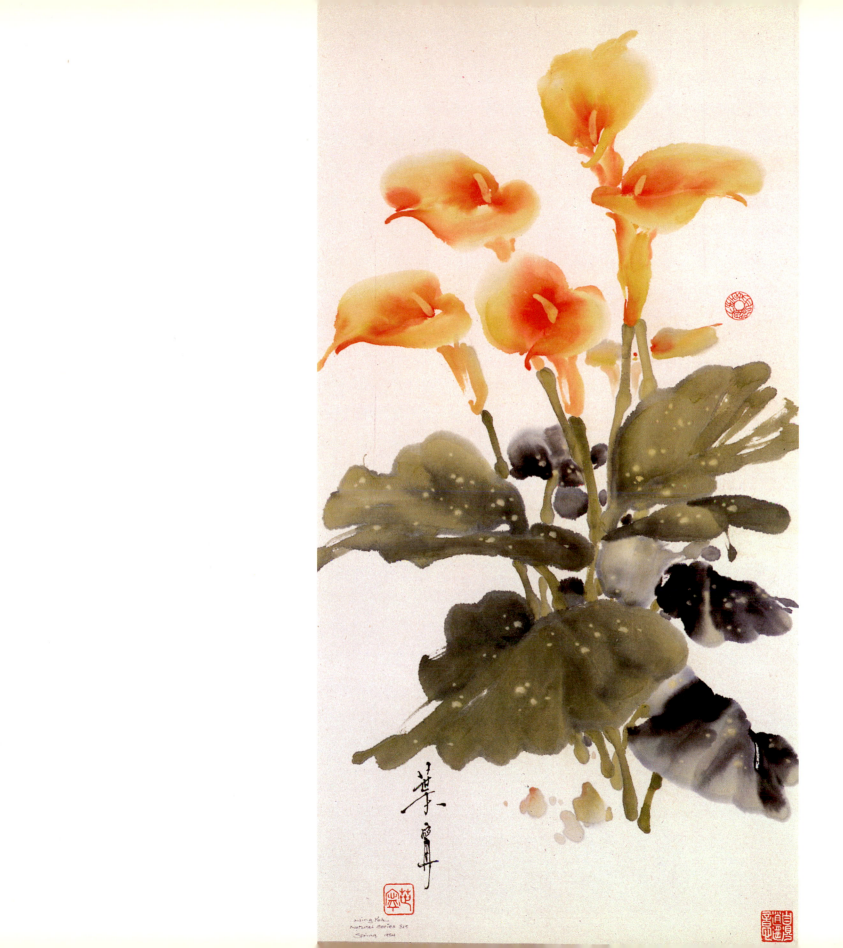

Ning Yeh.
Natural Series 815
Spring 1984

The West Hill

Private Collection

18"x36"
Paper: Jen Ho
Brushes: "Landscape" (line), "Big Idea" (texture, color), "Wash" (mist, sky, water).
Colors: vermillion, yellow ochre, manganese blue (structure, path); Prussian green with charcoal gray, Winsor emerald, Winsor violet, vermillion (tree, mountain, mist), French ultramarine, Winsor violet (distant mountain), manganese blue, Winsor violet (sky, water).

Mt. Hua Shan 華山

Millions of years ago, the muddy waters of the Yellow River rushed to the sea, and large deposits of mud settled to form the great northern plain. This plain was the beginning of the Chinese civilization. The Yellow River originated from the high plain, went northward, circled around the central plateau, then descended from the north with tremendous energy as it pushed south. The mighty river was halted by a gigantic rock and forced to turn 90 degrees to the east toward the ocean. The rock that stood in the way of the Yellow River was Mt. Hua Shan.

Mt. Hua Shan is located 120 kilometers east of the ancient city of Xian, in the province of Shensi (Shaanxi 陝西) in the heartland of China. The mountain has appropriately been recognized as one of the five sacred mountains in China. Each of these mountains has been given the title of one direction, with the extra mountain in the middle. Mt. Hua Shan is the "West Hill."

I compare Mt. Huang Shan (黃山) in southern China to Mt. Hua Shan as the Ying and the Yang. They both are my favorites. While Mt. Huang Shan represents mysterious grace and charm, Mt. Hua Shan impresses people with its sheer strength and awesome grandeur.

Among the various scenic mountains, the Hua Shan is the hardest to climb. The path upward is narrow and almost perpendicular. Steps were cut into the rock face, one by one.

The great poet Han Yu (韓愈 768-824) climbed the Hwa Mountain to look for inspiration. But when he had climbed less than half of the way, he lost all his nerve. Also, he could not bear the thought of climbing down. In despair, he wrote farewell notes to all of his friends and loved ones. One by one, he dropped the notes from the cliff. Fortunately, his notes were found, and the magistrate sent rescuers to lower him to safety with a rope. His friends observed Han Yu was "as if aged sixty years by the experience." This is one mountain I am not prepared to climb.

Yu Chuan Yuan (玉泉院 Jade Spring Garden), is the starting point of the mountain trail. A reclining statue of the "Sleeping Fairy" in the temple is dedicated to Chen Tuan (陳博), who helped the first emperor of the Northern Sung (960-1279) rise to the throne. Chen retired and became a hermit in the Jade Spring Garden. He developed a reputation for enjoying sleeping, and his sleeps sometimes lasted for months.

The emperor consolidated his power by eliminating some of the people who helped him. He came to Chen and tried to test his ambitions. They played a game of Go. (A Chinese chess game of profound strategy, Go can be mentally and physically draining. My father had a seal made saying, "Half of my life is ruined by playing Go"). The emperor lost the game with Chen, and he offered Chen whatever he wished. Chen pointed to Mt. Hua Shan and said to the emperor, "This is all I want." The emperor granted him the mountain and left him alone.

Seal: Not Wishing to be
Awakened from the
Dream of Spring

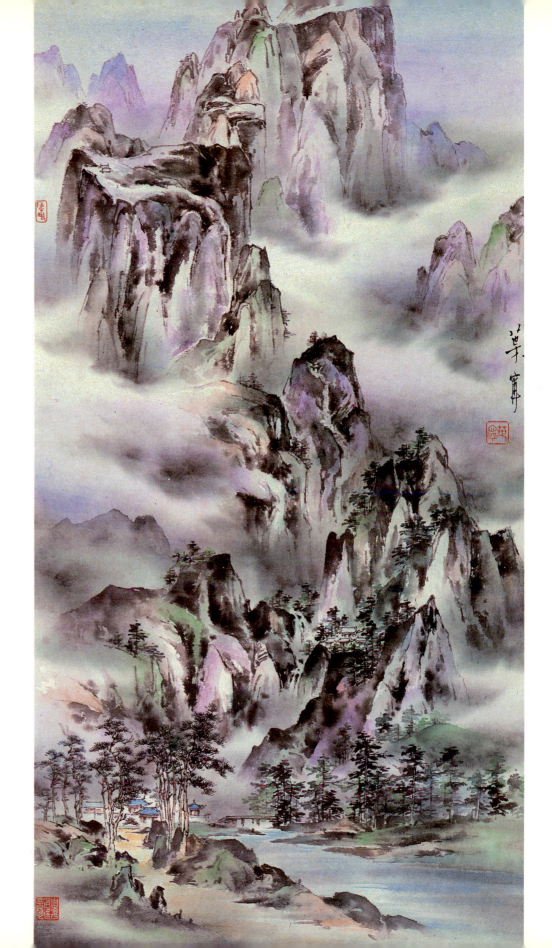

Spring Butterfly (Iris)

Collection of Clarence and Grace Sato

22"x36"
Paper: Double Shuen
Brushes: "Large Flow" (flower), "Idea" (beard), "Big Orchid Bamboo" (calyx, stalk), "Lan" (leaf).
Colors: Prussian green, French Ultramarine, Winsor violet, indigo, neutral tint (flower); yellow, vermillion (beard); green mixed by blending yellow and indigo, indigo, ink (leaf).

Butterfly Lovers 梁祝

Blessed with the colors of the rainbow, the iris has been recognized as the dancing spirit of early summer. Its soft, fluttering petals remind the Chinese people of butterfly wings, flapping gently in the breeze. The flower is known as Tze Hu-tieh, or "The Purple Butterfly."

The butterfly flower reminds me of a well-known play in China. the story of Liang and Chu, commonly known as as Tze Hu-tieh (紫蝴蝶), or "The Purple Butterfly."

In old China, a wedding between youngsters was arranged by the family without consulting the individual wishes of the couple-to-be. Many times the young man did not even have a chance to see his bride-to-be beforehand. Proper unwed ladies were not to show their faces in public, and they limited their activities mostly to family quarters which were confined by high walls. Even during the wedding ceremony, the groom had no opportunity to check what he was getting: the bride's face was covered with thick, red cloth. Imagine the anxiety and shock the groom must have felt during the moment of unveiling once the couple was finally alone in their bedroom. No wonder historians would note that "Many grooms shook like leaves and did not recall what happened that night; some actually fainted."

Chu Yin-tai (祝英台) was a beautiful young lady from a well-to-do family. Far more enlightened than her era, she refused to stay at home and receive her education from a private tutor. Instead, she disguised herself as a young man and enrolled in the academy for boys near Hanchow (杭州). For three years, she roomed with a poor young scholar named Liang San-pao (梁山伯). The only reason Liang could be at the academy was his outstanding scholastic performance. The young man was obviously possessed with studying not to notice his roommate was a girl who secretly had a crush on him. Numerous hints by Chu which were designed to reveal her true identity failed. (To modern folks, the problem would be so simple. But in the old days, people were not even supposed to touch each other, and things sure became a lot more complicated. How China would end up having so many people is a mystery to me.)

Upon graduation, Chu invited Liang to visit her home. There she revealed her womanhood, and, finally, all those hints began to make sense to the bookworm. He vowed to marry her after he returned to his village and reported to his folks for approval.

Due to the huge differences between the social status of the two familes, Chu's father was dead set against the romance between his daughter and the poor scholar. He hastily matched Chu to marry the son of a local gentry. Liang, hearing the dreadful news at his home, rushed to her. Stricken with anxiety, he fell ill and died outside of Chu's residence.

People who study hard should really take care of their health.

On Chu's wedding day, she ordered the carrier to make a detour to Liang's grave site so she could bid him a last farewell. The legend has it that her grief moved the spirit above and while she was kneeling in front of Liang's grave, the grave opened up to show Liang waving inside. Chu rushed in to join him. As the grave was about to close, two butterflies came out. One followed the other, and they gradually disappeared into the air.

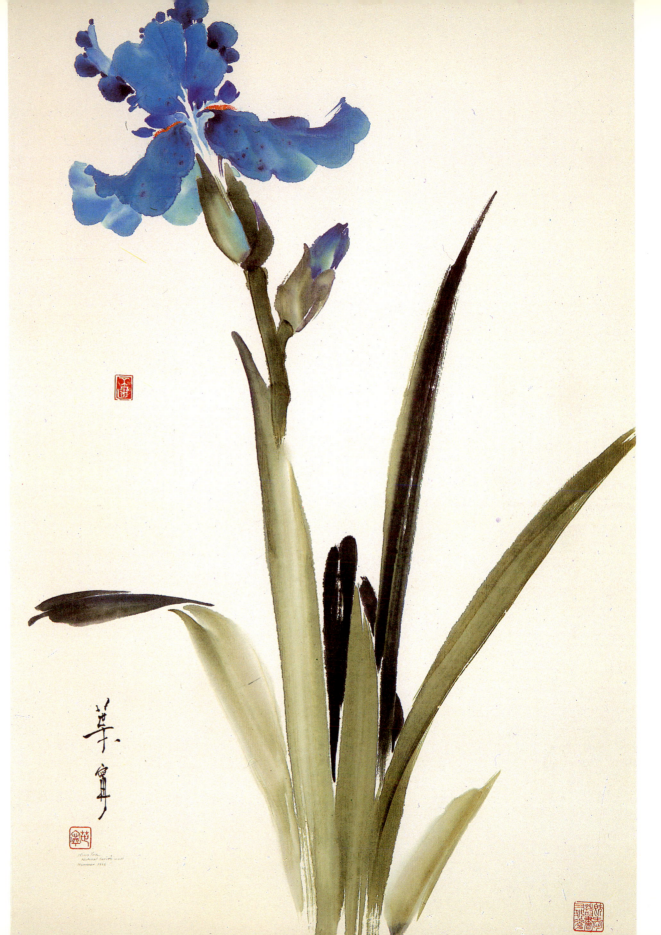

Seal: Dream of A Butterfly:
Chun-tze dreamt of himself as
a butterfly. Upon awakening, he
wondered whether he was a man
in the dream of a butterfly

Lotus of a Different Color

Collection of David M. Philips

17"x26"
Paper: Double Shuen
Brushes: "Orchid Bamboo" (petal outside, stalk), "Flower & Bird" (petal inside), "Idea" (seed pod, pollen, stalk dot), "Large Flow" (leaf).
Colors: poster white, vermillion, red (petal); manganese blue, indigo (leaf); yellow with white (pollen); ink (stalk dot).

The Song of Collecting Lotus Seeds

The sun is setting,
Gentle breezes chase away the heat of the day.
You roll the oar, I hold the pole;
One splash into the water,
We move past the little arch-bridge.

There are lotus glowing in white and crimson;
The boat is moving fast, and
The people are singing loud.

Together, we enjoy the fun of picking the lotus seeds . . .

Hung Tze (黃自 1904-1938), the greatest composer of modern China, wrote this song, as well as many other tunes which reflect the simple pleasures in life. His creative emotions, coupled with his strong love of the land and deep understanding of the culture, have made his music the most influential force in my parents' generation. My mother taught music for many years, and I was taught to sing all of his songs. They have had an enormous impact on my mentality.

Brush painting is a state of mind which is reflected by rhythmic movement. I paint with music all the time and find it to be an essential positive reinforcement for my work.

Seal: Subtle Mood Accompanied by Delightful Rhythm

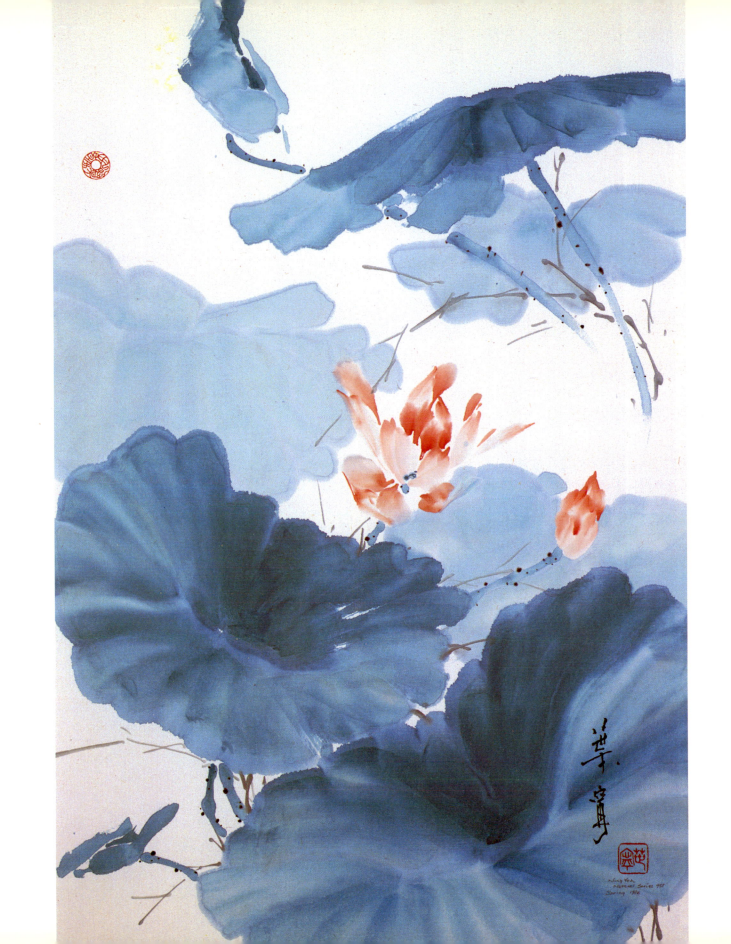

Ning Yeh
Natural Series #12
Spring 1986

45 秋色

Fall Colors

Private Collection

14"x26"
Paper: Double Shuen
Brushes: "Large Flow" (trunk, background), "Big Idea" (leaf).
Colors: ink, burnt sienna (trunk); vermillion, red (leaf); vermillion, indigo (background).

The Message of the West Wind (Autumn Wind) 西風的話

Last year, when I came,
You were just putting on your new cotton robe;

This year when I returned,
You all were getting bigger and taller;

Do you ever recall when all the lotus flowers in the pond
Had turned into dry seed pods?

Flowers have gone rare, but
Fear not the lack of colors,
For I have tinted all the leaves red.

— Hung Tze's tune, a favorite grade school song

Seal: A Psalm of Nature

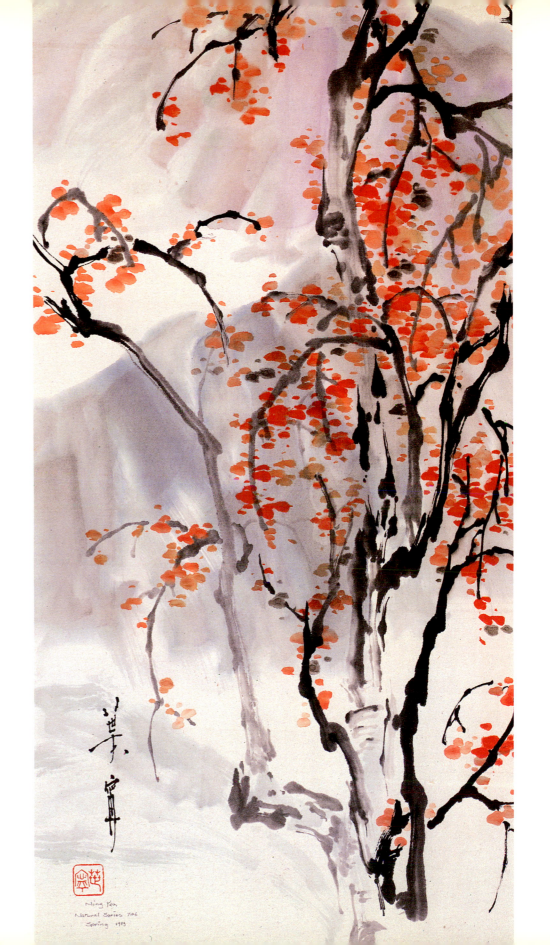

Ning Yeh
Natural Series 706
Spring 1983

Golden Mountain Temple

Collection of William and Jean Todd

18''x36''
Paper: Jen Ho
Brushes: "Idea" (line), "Big Idea" (tree, color, reflection), "Wash" (sky, water).
Colors: vermillion, burnt sienna, crimson lake, cerulean blue, French ultramarine, Winsor violet (structure, boat); yellow ochre, Winsor emerald, Prussian green with charcoal gray, Winsor violet, ink (tree, mountain); vermillion, Winsor violet, cerulean blue, indigo (sky, water).

Jin Shan 金山

When will the bright moon appear?
I raise a toast to Heaven and ask.
I wonder if the court in Heaven really knows what time of the year this evening is.

I wish to ride up there with the wind,
But I am so scared of living in crystal palaces and jade towers;
In those high places, I would be utterly alone and cold.
By far, it is still best for me to dance with my own shadow, among the plain folks I know.

Around the red chamber, peering through the silk window, the moon finally appears to visit the sleepless.

I know the moon holds no grudge against me, but why does she always choose to be this full and cheerful when I am not with you?

(Alas), just as we are happy and sad, uniting and departing; the moon has her moments of shade and shine, fullness and crookedness.

Seal: Poetic Song

No matter how long ago you trace back, (or where you are), things are never as perfect as you expected.

I only wish you and I could last until our ripe old age, although a thousand miles apart,
we can be together by sharing the brighter moments of the same moon.

Poet Su Tung-pao (蘇東坡 1036-1101) wrote the above passages while visiting the Golden Mountain Temple in the night of the Mid-autumn Festival. He was degraded during this visit, chased out of the court and forced to become a petty official in a remote region in southern China. Down and out, he wrote these lines to offer comfort to himself and his loved ones.

Golden Mountain (Jin Shan), stands along the middle Yangtze River and safeguards the city of Zhen Jiang (鎮江) in Jiangsu (江蘇) Province. It once was an island in the middle of the river, but in the last few hundred years, the river has moved north. The mountain is now linked with the land.

At the summit of the Golden Mountain stands the elegant Pagoda of Benevolence and Longevity. Following the contour of the hillsides, this ancient Jin Shan Temple was built with all its components becoming the integral parts of the mountain. Fifteen hundred years old, the Temple once was the home of 3,000 monks. (Monks actually have no homes, but 3,000 monks were there at one time, doing whatever monks are supposed to do. If I sound disrespectful to the Temple monks, you shall soon find out the reason).

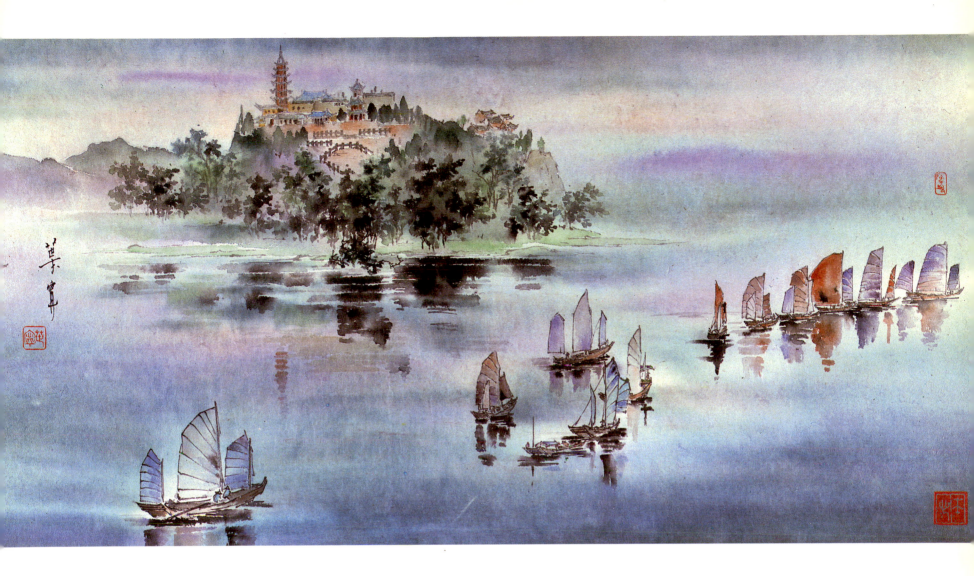

47 素貞

Su Jean

18"x26"
Paper: Double Shuen
Brushes: "Orchid Bamboo" (petal back side, stalk), "Flower & Bird" (petal front side), "Idea" (seed pod, pollen, stalk dot), "Large Flow" (leaf).
Colors: poster white, permanent magenta, crimson lake (petal); green mixed by blending yellow and indigo, indigo, ink (leaf); green (seed pod, stalk); white with yellow (pollen); crimson lake (dot on stalk).

The Tale of the White Serpent 白蛇傳

Every Chinese knows the Tale of the White Serpent, one of their most popular folk stories. The West Lake and the Golden Mountain Temple are the stages for this story.

According to Chinese legend, an animal, after thousands of years of enriched existence, would take the shape of a human being. One of the most celebrated among these animals (an earlier Chinese answer to modern day Joan Collins in the West), was the White Serpent, who transformed herself into a beautiful woman named Su Jean, meaning pure and faithful. She met and fell in love with a handsome young mortal named Hsu Hsien (許仙) during a rainy day tour of the West Lake in Hanchow. Su Jean and Hsu Hsien got married, and Su Jean helped her husband build a successful practice in medicine.

But soon their happy family life was disrupted by an old monk named Fahai (法海) from the Golden Mountain Temple. The monk sensed the spirit of the serpent. On the fifth day of the fifth moon, a day set aside for the Chinese to chase off evil spirits, Fahai dropped his potion into Su Jean's wine and forced her to reveal her true serpent form. But even after discovering the true identity of his wife, Hsu Hsien's devotion remained firm.

The monk then kidnapped Hsu and locked him in the Golden Mountain Temple in order to force a separation. Su Jean came to the Temple and kneeled outside the gate to beg for a reunion with her husband. The monk refused. With all her power, she gathered all the shrimp and crab spirits, along with the river dragons, and flooded the Temple with the waters from the mighty Yang-tze. While the battle was raging, Su Jean felt labor pains and had to withdraw from the Temple. In this moment of chaos, Hsu was able to flee from the Temple. Guided by fairies, he rejoined Su Jean, along with their newborn son.

This proved to be their last meeting, for soon Fa Hai gathered help and sealed the White Serpent under the Lei Fong Pagoda (雷峯塔) near the West Lake. The seal lasted one hundred years until the pagoda collapsed. By the time the White Serpent was free, her husband was no longer alive. Su Jean revisited her home and found generations of her descendants continuing the family business and living well. With joyful tears, she faded away.

Monk Fa Hai's body is still kept intact today in a cave below the temple. The temple records document the great flood, and the pagoda near the West Lake did actually collapse. Was the White Serpent real or fictional? I can visualize interviewers from America surveying the corner streets in Hanchow, only to find the Chinese responding with a smile. If you ask the lotus flowers in the West Lake, they all nod their heads.

Seal: Everlasting Beauty

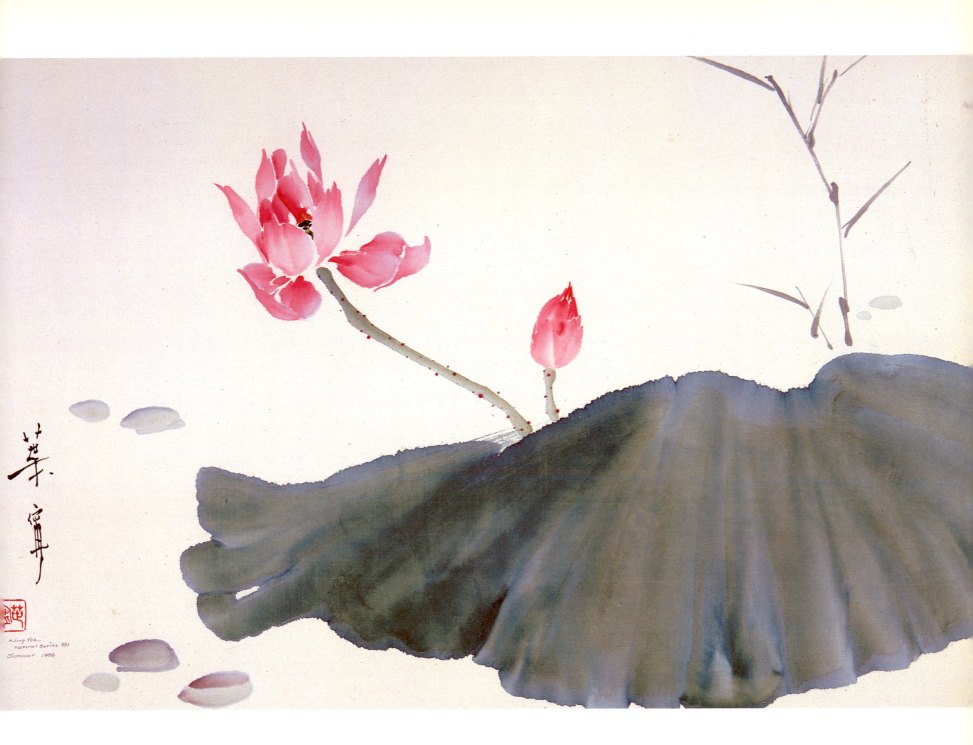

Ning Yeh
Natural Series 991
Summer 1986

97

Red Peony

Private Collection

14"x26"
Paper: Double Shuen
Brushes: "Flower & Bird" (petal), "Idea" (seed pod, pollen, vein), "Large Flow" (leaf), "Orchid Bamboo" (Calyx, branch).
Colors: red, crimson lake, purple madder, neutral tint (petal); poster white with yellow (pollen); green mixed by blending yellow and indigo, indigo, ink, crimson lake (leaf, calyx, vein); burnt sienna with ink (branch); crimson lake, ink (dot).
For detailed, step-by-step instruction on the peony, see Lesson 13-15 in the Study Guide.

Earlier Experiences

I held my first "one man show" in the United States in Fresno in 1969. I looked through the Yellow Pages to find a place to have the show and was given a show from the first number I called. The place was called "All About Art," and it was run by a kind lady, Mrs. Reese. The "Fresno Bee" ran a full page article about the event, and we were very excited. On the day of the reception, my wife, Lingchi (楊玲琪) and I stood at the door of the small gallery for a whole afternoon, but nobody showed up. By closing time, a young man who worked in the meat market across the street came in after he had finished work. Eventually, he introduced me to a Chinese family in Selma, who made several purchases.

Seal: Holding a Glass in Hand, Long Awaiting, to Greet Whoever Appreciates

Another experience occurred three years later, at the Los Angeles County Fair. The Fair's art director, Mr. Richard Peterson, was born and raised in China and spent over twenty years in both China and Taiwan. In 1972, he offered me my first paying art demonstration job. I had just gone through an operation for acute appendicitis, and since I was only working part-time at the library in my graduate school, I really appreciated his assignment. There were seven artists working at the Fair, and on the first day, no one stopped at my booth. An elderly Indian sand painter was getting the crowd. Tired and depressed, I sat at the little kitchen with Mr. Peterson. I had thoughts of quitting; mainly I felt I did not do a good job. "You must realize the attention span of the Fair folks is very short. There is so much to see, and many of them are constantly looking for their kids," Mr. Peterson said. "Work out a short program, get a few folks interested. Grind your ink, talk to people . . . Once you have a few people, everyone else will want to know what is going on. After the short program, then start your real demonstration. Don't sit there all day and paint. Develop a schedule, tell folks when you will do the next demonstration. Take your breaks." The advice worked. Two days later, the sand painter complained that Ning was blocking the traffic.

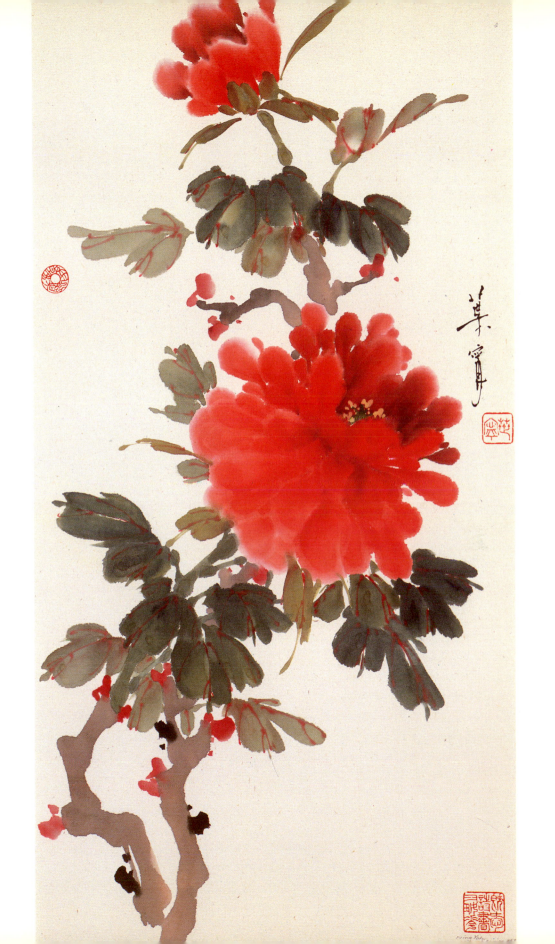

El Capitan (Yosemite)

Private Collection

Paper: Jen Ho
Brushes: "Mountain Horse" (texture), "Big Idea" (color, tree), "Wash" (mist).
Colors: vermillion, burnt sienna, green mixed by blending yellow and indigo, indigo, ink.

First Stop: Fresno

I do believe in fortune. It seems that I frequently have found myself in the right time and the right place, with the right people coming along to help me to make some of the most critical decisions.

In the latter part of my college days, I was given the opportunity to stage art demonstrations in Taiwan for visiting foreign dignitaries. A Deputy Secretary of State, Michael Ciplinski, was one of the visitors. At the time I met him, I was in a dilemma, facing the career decision of which branch of diplomatic services to enter after college. He suggested that he arrange a lecture-demonstration tour among the California Universities for me, after I completed my post-college military service in Taiwan. The suggestion prompted me to think seriously of coming to America.

I attended a seminar run by the students who had studied in the United States. I was told that haircuts and suits were very expensive in the United States. I was urged to guard the long tube which contained one's chest X-ray carefully, for without it, one could not pass immigration. Also, I was told not to pass up the opportunity to buy a cheap camera when the airplane made its stopover in Japan.

A letter of invitation was sent by a professor at the California State University at Los Angeles. Several family friends put together a loan for a plane ticket and on September 1st, 1969, I flew from Taiwan to the United States.

The airplane was filled with students. Every young man looked like me: a Marine-like haircut; brand new, ready-made suit with a cheap Japanese camera striped across it; holding a long X-ray tube. A girl's family asked me to take care of her on the airplane. She had relatives in San Francisco, and the girl's family promised to ask their relatives to help me establish contact and become a little familiar with the new world.

We landed at San Francisco Airport at two p.m. The girl's relatives were so excited to see her that they left without me.

I decided to fly to L.A. to look for the professor who invited me. At 4:30 p.m., I arrived at LAX. My English was so inadequate that I could not understand the telephone operator's instructions. A soldier on leave helped me to get through, but the professor had gone for the day. I decided to go to Fresno.

Fresno?

While in Taiwan, I had applied for graduate schooling in the States, and I ran into an recruitment brochure which said, "Fresno State is located in the beautiful San Joaquin Valley." Next to this statement was a beautiful picture of Yosemite Valley. Immediately I envisioned carrying books and roaming about a garden-like campus, looking up to see magnificent rocks with cascading waterfalls. Checking my map, I found Fresno in the middle of the Golden State. Growing up in Taiwan, I had no idea how big a country the United States was. I had plans to go to San Francisco in the morning, L.A. at night, and thus cover all of California. (to be continued)

Seal: Journey of Heart

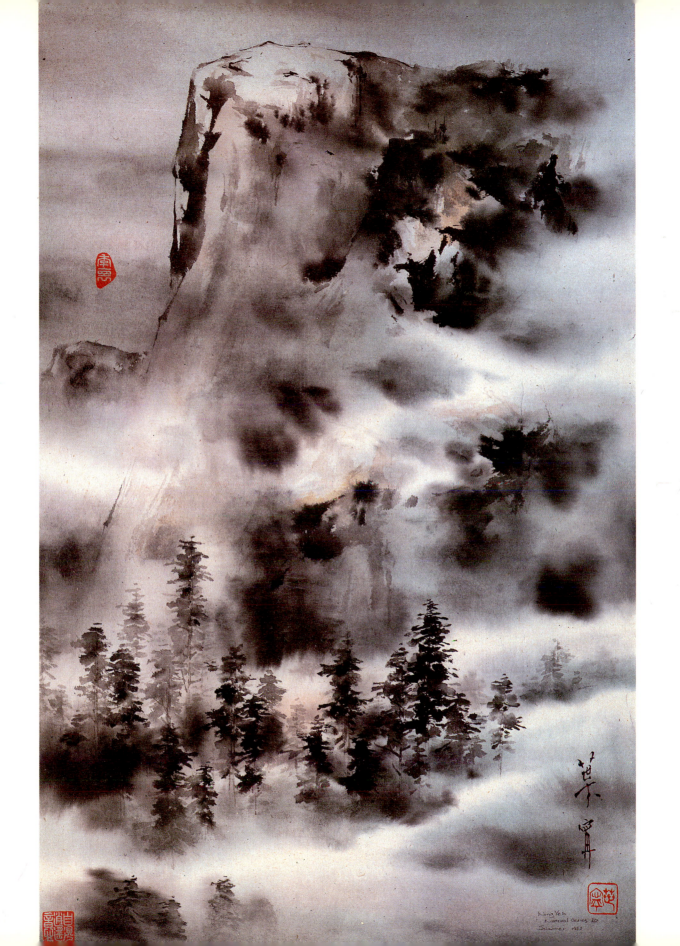

King Yeh
Numeral Series XX
Summer, 1982

50 紅泉

Red Fountain (Hollyhock)

Collection of Dale Vaznaian

18"x26"

Paper: Double Shuen
Brushes: "Flower & Bird" (flower), "Large Flow" (leaf), "Big Idea" (stalk, stem, vein, pistil), "Idea" (pollen).
Colors: vermillion with red (underside petal); red with crimson lake (topside petal); yellow, purple madder (center); poster white (pistil); poster white with yellow (pollen); vermillion (petal vein); green mixed by blending yellow with indigo, indigo, ink (leaf, stem, stalk, leaf vein).

Yi Chang Hung 一丈紅

The hollyhock grows in multitudes of flowers along a tall stem. Many farming villages use the flowers as fences. In China, the hollyhock is called "Yi Chang Hung", meaning "Ten-foot Tall Red." Its petals are used as color dye, and its roots are used in herb medicine.

First Stop: Fresno (Part Two)

I was given a tuition scholarship by Fresno State. A letter noted that I had to be at Fresno for an orientation meeting on September 2; otherwise, my scholarship would be cancelled.

There was one flight to Fresno that night. It was booked solid. The counter lady suggested that I go Greyhound. "Greyhound?" I retreated back to a corner, and frantically searched through my dictionary. I found that the greyhound is some sort of a dog. When I eventually got the right idea, I realized it would take about seven hours from LAX to Fresno by Greyhound. It would be past midnight when I arrived, and I had no place to stay.

I went back to the airline counter and asked for help. "You can try standby." "You mean to stand, not to sit?" "No! you take a number and wait until the regular passengers get on board and then try your chances." I was number 13 on the standby list and the flight was at 7:30 p.m.

By now I temporarily had no more decisions to make. I waited for my chance. Hunger started, and I became aware that I had not eaten anything for a whole day. The cafeteria looked expensive. (When I left Taiwan, the island was still an agricultural society. I got paid less than $20.00 a month in the military.) At one corner of the waiting room, a hotdog stand was sending an irresistible fragrance to me. I grabbed my enormous lugguage and slowly moved toward the stand. (I had carried all my stone seals, ink slates, books, a ricecooker, and tons of gifts entrusted by my family friends for their relatives in the United States, among other things).

The series of disappointments and setbacks had made me lose my self-confidence. Being so uninformed, I did not trust that grotesque round thing called a hamburger which everyone was getting. The hotdog was the only food I knew. Finally someone else came for a hot dog. I studied how he ordered and how much he paid. I counted the exact amount of money, gathered whatever nerve I had left, and approached the stand: "One hot dog, please." "Sorry, I have just sold the last one." Completely crushed, I retreated back to my corner.

By seven-thirty, I was the last standby passenger on board the flight to Fresno. Sitting next to me was an oil man from Texas. He started talking to me. He had been to Taiwan and talked about the beauty of the island. Many thoughts came to me all of a sudden, and I had to turn my head to the window to prevent my tears from been noticed. From the window I saw rows of bare mountains. "Where is Yosemite?" (to be continued)

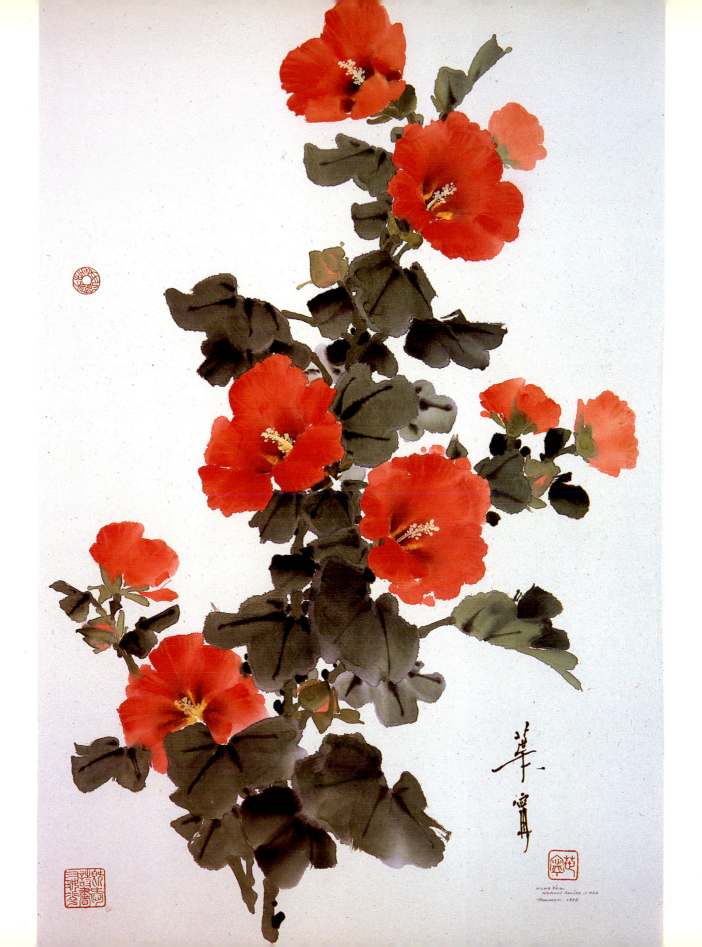

Seal: Song of a Wandering
 Soul

51 風竹

Windy Bamboo

Collection of William and Jean Todd

18"x26"
Paper: Double Shuen
Brushes: "Orchid Bamboo" (leaf, trunk), "Idea" (ring, branch).
Colors: ink, green mixed by blending yellow and indigo, indigo.
For detailed, step-by-step instruction on the bamboo, see Lesson 4-6 in the Study Guide.

First Stop: Fresno (Conclusion)

As I came out of Fresno Airport, at 9:30 p.m., I was greeted by intense heat. I went to the nearby telephone booth. In Taiwan, one of my art patrons was the principal of the Taipei American School. He told me that his college roommate, Dr. Johnson, worked in the education department at Fresno State College. I looked at the phone book and found there were hundreds of Johnsons even in Fresno. I decided to try my luck. On my third call, I reached a Johnson who knew Dr. Johnson and told me his first name was Glenn. Finally, I got hold of Dr. Glenn Johnson, who was having a party at home. He was on the phone for a long time, trying to absorb the incredible story of a perfect stranger in a desperate situation. I heard his wife urging him to come back to his guests. He replied with a loud voice, "A young man from Taiwan, saying he is a friend of Howard's, is trapped at the airport." He came back to me on the phone. "You stay put, I will be there in fifteen minutes. What do you look like?"

I looked like an uprooted bamboo stalk in the wind. "I am bare-headed, wearing a pair of thick glasses and wearing a Hawaiian shirt." He described himself, and fifteen minutes later, three cars pulled into the airport. Dr. Johnson's entire party came to welcome me.

That night, after a great meal, I opened my luggage. My friends' relatives could wait, I gave everyone who was at the party something. I was so grateful.

I attended the orientation meeting on time. The lecture tour of the California State Universities never materialized, because each school operated independently. It did not matter; I met Lingchi in Fresno. Three months later, I was married. My flamboyant bachelor life came to an end because I was dying for Chinese food, among other things.

Dr. Johnson had passed away a little earlier, and he did not share the joy of my wedding.

I stayed in Fresno for two years. I have no regrets; I was not ready for a big city like Los Angeles. I was able to concentrate my efforts on studying, and I truly came to know some great folks who made me later feel good to be a part of American society.

I also made a point to pick up whoever was at the airport from Taiwan. My friends would call me from San Francisco or Los Angeles (They did not know how big this country was either). "You stay put, I'll be there in six hours," I would say and I did show up every time. And I took my friends to Yosemite. In two years, I visited there more than twenty times.

Seal: Home is Where My Heart
is at Peace

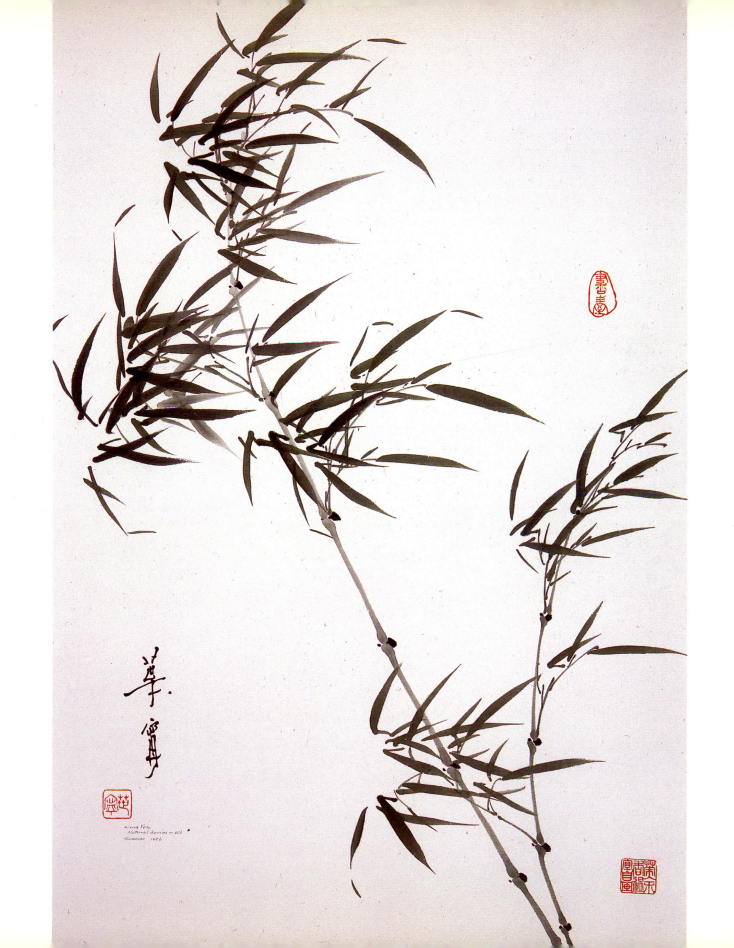

Christmas Spirit

Collection of Bill and Sheri Anderson

18''x27''
Paper: Double Shuen
Brushes: "Big Idea" (flower, center dot), "Big Orchid Bamboo" (leaf, branch), "Idea" (vein).
Colors: red, crimson lake (flower); yellow, green mixed by blending yellow and indigo, vermillion, red (center dot); green, indigo, ink (leaf); burnt sienna with ink (branch); poster white with light green (leaf vein); crimson lake (flower vein).

Yi Ping Huang 一品紅

The poinsettia is known as "San Dan Hung" (聖誕紅), or Christmas Red, in China. Because its color resembles color worn by the first rank officials, it is also known as "Yi Ping Hung," which means "First Rank Red."

Seal: There are Still Some Splendid
Arts and Genuine Elegant
Spirits that Exist Today

People in Fresno

At the start of my second semester of graduate schooling in the United States, our Governor stopped all of the tuition scholarships for foreign students. Having no legal status to enable me to work, and with a baby coming in September as a result of a "happy accident" (I do apply my painting philosophy to life), the situation looked bleak.

Upon hearing of my predicament, Dean Phyllis Watts of the graduate school called me to her office and said, "Stay in school. This should cover your tuition; you can pay me back later." She then wrote a personal check and handed it to me. A Korean professor in my Department offered me an internship working at the city hall. Dr. Heines asked us to stay at his home while he took a European trip that summer. Dr. Wong delivered my son without charge. Also, he stayed at our home until the last minute, then went to the hospital with us to save us the cost of hospitalization.

Lingchi worked as a student helper in the office of Paul McGuire, the vice president of the school. He and his wife, Eileen, came to know us as their children. Mr. McGuire hosted a private show for me, and it was so private that he practically bought the whole display! He wanted more.

That summer, I did a large painting with fifty horses grouped in the shape of the map of the States as a token of my appreciation for his patronage. "Don't thank me, a few years from now, I will thank you for doing this," he said.

These are a few reasons why an artist feels compelled to excel.

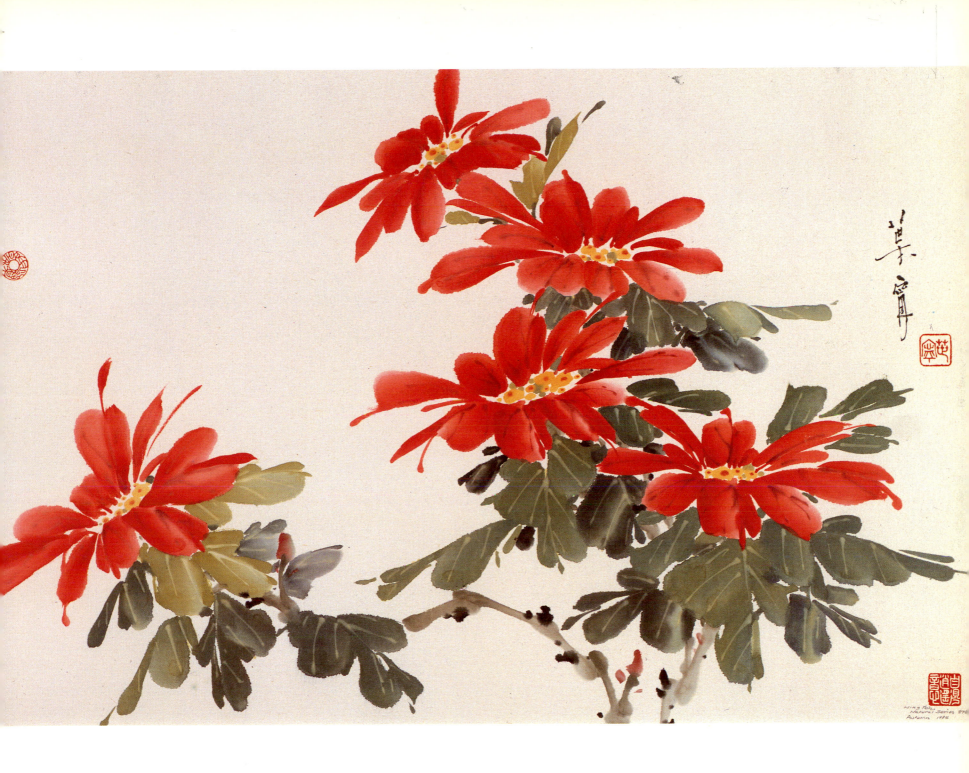

Wing Poly
Natural Series 878
Autumn 1986

Trees

Collection of Louis and Jean Lee

18"x36"
Paper: Ma
Brushes: "Big Orchid Bamboo" (trunk, branch), "Big Idea" (leaf), "Flower & Bird" (mountain), "Wash" (mist).
Colors: ink, burnt sienna (trunk, branch); green mixed by yellow and indigo, vermillion, indigo, ink (leaf); Winsor violet, neutral tint (mountain, mist), French Ultramarine (distant mountain).

The Eye of the Dragon

I named my first boy "E-van;" (一帆) it means "smooth sailing." When he was born, we were on rough seas, and we really needed a smooth sail. When Jashin (家欣), my girl, came along, things were settling down. Jashin means "joy in the family." Both names have been changed by my parents, who kept the sound of names but chose the characters with different meaning. "Evan" (逸凡) means simple elegance, and "Jashin" (佳欣) means joyful beauty. I think my folks were right.

Happy dots in a painting are like children in a family. When they behave, they can provide meaning to the empty space; they can tighten the relationship between the father (the line and framework of a painting), and the mother (the shape and substance). In many cases, happy dots highlight the energy and provide the excitement. They are the soul of a painting.

During the Liang (梁) Period of the Southern Dynasties (420-588), the artist Chang Tseng-yu (張僧繇) was well-known for his animal and figure paintings. While visiting the Temple of An-le (安樂 tranquil-happiness) near Nanking (南京), he was asked by the monks to draw something on the temple wall to commemorate his visit. Chang did four lively dragons. But to the dismay of the monks, the artist left the eyes of the dragons blank.

After a few years had gone by, the monks were anxious to see the dragons completed and urged the artist to return. The artist warned that it was best to leave the dragons alone and that grave consequences would occur if the eyes were added.

Eventually, Chang returned to the temple. Gathered there were the monks and hundreds of worshippers. Everyone was begging for the opportunity to watch Chang complete his painting. With great reluctance, Chang picked up his brush and tipped it with thick ink. As he dotted the eye of one of the dragons, the dragon blinked its eye.

Suddenly, the sky turned pitch dark and thunder and lightning started. The Temple wall cracked. The dragon blasted out from the tumbling ruins, and carrying the artist on its back, soared into the sky and vanished into the rainbow-colored clouds. When the commotion ceased, the temple wall remained only half standing, with three incomplete dragons.

The story highlights how a dot can provide the essence of the spirit of a painted subject. Another message, as I see it, is never to ask an animal painter for free paintings.

Seal: Whispering Waves:
　　　Sight and Sound of Wind in the
　　　Forest

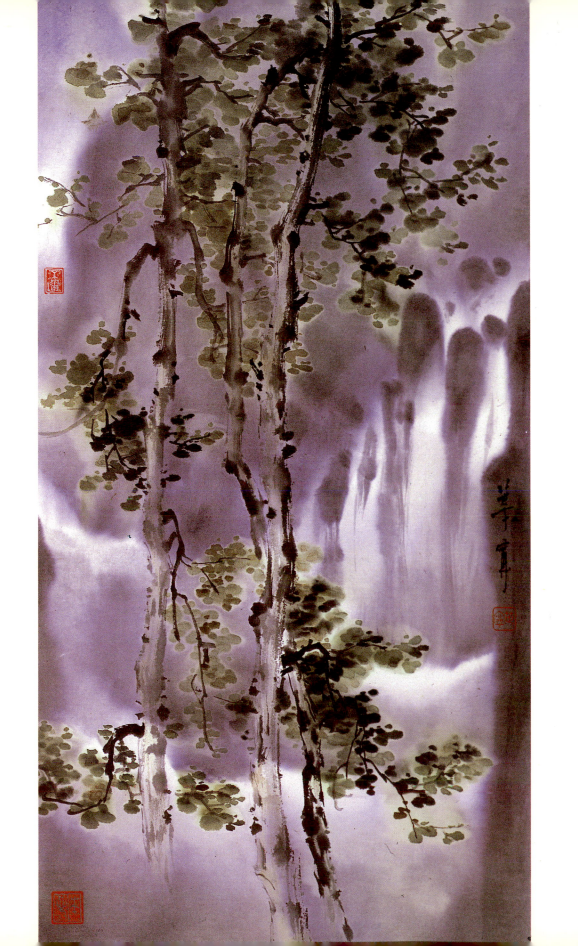

Devotion (Camellia)

Collection of Betty Watari

18"x36"
Paper: Colored Shuen (brown)
Brushes: "Large Flow" (flower, leaf), "Idea" (stamen, pistil, pollen, vein), "Orchid Bamboo" (branch).
Colors: vermillion, red, crimson lake, purple madder (flower); poster white (stamen, pistil, vein), with yellow (pollen); green mixed by blending yellow and indigo, crimson lake (calyx); green, indigo, ink (leaf); burnt sienna, ink (branch).
For detailed, step-by-step instruction on the camellia, see Lesson 8-10 in the Study Guide.

Shan Ch'a 山茶

The camellia (Shan ch'a) is the most popular and highly respected flower in Southwest China. It was honored as the national flower for the ancient southern kingdom, Dai Li (大理 today's Yunnan Province). In a land marked by steep hills and roaring rapids, the camellia transforms the hills and valleys into oceans of red and white in early spring.

The symmetrical beauty and long-lasting quality of the flower have long been appreciated by young lovers as the token for expressing devotion to each other. In the eyes of the Chinese, the petals reflect the spirit of a lady, and the holder of the petals (the calyx) represents the young man entrusted by the lady as her protector. The calyx of the camellia falls with the petals when the flower has finished blooming. This is unlike most other flowers, where the calyx seems to hang around the tree even after the petals have dropped. This phenomenon symbolizes an everlasting union between lovers. In many parts of China, the camellia is considered as the flower for young sons and daughters.

I did this painting a few years back. By the time I selected this flower as a subject in my television series, my camellia painting had changed.

The longest times I have gone without painting have been while taking trips with my students through the Orient. The Chinese have a saying, "Traveling ten thousand miles is like reading ten thousand volumes of books." (行萬里路，讀萬卷書) I have found that each journey has prompted a breakthrough in my painting exercise.

I paint every day. When I am motivated to do a certain subject, I concentrate for a period of time on just that subject. Good work never comes easy. I need several days to feel at one with the subject and master the necessary strokes. Almost invariably, I have to go through moments of silent desperation before a "masterpiece" emerges. At that point, I record some of the findings so I can share them in my class. This does not mean I have the subject down pat, for the next time I start working on it again, I may find that I have lost it. Then I go through even more struggle and frustration, because I know I did better before and I need to do better than before.

Recently, I met Hu Nien-tsu (胡念祖), a landscape artist I admire very much. He said, "There are no rules in painting; everyone does his own thing." However, he added, "With a good work, everyone can see it is good."

I develop certain guidelines to help my students. But I should hope my students do not take them too seriously. I break my rules all the time myself.

Seal: Constant Change and Adjustment

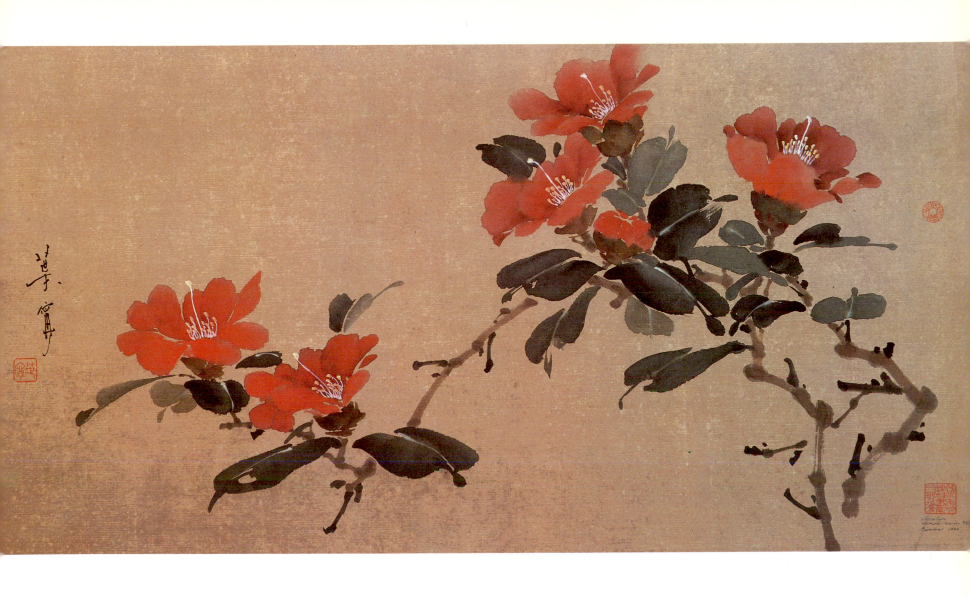

111

A Landmark Painting

Collection of Paul and Gwen Dent

18"x26"
Paper: Colored Shuen
Brushes: "Idea" or "Orchid Bamboo" (petal, calyx, stem, vein), "Flower & Bird" (leaf).
Colors: poster white (petal); Winsor violet (center shade); green mixed by blending yellow and indigo, indigo, ink (positive leaf); green with vermillion (negative leaf); ink (vein).

Natural Series 999

At the end of each month, I lay all the works down on my studio floor, select the best ones to mount, and tear up the rest. It works out that I keep about one out of five paintings.

When I was in Taiwan, our family used to gather all the discarded paintings of the year and burn them on New Year's Eve in front of our ancestors' plaque. This was done to show the ancestors that we had worked hard that past year, and we prayed that they would bless us with more inspiration in the coming year.

In each of the villages in China, there is a Pagoda of Learning by the roadside. All the papers that contain writing or painting are to be collected and burned there. Works done with brush and ink are sacred. If they are treated as trash and allowed to be trampled upon, the village folks will become illiterate.

There also is the consideration of quality control. People went through our trash, and even if we tore the paintings into pieces, the mounting technique was so good that the painting still could be put back together. We actually found discarded works which had been mended and offered for sale at the street corner.

I feel sorry for great artists like Hsu Pei-hong (徐悲鴻). Many of his works which were not representative of his best effort appeared in album collections. The artist is no longer here to defend himself.

I number all my approved paintings to keep a prospective record. My family tradition, the horse paintings, are numbered separately from the rest of my works. I call all my non-horse works "Natural Series."

Even with careful selection, though, painting every day does make the numbers become sizable. Both my horse painting and Natural Series are reaching one thousand as I approach forty years old.

Seal: Resourceful, Never
Ending Vitality and Energy

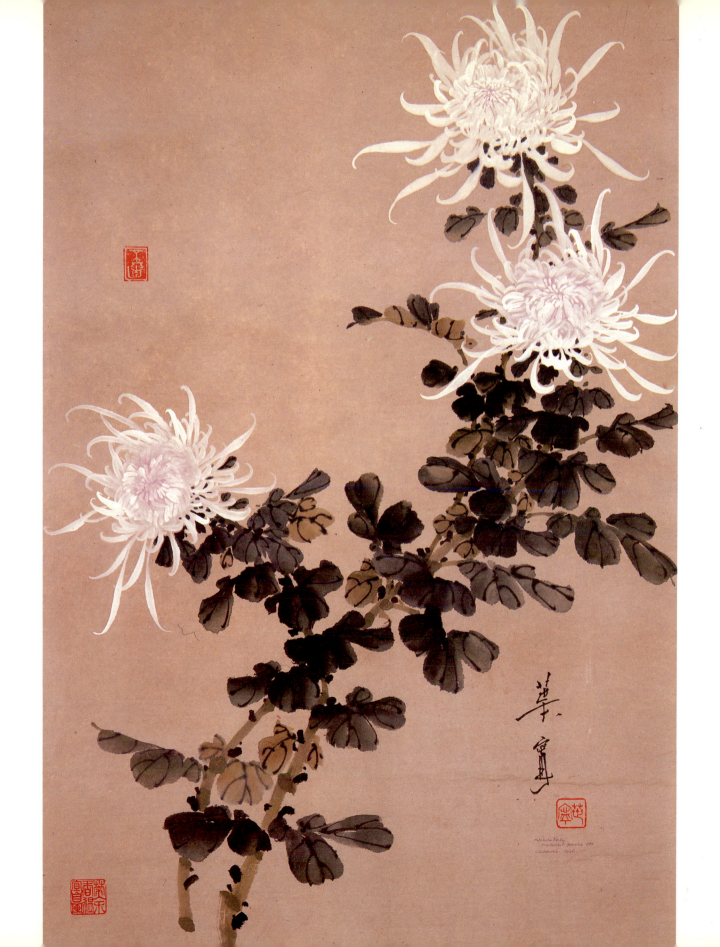

Small Yingchow

18"x27"
Paper: Jen Ho
Brushes: "Idea" (line, dot), "Big Idea" (color, texture), and "Wash" (mist).
Colors: vermillion, burnt sienna, French Ultramarine (structure); green mixed by blending yellow and indigo, ink (tree); poster white, yellow (flower); dark green, Winsor violet, vermillion, Prussian green with charcoal gray (mist, water).

Hangchow 杭州

"Above, there is Heavenly Paradise;
 Below, there are Suchow (蘇州) and Hangchow"

Hangchow is a cultural city with a history of more than two thousand years. More romantic tales have been set in its famed West Lake area than in any other place in China.

Among the ten best sceneries of the West Lake is the isle of Small Yingchow. Built in 1607, the isle reveals the subtlety of beauty which can only be appreciated once you are inside its gateway. Surrounded by willows and flowers, there is an "inner lake" with a smaller island at its middle. Small Yingchow is actually "a lake within a lake, an isle within an isle." The smaller isle can be reached by a zigzag bridge which has thirty turns. Only southern Chinese with their leisure mentality could think of a bridge like this. They would reason that people should see all the scenery that surrounds them, and people in a hurry would be stopped immediately at the first sight of the maze-like bridge. The bridge chooses only the ones who could appreciate her. Once on the bridge, terraces and pavilions with elegant calligraphy and poetry await the "chosen ones."

Seal: A Lovely Time with Beautiful Scenery

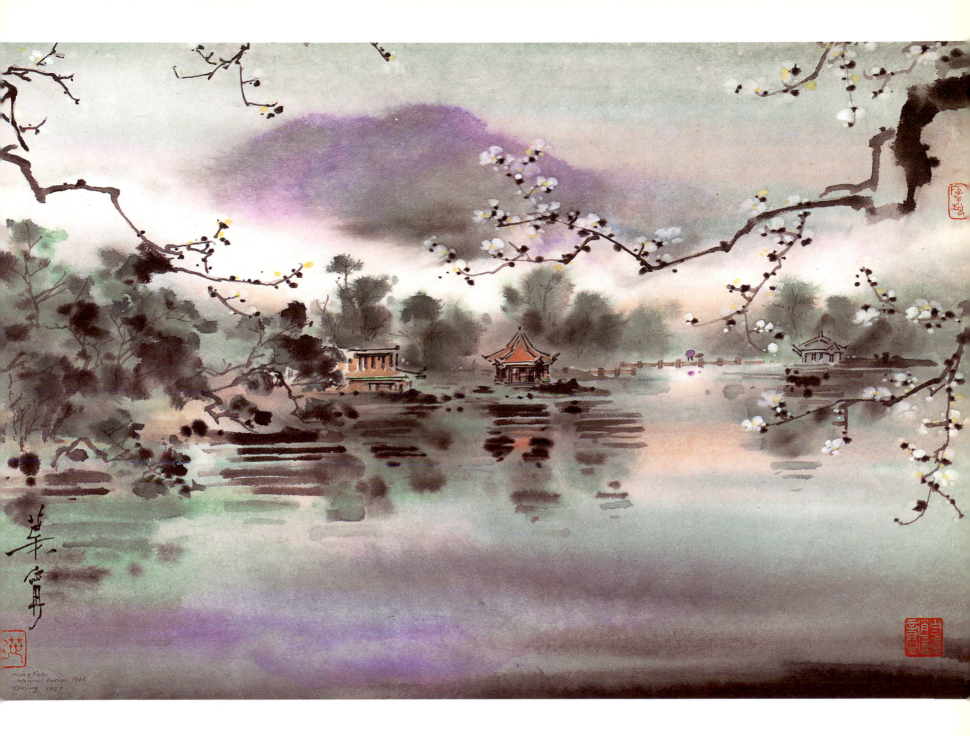

Ning Yeh
Nature Series 1065
Spring 1987

Midnight Queen (Night Blooming Cereus)

Collection of Bill and Para Horvath

17"x26"
Paper: Double Shuen
Brushes: "Flower & Bird" (inner petal), "Orchid Bamboo" (outside petal, trumpet), "Idea" (stamen, pistil, pollen), "Lan" (leaf, stalk).
Colors: poster white, permanent magenta, crimson lake, purple madder (flower), poster white (stamen, pistil), with yellow (pollen); green mixed by blending yellow and indigo, indigo, ink (leaf); green, crimson lake, purple madder (trumpet, bud).

Tan Hwa 曇花

In southern China exists a flower called "Beauty under the Moon." It only opens after midnight, and it withers before dawn. It has the most elegant jade white color, or the most subtle pink. When it opens, hundreds of silver, fine threads tremble at its center, and the whole room is instantaneously filled with fragrance. The flower seems to know how brief are the good times, for it lets out a gentle sigh when each of its petals opens, as if to call attention to the rare moment of beauty.

The Emperor of Sui (隋 581-618) was enchanted by the above description of the Night Blooming Cereus (Tan Hwa in Chinese), which is found in Hangchow in southern China. He dreamed of riding on a dragon boat with all his court ladies to visit the flower. But the rivers in China only run from east to west. The Emperor decided to mobilize the whole country to build him a canal from the northern capital south to Hangchow. This waterway was eventually named "the Grand Canal."

Before he could see its completion, folks got tired of the endless forced labor and overthrew his dynasty. He never did get to see the flower.

In Zen,
What is real is mere illusion;
In painting,
What is illusion is real.

Although Tan Hwa opened her eyes only for a few moments, She discovered the truth.

— — Anonymous

Seal: Grace

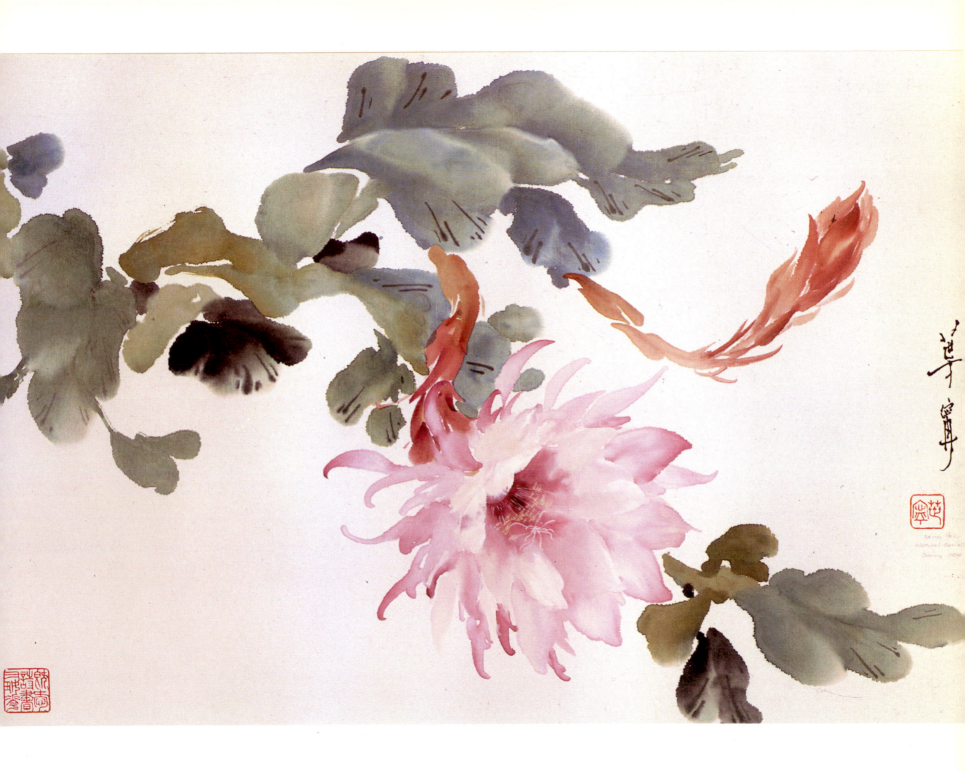

117

Stillness (Horse)

Collection of Luther and Alice Cushing

17"x26"
Paper: Double Shuan
Brushes: "Extra Large Long Flow" (horse), "Mountain Horse" (background).
Color: Brown Bottled Ink (finest)
For detailed, step-by-step instruction on the horse, see Lesson 16-17 in the Study Guide.

Standing Horse

Where is the other leg of the horse?

I know an artist who was once asked by a patron to add a leg which was not shown on the horse painting he had just aquired from the artist. Instead of one, the artist added two. "So, you want more legs?"

Most of our horse paintings show dynamic movement. The horses are constantly in motion, and few stand still.

The horse in a stationary post is harder to do. Anatomically, four legs standing will form a square. Only a square mind would want to have a square painting. It is also harder to reveal the spirit of vitality in a standing horse.

Happy Accidents

All my family members enjoy selecting horse painting as a subject for art demonstrations, but I have yet to produce a "masterpiece" through demonstration. I have a very hard time trying to discourage patrons who insist on acquiring the paintings that they have personally witnessed, but I have managed to keep all my demonstration works.

Once, the commanding general of the Seventh Fleet came to our studio in Taipei. My father decided to impress him with a horse painting that would be the size of a real horse. He ordered several army blankets to be placed on the studio floor, and big sheets of rice paper were laid on top. He took off his shoes, wore thick white cotton socks, and stood on the paper with a giant goat hair brush. He looked proud as a peacock, as he was thoroughly enjoying the lights and cameras that came with the international group of reporters. I held a tray with ink and water nearby.

As he loaded the brush with ink and attacked the paper by drawing the eye of the horse, the ink started to run. The horse's eye was rapidly turning blind (due to my inexperience in preparing that much ink, I did not grind the ink stick hard enough).

Without a second thought, he stpped on the horse eye with his foot, the white sock served as a blotter and picked up all the excess moisture. Calmly, he proceeded and completed the life-sized horse painting in a masterful way.

If you have heard military people talking about a general painting big horses with his socks, you know who that was.

There comes an occasion for every horse painter to have the desire to do a life-sized horse. In 1974, for the preview of the L.A. Fair, I did a life-sized horse painting demonstration at Claremont Graduate School. I did it by putting several long tables together. When I got to the tail part, I took the brush and ran with it. As I lifted the tail, a jet stream of ink spilled on the lady standing at the end of the table, then proceeded to climb the wall all the way up to the ceiling.

A real tall-tail story for ladies who want to see "splash ink" at work.

Seal: Playing with Ink

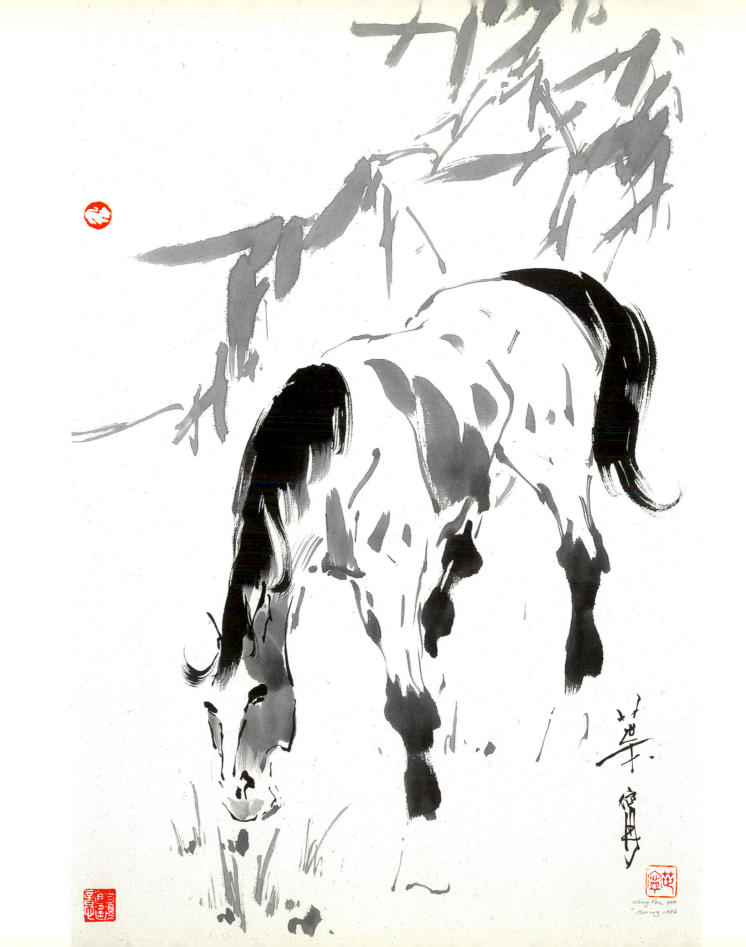

Ning Yeh 葉
Spring 1986

Buddha and Friends

Collection of Patricia Klenck

18"x36"
Paper: Jen Ho
Brushes: "Landscape" (line), "Big Idea" (texture, color), "Wash" (shade).
Colors: gold, ink, Prussian green with charcoal gray, Winsor violet, French ultramarine.

Longmen Status (Loyang)　洛陽龍門

The old soldiers in my father's army loved to tell ghost stories to my brother and me. Although we were scared stiff, we pretended we did not care in order to keep the image of the general's sons intact.

I ran across an old photo of the Longmen Buddhas and learned that among them, the heavenly guard specializes in chasing away evil spirits. I drew a picture of the quard and placed it under my pillow.

My brother, for some reason, constantly had nightmares when he was little.

The biggest grotto at Longmen (龍門) was built 1,300 years ago by Empress Wu. The statue of the seated Buddha is the biggest in China (Of course, if it was built by Empress Wu). Accompanying the Buddha are his disciple (his head was damaged, but I fixed it), Bodhisattva, the Divine General, and the Heavenly Guard. These are, in my opinion, the most expressive statues ever created among Chinese stone sculpture arts.

The Buddha, over 17 meters tall, is calm and wise. His disciple looks sincere and honest. The Bodhisattva has a benevolent attitude, with a hand gesture which seems to say, "Yes, I know you have sinned, but it is O.K." The Divine General, holding a pagoda, is "macho" and determined. The Heavenly Guard, with a devil trampled under his foot (I never put devils into my paintings), is bulging with muscles and fierce-looking.

The year this painting was made, several accidents had happened in my family before I decided to paint these statues. Buddhas, being what they are, would not mind that I borrow their presence. I have not made a habit of burning incense to greet the Buddhas routinely, but in time of crisis I do know how to cling to the Buddhas' feet.

Seal: Living at Ease with
Tranquil Mind

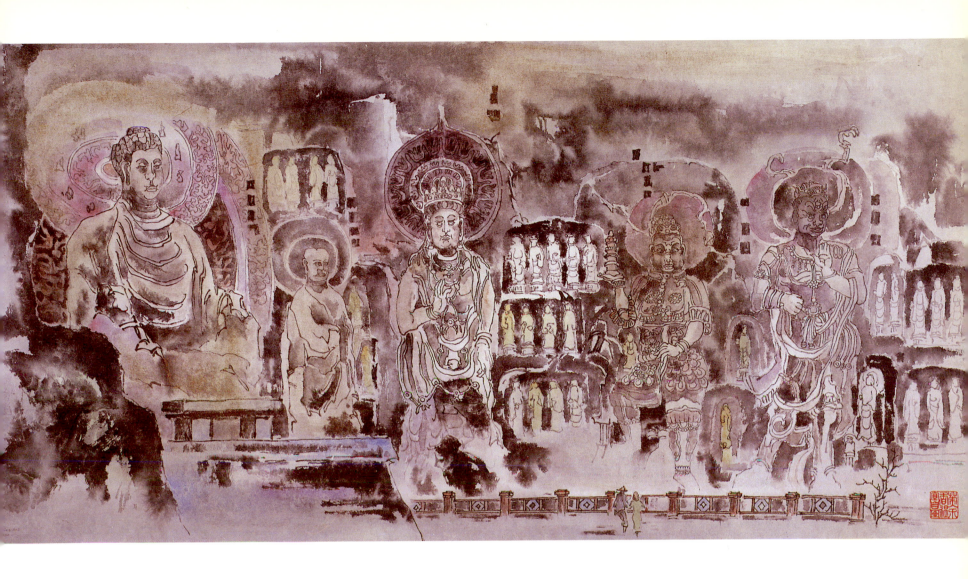

Happy Dots (Begonia)

Collection of Irene Kane

17''x26''
Paper: Double Shuen
Brushes: ''Big Idea'' (flower, stem), ''Idea'' (stamen, vein), ''Flower & Bird'' (leaf).
Colors: crimson lake (flower, stem, branch); poster white with yellow (stamen); green mixed by blending yellow and indigo (leaf), with crimson lake (back side leaf).

Chiu Hai Tang　秋海棠

The map of China resembles a leaf of the begonia, with the Shantung (山東 Shandong) peninsula as its stem and the ridges of the Chin mountains dividing the land into northern and southern China. The flower allows the cheerful happy dots to come out to play. The Chinese call the begonia ''Chiu Hai Tang.''

The ultimate story of a happy dot occurred in the Sung Dynasty. In old China, the only way for a young man to move out of the vicious cycle of poverty was to study hard and distinguish himself in the Imperial Examination. Not only did he have to be a good scholar, but also a good calligrapher, as the examiner would not tolerate poor writing.

One night when a young scholar was studying alone in an old temple, a flash flood came. In minutes, the old temple was reduced to only its roof above water. As the young scholar climbed up to the rooftop, he noticed a group of ants, trapped on a floating leaf and about to be rushed away by the flood. The ants looked anxious.

I have yet to see an ant that looks calm.

The young scholar picked up the leaf and took it with him to the rooftop.

That year, the young scholar entered the Imperial Examination. His essay was excellent; his writing style was elegant. He should have been the first in the group, but unfortunately, he misspelled one word. One dot was missing. According to the rules, no matter how good he was, he would not be given a grade.

The Chief Examiner felt very uneasy after he rejected the young scholar's essay. He could not sleep that night, and the next day, he decided to take a second look at the young man's paper. When he carefully went through the essay this time, he could not find any mistakes. Amazed, he took a close look at the misspelled word. He found an ant sitting very still at the place where the missing dot should be. He tried several times to brush the ant away, but the little creature would always crawl back to that same spot.

''It is meant to be,'' The Chief Examiner exclaimed. He gave the young scholar first place. The young man later became one of the most prominent officials and a literary giant in the Sung Dynasty.

A happy dot can change one's life.

And, of course, another moral is to be kind to little creatures. I have seen a very fragile-looking lady become violent over a little bug on her lettuce in a restaurant. For heaven sakes, share the lettuce; the little bug will not eat much!

Seal: Happy Dot, Clever Idea

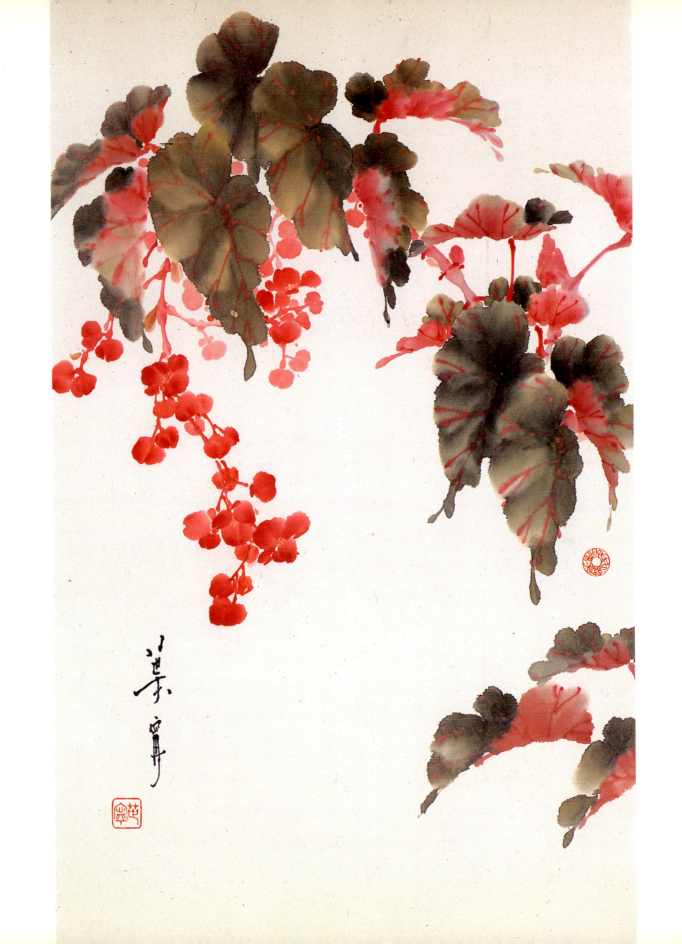

61 凌波仙子

Water Fairies (Narcissus)

Collection of Else Kemper

18''x27''
Paper: Double Shuen
Brushes: "Big Idea" (flower); "Large Flow" (leaf).
Colors: yellow, vermillion (outside petal); burnt sienna, brown madder (center); poster white with yellow (center dot); burnt sienna (sheath); green mixed by blending yellow and indigo, indigo (stem, leaf).

Shui Hsien 水仙

The display of narcissus is an integral part of the Chinese New Year celebration. Shui Hsien, the Chinese name for narcissus, means "Water Fairy." Many people feel that the flower represents the spirit of Lady Cheng Fei (甄妃).

Cheng Fei was a famous beauty noted for her literary talent during the fading era of the Han Dynasty (漢 206 B.C. to A.D. 220). She was married to the son of Lord Yuan (袁紹). When the treacherous prime minister, Tsao-tsao (曹操), conquered Lord Yuan, Cheng Fei was forced to marry Tsao-tsao's first son, Pai (曹丕).

Tsao-tsao had a younger son named Tze-chien (子建) who was extremely popular, noted for his elegant appearance and unmatched poetic talent.

For a time Pai was engrossed with a desire to overthrow the Han Dynasty. When Tsao-tsao died, Pai made himself the Emperor of Wei (魏 A.D. 220-265). When the dust settled, he discovered a romance had developed between his wife and his younger brother. In the heat of anger, Pai demanded that Lady Cheng Fei end her own life by taking poison. Pai had always been jealous of the talent and charm of Tze-chien, and his death sentence to his brother had an unusual twist. He claimed if his brother could com-

pose a poem instantly during seven paced steps, he would set him free. He figured that no one, not even someone as talented as his brother, could fulfill such a demand. He then would be able to publicly embarrass his brother about his much acclaimed talent. But Tze-chien responded immediately, and sang a verse with this meaning:

> When the beans are boiled
> By the flames of the burning bean stalk
> The beans are crying in the boiling pot:
> "You and I come from the same roots,
> How can you burn with your flame
> The flesh of our mutual sire?"

Moved by his brother's poem, Pai commuted the death sentence to exile. As a souvenir, he gave Tze-chien a pillow which had belonged to Lady Cheng. As he travelled by boat along the Lo River, Tze-chien slept on the pillow. In his dreams, Lady Cheng came to him in an intimate and joyous reunion. He recorded the impressions of his dream in a poem which later became very popular.

After Pai died and his son became emperor, the son felt embarrassed by the poem which told of the intimate details of a reunion between his uncle and his mother, Chang Fei. He ordered the name of the poem changed from "A Song of Cheng Fei" to "A Song of the Water Fairy." This way, his uncle was simply rendering his impressions of a fairy goddess in the Lo River.

In China, many bulbs of the narcissus are carved so the plant can grow into a pre-conditioned shape. I think of many famed beauties like Lady Cheng, whose fates were not of their own making. What could be more appropriate than to compare them with the fragile beauty of the narcissus?

Seal: Delicate

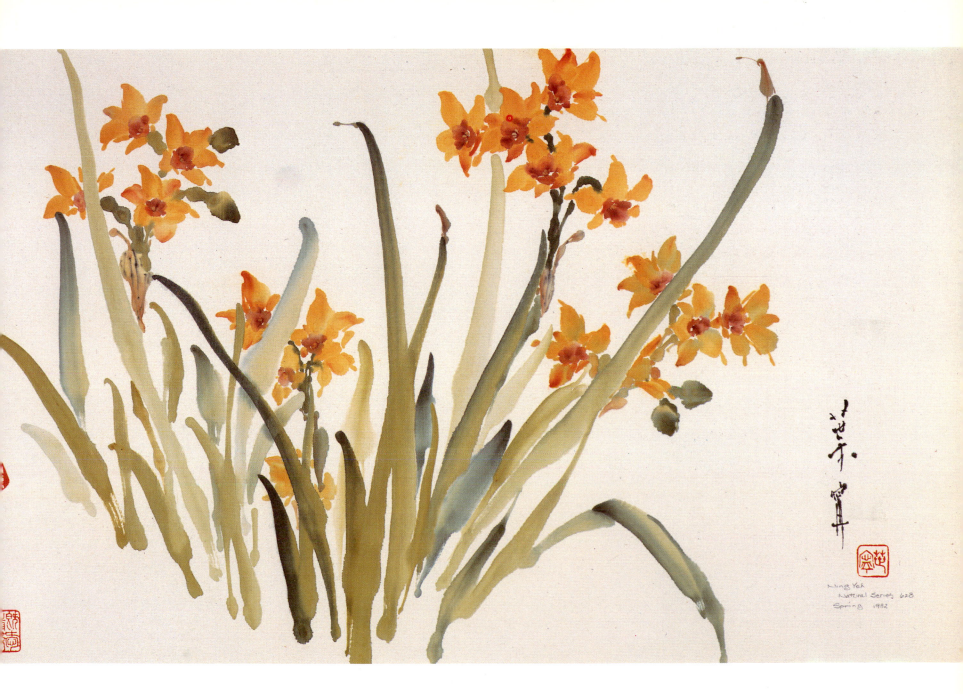

Ning Yeh
Natural Series 628
Spring 1982

A Script

Collection of George and Mary Connelly

16"x24"
Paper: Double Ma
Brushes: "Idea" (line), "Big Idea" (color, dot, shade), "Wash" (background).
Colors: vermillion (face, body); red, French ultramarine (cloth); burnt sienna (hat); poster white, permanent magenta (flower); vermillion, Winsor violet, Prussian green with charcoal grey, Winsor emerald (background).

Seal: A Script:
 The Age of Innocence

The Age of Innocence

> Do you recall the time
> When we were very young?
> I loved to talk, and you loved to laugh.
>
> One day we sat
> Shoulder to shoulder,
> Underneath a peach tree.
>
> A breeze passed through the tip of the branch,
> While birds sang.
>
> Not knowing why,
> We both fell asleep.
>
> While dreaming,
> We lost count of the falling flowers.

— lyrics of Hung Tze's tune

I used to sing this song whenever I was having a particularly happy time. A few years ago, while travelling with my students in Taiwan, I found a tape of the instrumental version of all of Hung Tze's major pieces. For the longest time, I played the tape while painting. I sang out loud and cried like a child. Some of my best works came out during these times.

I have never stepped out of the college environment. Compared to many of my childhood friends who are now very successful businessmen, I live a simple life. I consider this prolonged age of innocence a blessing.

126

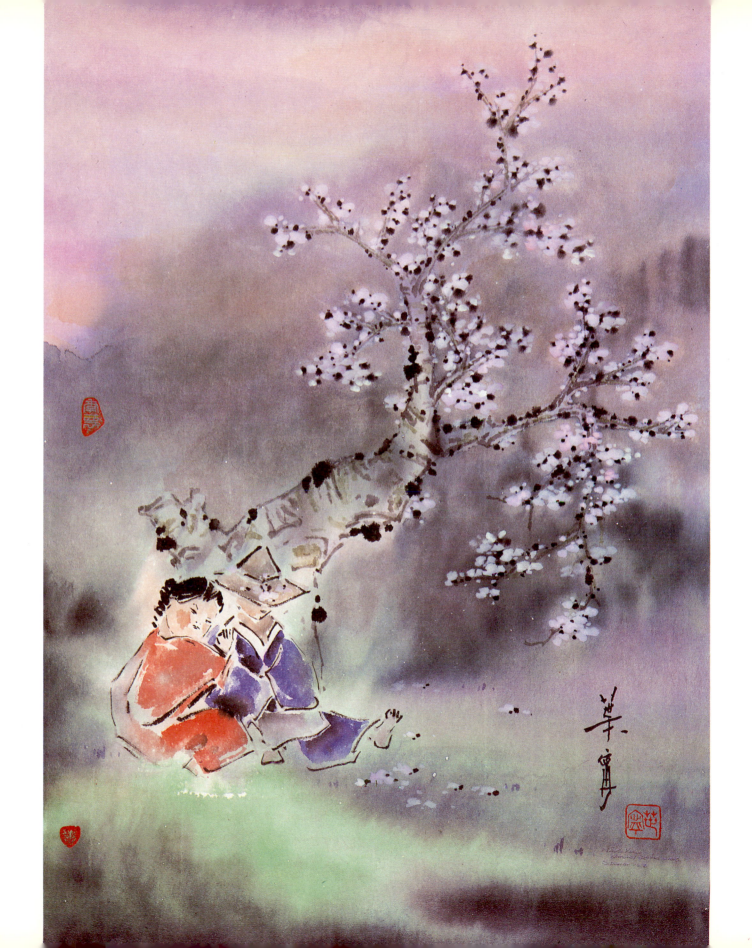

A Taoist Retreat

Collection of Don and Lynn Ackelson

22"x36"
Paper: Jen Ho
Brushes: "Mountain Horse" (texture), "Landscape" (line, structure, tree), "Big Idea" (color, shade), "Wash" (mist, sky).
Colors: vermillion, purple madder (structure); burnt sienna, Prussian green with charcoal gray, manganese blue, Winsor violet (mountain, sky, mist)

Mountains Afloat　山在虛無飄渺間

Fragrant mist gathering and vermillion
colored clouds surrounding,
There exists a cave named "Pure Aloof" on the fairy
island beyond the sea,

Where splendid flowers and jade trees,
soaking in the morning dew,
Shine in their everlasting glory.

Yet, how laughable,
Countless devotees of desires trapped under
the red dust of the city,
Separating, uniting, with sadness and joy.

Engrossed in their endless dreams.

No one can see,
Like flowers in the mirror,
Or the moon on the water,
Everything shall end in a void.

Hung Tze passed away at the age of thirty-four. This song was among the tunes in his unfinished last play. How I wish he could have lived to a ripe old age.

I am not a Taoist. But I do find Taoism very soothing to my soul. When things are not turning out to my expectation after I have exhausted my best effort, it is comforting to see the world in the Taoist view.

Jiang Tze Ya (姜子牙) practiced the Taoist retreat in the snow-capped mountains above the Wei River (渭水). For more than sixty years, he fished without a hook or bait and held his fishing line three inches above the water. The idea was that unless the fish really wanted to be caught, he would stay as a starving fisherman. Finally, when he was eighty years old, the fish came. The Emperor of Chou invited him to be the "Grand Duke."

Eighty years is a long time to wait; some young Chinese fishermen decide to come to the United States nowadays.

Seal: Mountain Afloat

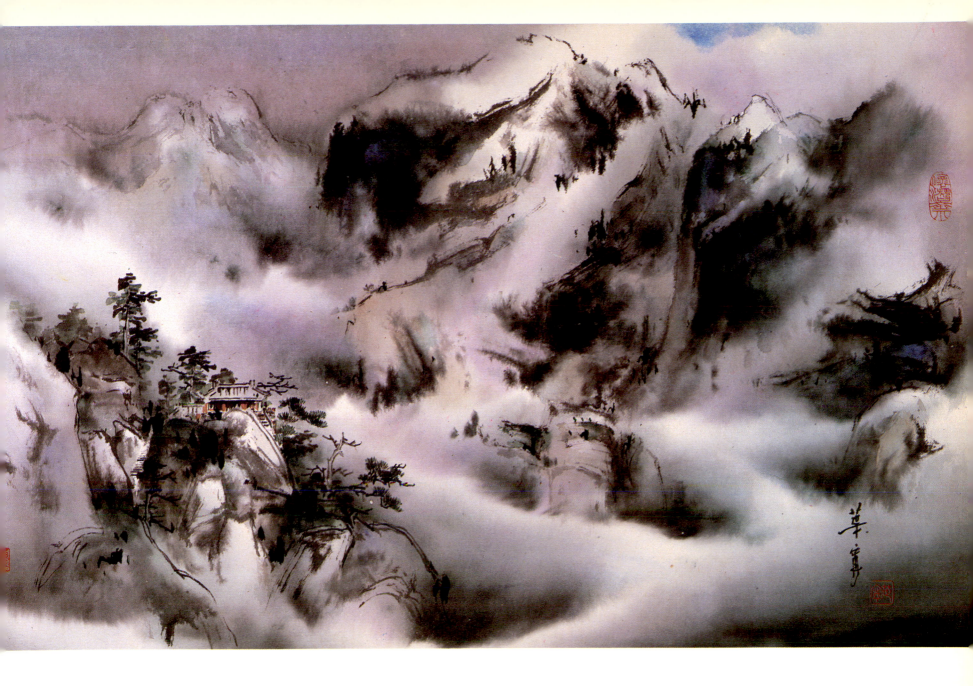

The Eight Immortals

Collection of Mickey Jackson and Al Mortenson

27"x54"
Paper: Double Shuen
Brush: "Large Flow"
Color: ink
For detailed, step-by-step instruction on the horse, see Lesson 16-17 in the Study Guide.

The Spiritual Essence

During the Spring-Autumn Period (春秋 770-221 B.C.), Muh, the Duke of Chin (穆王), was the most celebrated collector of well-bred horses. Among them, there were eight magnificent creatures, each with remarkable personalities.

The Duke had a horse trainer named Pai-le (伯樂) who was known as the all-time horse lover in Chinese history. When Pai-le was growing old, he recommended a young man named Chiu Feng Kao (九方皋) to replace him. The Duke trusted his new horse trainer to look for a good horse. Three months later, Chiu found one and reported back to the Duke. "What color is it?" the Duke asked. "Yellow," Chiu replied. "Is it a male or a female?" "Female." When the horse was brought in, it was a black male. The Duke was outraged and asked for Pai-le. "This is terrible! The man you recommended could not even tell the color and sex of a horse! What good is he?" After the Duke had let off his steam, Pai-le sighed and then replied:

"This is exactly why that although there may be thousands of horse trainers, few would have Chiu's quality. What Chiu sees are the intangibles. He looks for the essence and forsakes the details. He captures the spirit and forgets the form. He sees what he needs to see and leaves out the rest. What he really gets is what is the true value of the horse."

When the Duke tried the horse, it was indeed the best.

Seal: Sky Shore: Spirit
Reaching the Shore of Sky; Sky Has no Shore, Hence the Spirit Is Free

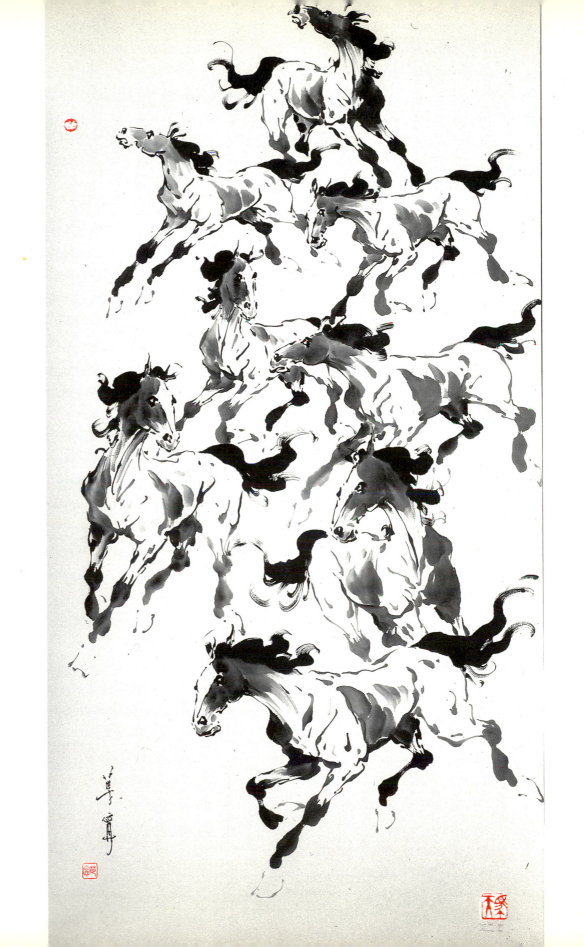

Wishing Stars (Morning Glory)

18"x26"
Paper: Double Shuen
Brushes: "Big Idea" (flower), "Big Orchid Bamboo" (leaf, vine), "Idea" (vein, calyx).
Colors: French ultramarine, Winsor violet (flower); green mixed by blending yellow with indigo, indigo, ink (leaf, vine, vein).

Chien Niu 牽牛

Chien Niu was the name of a boy star who was entrusted by God to take care of water buffalo in the heavenly kingdom. A girl star named Chih Neu (織女) was put in charge of the seamstress duties. They fell in love, and the romance caused them to neglect their duties. The God, in anger, forced the young lovers to be separated on both sides of the Silver River and allowed them to meet only once during the whole year. On the night of the seventh day of the seventh moon, thousands of magpies were sent to form a bridge to allow the boy to visit his lovely seamtress. By dawn, he had to return and start another long wait for the next year. The star-shaped morning glory, which opens in the morning and withers quickly before dusk, is Chien Niu's eager account of each day of the year.

The seventh day of the seventh moon is the night for lovers in China. One can see the bright Milky Way forming the link between two bright stars, bringing another memorable night for Chien Niu and Chih Neu.

Seal: Fulfillment of an
 Everlasting Wish

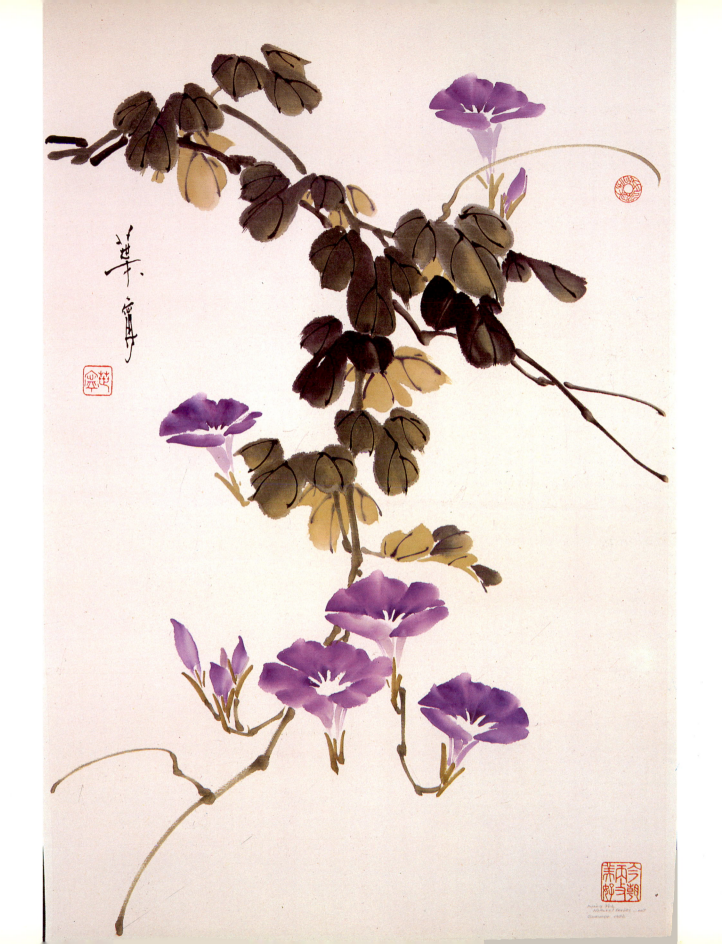

Source of Inspiration

Collection of Robert and Shirley Levy

22"x35"
Paper: Jen Ho
Brushes: "Landscape" (line), "Big Idea" (texture, color), "Wash" (mist).
Colors: vermillion with white, red, burnt sienna (structure); vermillion, burnt sienna, Winsor violet, Winsor emerald (light mountain); Prussian green with charcoal grey (dark mountain, mist), Winsor violet, manganese blue (sky).
For detailed, step-by-step instruction on landscape, see Lesson 18 in the Study Guide.

Huang Shan 黃山

To find the source of inspiration of Chinese landscape painters, one must visit Huang Shan — the Yellow Mountain. As an artist, I consider Mt. Huang Shan as my personal favorite mountain in China. One may like the Stones or the Mamas and Papas, but when it comes to the nitty gritty, is there any doubt that the Beatles should have been Number One?

The spectacular rocky peaks of Huang Shan, the poised pine forests, waterfalls and springs, together with the everchanging mists in the air, offer a complete scenery in the mind of a Chinese artist. In the map of Huang Shan the names of various "seas" are found. Yet the Yellow Mountain has no oceans nearby; these names refer to the "Sea of Clouds" which frequents the mountain. When the cloud gathers, all the mountain peaks become fairy islands above an ocean of white.

Huang Shan was named after the first emperor of China — Huang Ti (黃帝 the Yellow Emperor, about 2700 B.C.). Legend claims that he had collected herbs in this mountain.

Seal: A Thousand Miles of Scenery in a Day's Journey

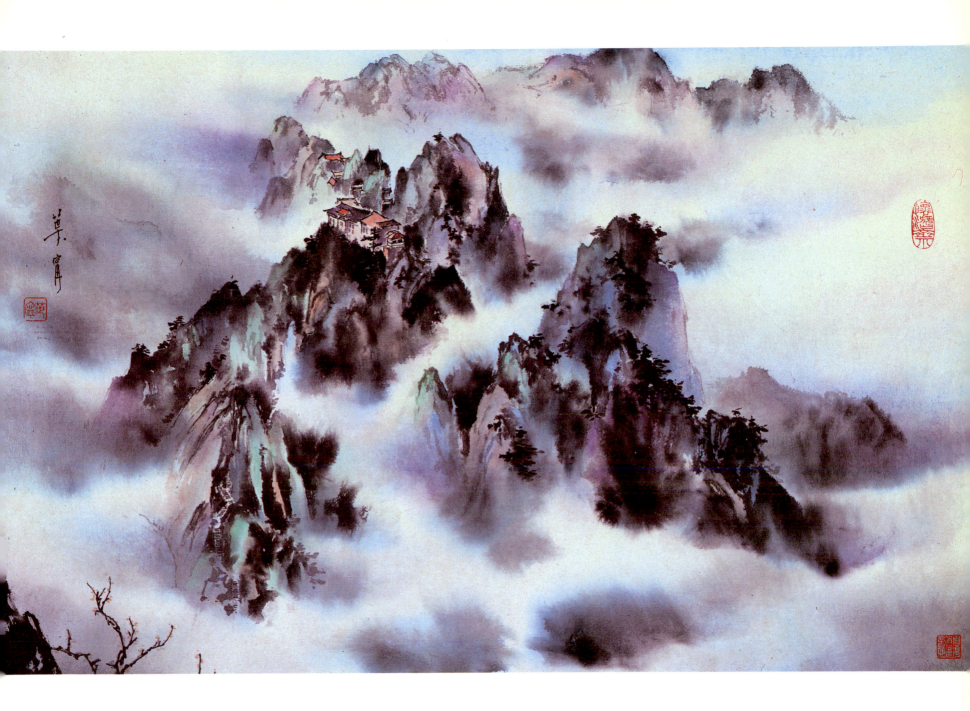

135

Cluster of Joy (Wisteria)

Collection of Rose Voss,
Ooyce O'Donner interior design

22"x35"
Paper: Double Shuen
Brushes: "Big Idea" (bud, calyx and yellow dot), "Large Orchid Bamboo" (leaf, open petal, branch), "Idea" (stem).
Colors: French ultramarine, Winsor violet, neutral tint (bud); poster white, permanent magenta (open petal); green mixed by blending yellow and indigo (stem); add ink (calyx dot); white and yellow (yellow dot); green, indigo, ink (leaf); green, vermillion (young leaf); burnt sienna, ink (branch).

Tzu Teng 紫藤

The wisteria is called "Tzu Teng," or "Purple Vine," in China. In one cluster, the petals shade harmoniously from the strong, dark purple tip to the soft, light pink at the opened base.

When a plant in my yard starts budding, I cannot help wondering: Which bud will become a leaf? Which will become a flower? Which would not make it? . . . Does the plant have a master plan for its own growth? Of course not. A plant has no brain; it has to do what my son Evan dreads the most--vegetating all day. Yet a few days later, the flowers bloom; the leaves extend; even the buds which did not make it are so meaningful on the branch. Real beuaty in nature lies in its spontaneity.

Among all the plants, vines are the most vivid examples of nature's playful spontaneity. When they decide to grow, they grow without knowing where to grow to. They never miss a opportunity to engage themselves in a playful act with whomever they meet. If no one is within reach, they play with themselves. Even if there should be only one vine, it still crawls in style. It refuses to act the same way each day. The vine writes its diary on its body. "Yesterday, the wind was strong; today, I met a friend." The movement of the vine dutifully records the memory of its adventures. Even as the vine grows old, it still remembers: Once upon a time, it had a friend. The friend might have gone, but the vine still embraces.

Among the vines, I am partial to the wisteria. The flower series reminds me of a special kind of fireworks. Once it bursts into the air, it radiates like a fountain which consists of hundreds of little stars. Teeter-tottering in the spring breeze and nodding in agreement with one another, wherever they may be, the wisteria seem so contented and cheerful as if saying, "We do not know or care where we are; we just like to show the happiness of our growth."

My students do not like to miss my class. They never know what they might miss and they are constantly curious to find out what I am about to offer to them. I teach the subjects which I am intensely interested in learning myself at the time. Wandering aimlessly, I reach a subject I like. Then I start to go in circles around that subject and create "a fine mess." I record my findings and share with my students. All of a sudden, hundreds of little stars appear.

Seal: Heart-felt Sharing of
Inspiration Transcends beyond
Time and Space

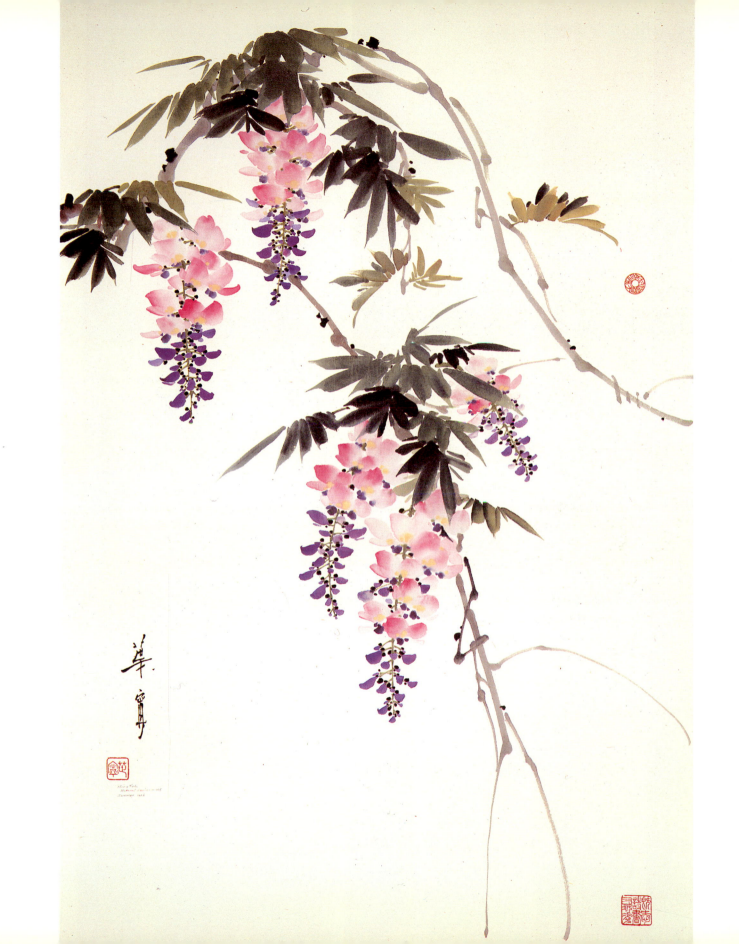

Impressions

Private Collection

18"x26"
Paper: Ma
Brushes: "Big Idea" and "Mountain Horse."
Colors: ink, Prussian green with charcoal gray, Winsor violet, vermillion, and burnt sienna.

The Pursuit of the Intangible Spirituality

It is hard to find a how-to book on Chinese brush painting. Chinese brush painting was never meant to be an exact science. When the concern has to do with the essence of the universe, it is better left unsaid.

During the "Spring-Autumn" period (春秋 770-476 B.C.), a school was led by a master who never ventured an answer to his disciples' questions. When a tentative answer was offered by a student, his holiness would invariably claim, "Not quite." Yet what exactly was right was never suggested. Another famous line of an old master was "What looks not but feels is, IS." Such teachings really do little to help the anxiety-stricken student who really needs a nitty-gritty answer. But they do set the tone for what is really important, or not important, in the quest for a good painting. I treasure sayings like this as a last resort to students who are in hot pursuit to "get to the bottom of this" (a common concern in the West).

A nitty-gritty answer for this painting:

It has come to my attention that more often than not, after a whole day of struggle, the best painting I did was the collage of blobs on the paper towel which was used to wipe moisture off the brushes. God was trying to tell me something (I still did not quite get it, I am still trying to paint). Furthermore, the best painting was not the paper towel on the surface; rather, it was the one hiding below the surface, the one which was totally untouched by my strokes and therefore remained undamaged. The humiliation was so complete that I even felt embarassed to put my signature on it, since I did not do a thing to produce the painting.

In order to have a sense of participation, I now collect scrap rice paper. Before I quit working for the day, I put two or three papers in a pile and use whatever colors are left on my dishes to fool around. It is like while waiting for the ride home, one throws in the last quarter in the casino, hoping to hit the jackpot. On this occasion, it worked.

Seal: The Realm of Creation

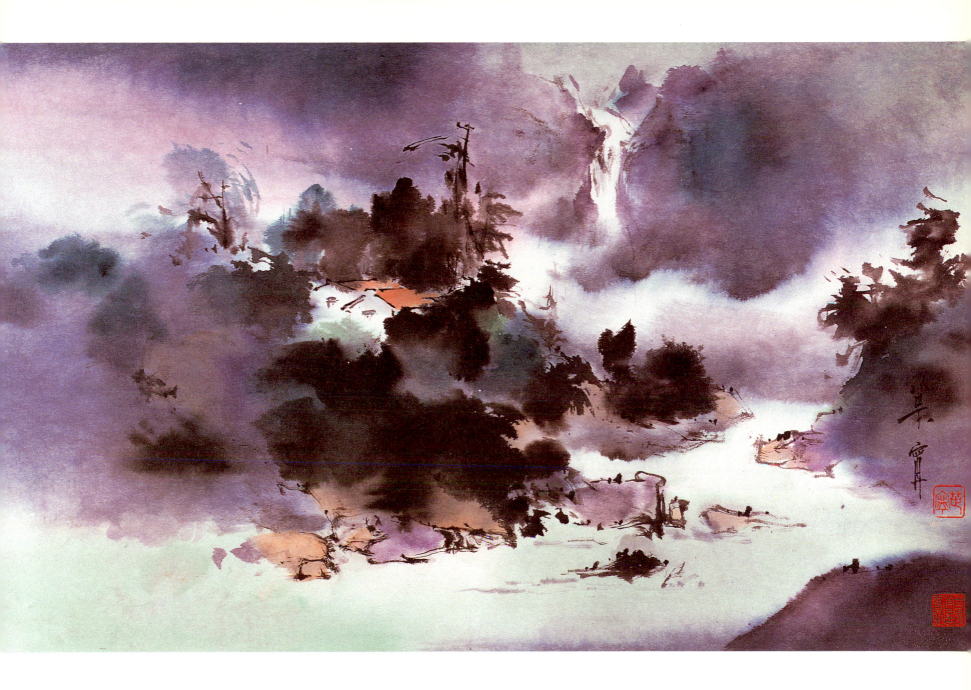

69 金果

Golden Fruits (Persimmon)

18"x26"
Paper: Double Shuen
Brushes: "Big Idea" (calyx, stem), "Large Flow" (fruit, leaf), "Orchid Bamboo" (branch).
Colors: green mixed by blending yellow and indigo, indigo, ink (leaf); green with ink (calyx); vermillion and red (fruit); burnt sienna with ink and green (branch).

Shih Tzu　柿子

If you visit the Ming Tombs (明帝陵) near Beijing (北京) in early autumn, right about the time of the first frost, you will see a whole mountain of red and gold. A forest of persimmon trees, with their leaves turning red, bear clusters of golden fruit on every branch.

The persimmon is the fruit served at the Mid-autumn Festival, on the fifteenth day of the eighth moon. When the moon is at its fullest, every family member comes home to the round dinner table to enjoy being together.

In China, the saying, "Everything goes smoothly," is pronounced as "Shih shih ping an." (事事平安) The first two characters sound the same as those used for the persimmon. The fruit has come to symbolize the happiness and tranquility of home.

The Chinese word for profit is pronounced "Li-shih" (利市). The persimmon, therefore, is also considered a fine omen for success in business.

The persimmon tree enjoys longevity in its fruit-bearing. Most trees can bear for up to 200 years. In the town of Ho Tse (荷澤), a 500-year old persimmon tree still produces ample fruit. Because the persimmon usually tastes bitter and tough while on the branch, the birds and bugs tend not to choose persimmon trees as their homes.

The heavy weight of the fruit requires a sturdy trunk and branch; the persimmon tree is an excellent material for fine furniture.

The persimmon tree has ample foliage; the leaves are huge. In the summer, the tree provides ideal shade. When frost visits the red leaves in autumn, each leaf becomes a masterpiece of impressionistic painting. Chinese people like to collect the fallen leaves and use them to practice calligraphy and painting.

The persimmon fruit is served either fresh or preserved. The taste for the fruit is an acquired one. At first bite, the persimmon seems bitter; after a while, it turns sweet in one's mouth, much like taking advice. The fruit of the persimmon is also used to make wine, vinegar, sugar, paint, as well as in herbal medicine. From top to bottom, the persimmon tree is indeed a treasure.

I paint most subjects in nature with a very loose interpretation. Even with earnest research, sometimes I cannot avoid causing a few "scientists" to raise their eyebrows. "I have never seen a peony of this color before, and I know my peony," I overheard one lady murmur at my show. (My students claim that I hear everything. My wife holds the opposite opinion.) The nearly square-shaped persimmon is very rarely found in the United States. "What is that?" "It is a persimmon." "Oh . . ."

Persimmon is one of my favorite painting subjects.

Lingchi and I have been married for seventeen years. I used to compare her to a number of flowers. Lately, I have been contemplating the persimmon fruit. I dare not tell her. Somehow, she seems to know already.

Seal: Longevity

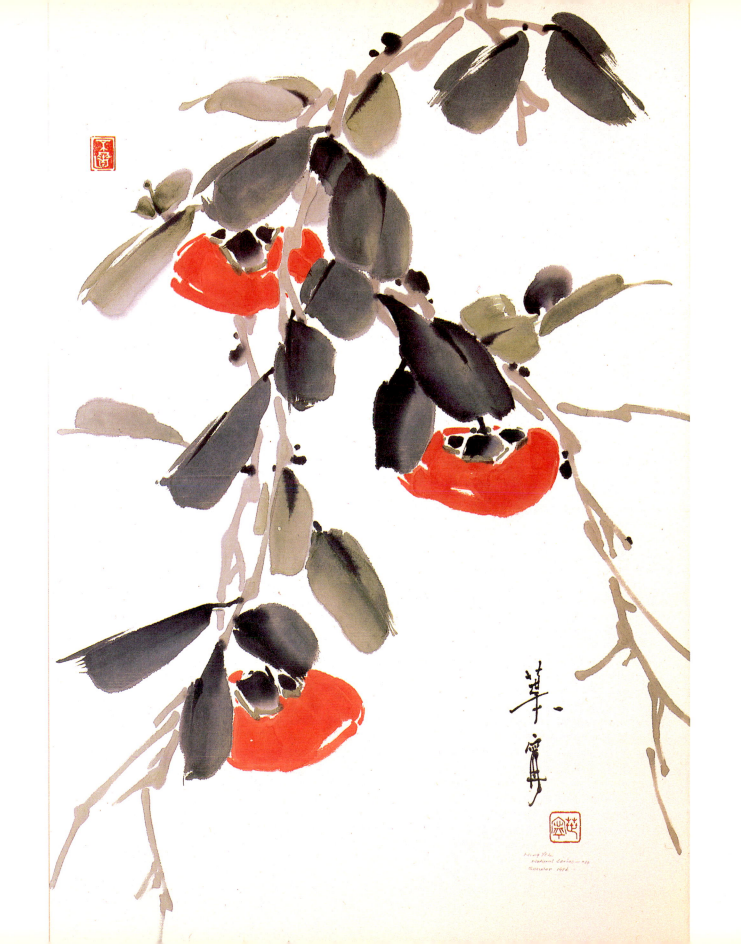

Calligraphic Expression (Ink Bamboo)

23"x36"
Paper: Double Shuen
Brushes: "Large Soft" (trunk), "Idea" (ring, branch),
"Orchid Bamboo" and/or "Big Idea" (leaf).
Color: ink
For detailed, step-by-step instruction on the bamboo, see
Lesson 4-6 in the Study Guide.

The Importance of the Strokes and Ink

Chinese brush painting is an extension of Chinese Calligraphy. Many artists use the word "writing," instead of "painting," to describe their efforts. The brush works, in the form of strokes, shapes, and dots, are considered to have their own vitality and spirit. The brush strokes are not considered merely as tools to define the shapes; they are the "bones" of the painting. The execution of these strokes has always been one of the main concerns in the mind of Chinese artists. How to hold the brush? Whether to use the fingers, wrist, or arm to do the stroke? Is the brush vertical or oblique? Where is the tip travelling during the course of the stroke? How wet? How much pressure? How fast? Which direction? These, and many other questions, are all part of the serious considerations in brush painting.

While the brush strokes are the framework, the ink is the substance for Chinese brush painting. Ink, in the mind of Chinese artists, is never a color. Ink is all of the colors. The range developed through the mixing of water and ink can be so broad that it encompasses all the needs of the artist. For an art that emphasizes the harmony between extreme opposites, no color comes as close as ink to contrast against the space. For a culture that values subtlety, nothing can be less colorful than ink and yet have the ability to suggest the most. Even today, the majority of Chinese artists still detest the excessive use of color and consider their black and white studies as their ultimate achievements.

Seal: The Spirit of Stroke,
The Taste of Ink

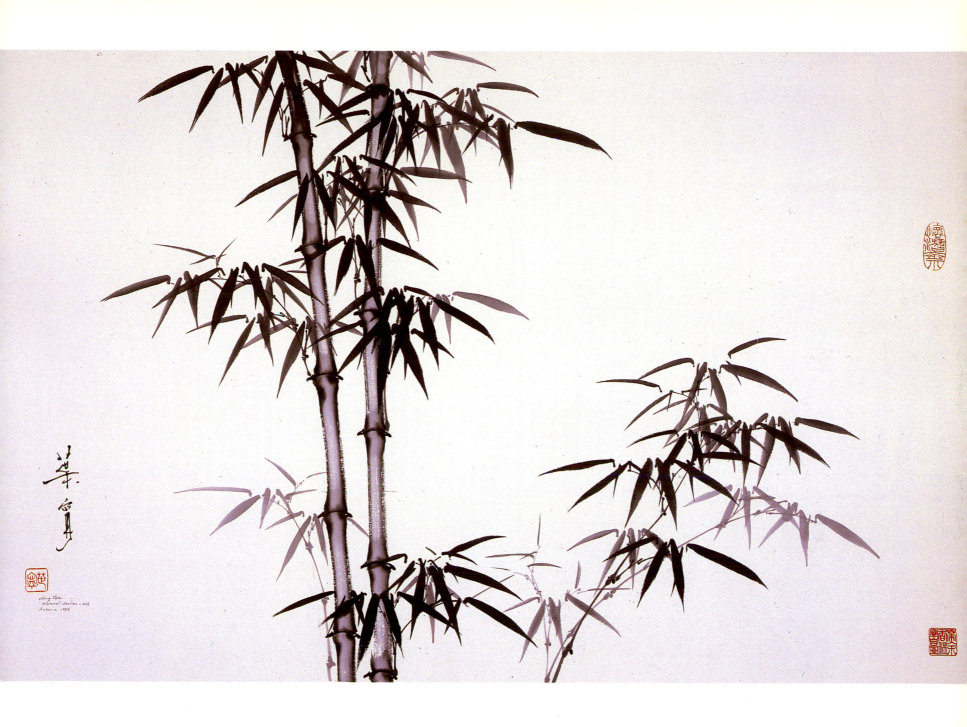

Ning Yeh
Natural Series - 016
Autumn 1986

143

For Jashin, with Love, from Dad

Collection of Jashin Yeh

15"x19"
Paper: Double Ma
Brushes: "Idea" (detail), "Big Idea" (shade), "Lan" (hair).
Color: ink

Portrait of Daughters

I met Shu Jiading (舒家鼎) earlier this Summer. He is an artist trained in China who now lives in Japan. Although I did not know him, I liked him immediately when I saw him. He carried a photo album filled with faded photographs of his native town and his relatives. I admire a person who places such high value on his past and who is so willing to share with perfect strangers.

We were at a dinner party hosted by a friend when he gave me one of his painting albums. I did not have a chance to look through the album; I only noticed that he had signed it and given me a very complimentary title. When I went home and studied his album, I came to realize how talented an artist I had just met. I was especially impressed with his study of his daughter. I felt the urge to paint a painting of my Jashin. I could not quite do justice to my daughter like he did to his. But, Jashin, being such a sweetheart, still liked her daddy's attempt. I think Shu would understand imitation is the highest form of flattery.

Seventeen years ago, I did a portrait of Jashin's mother; now it is my girl's turn.

Jashin is ten years old. She wants to be a teacher for little children. I really cannot ask for a better little girl in my life. "How about Evan, why doesn't he get a portrait?" Being a ham like his daddy, Evan has been a model for well-known lady artists both in the United States and in China. They have captured his spirit so well that I do not think that I can do any better. Evan is sixteen; he wants to be somebody who is really big, but he has not decided the exact nature of this big person. I am blessed with two wonderful kids.

It is a father's right to be partial to his little girl.

Seal: Love

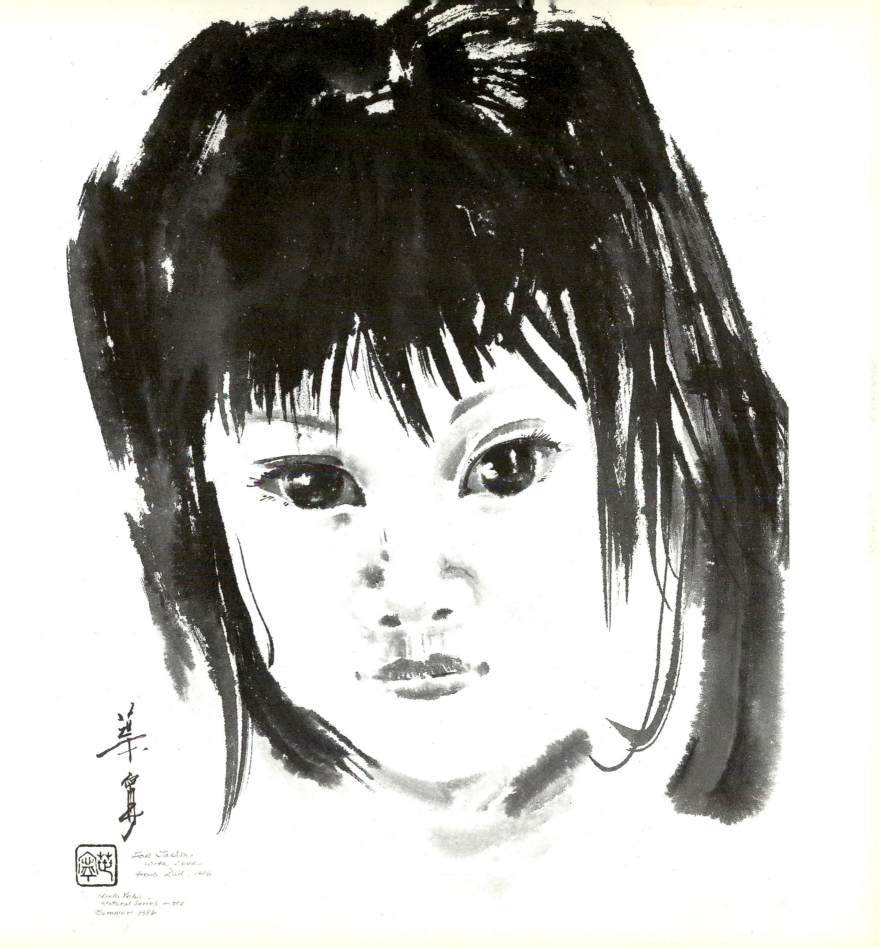

For Jochim
with love
from Dad, 1986

Ning Yeh
Natural Series - 002
Summer 1986

New-born Bamboo

Collection of Mervin and Eleanor Cooper

18"x26"
Paper: Double Shuen
Brush: "Orchid Bamboo"
Colors: "vermillion ink," burnt sienna with ink.
For detailed, step-by-step instruction on the bamboo, see Lesson 4-6 in the Study Guide.

The "Four Gentlemen" Led the Way

I observed with bewilderment when a group of my students, upon the completion of their first semester, decided to make buttons to raise funds for their local brush painting chapter of our society. The button reads: "Chinese Brush Painters Do It with the Four Gentlemen." After praying to my forefathers for forgiveness, I decided that the message, whatever it means, becomes servicable.

How unusual to find a culture which indoctrinates its artists to begin their painting exercises with four simple plants: orchid, bamboo, plum, and chrysanthemum. Why? Searching the historical documents, I failed to find concrete reasons. Maybe the answer was too obvious for the Chinese. They would simply say: "Why? Why NOT?" The four subjects are so familiar, so comfortable, that the Chinese artists intuitively feel them to be a part of themselves. Since bamboo is so common, there is no need to paint a bamboo that looks like a bamboo. Artists are left with ample freedom to express themselves.

From the name "the Four Gentlemen," one can see that these subjects are no longer plants; they are animated human spirits full of admirable virtues. It is true that the "Four Gentlemen" exercise provides artists with the basic training of all the technical elements, but more importantly, it sets forth a noble purpose for aspiring artists.

Red Bamboo 朱竹

Red bamboo is the creation of poet Su Tung-pao (蘇東坡). While watching students taking an examination, Su felt bored and decided to practice bamboo with the red ink which the Chinese teachers used to correct papers. His creation caused some concern from other bamboo painters. "There is no red bamboo in the world," one painter told him. "There is no black bamboo either," Su replied.

The new-born bamboo is flamboyant and cheerful. The leaves grow every which way they please. They do not know how tough life is. The mature bamboo, which has experienced the rain and wind, has its leaves drooping down.

Seal: Noble Elegance

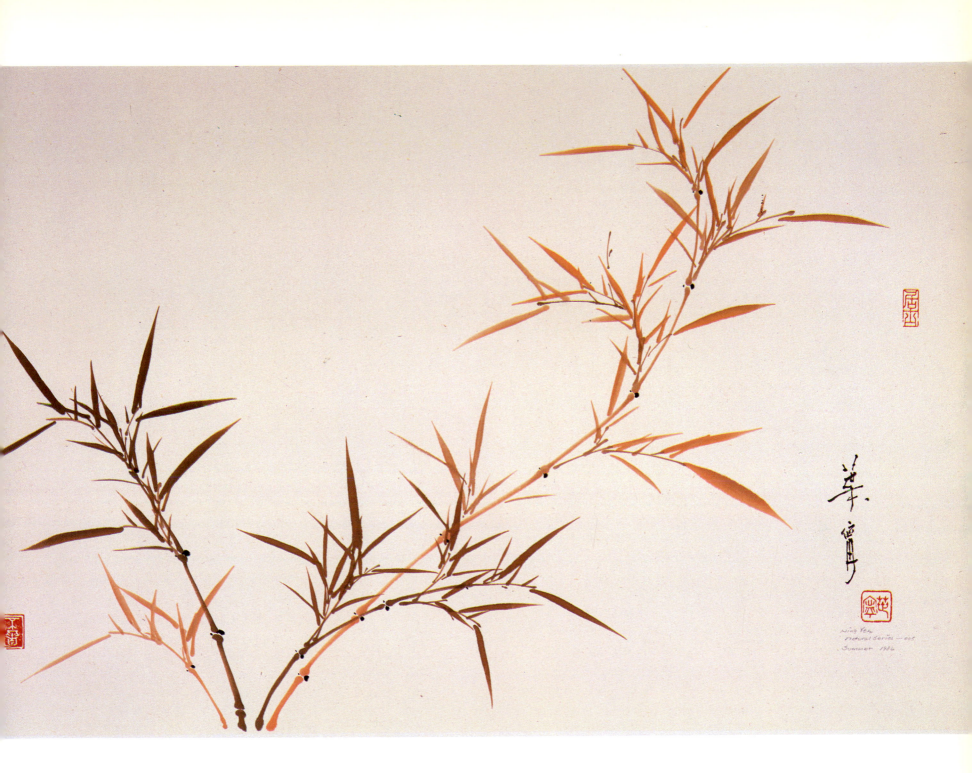

Ning Yeh
Natural Series West
Summer 1986

147

Enduring Devotion (Azalea)

Collection of Larry and Peggy Petersen

23"x36"
Paper: Double Shuen
Brushes: "Large Flow" (flower), "Big Idea" (leaf, branch), "Idea" (stamen, dot, vein).
Colors: poster white with vermillion, purple madder (petal, bud); purple madder (center, dot); poster white (stem, pistil); white with vermillion (pollen); yellow with indigo, indigo, ink (leaf); burnt sienna with ink (branch).

Seal: Subtle Glow of Jade

Tu Chuan 杜鵑

Tu Chuan is the Chinese name for the azalea flower and for the cuckoo bird. The endless crying of the cuckoo bird during the month of February is said to have been prompted by the subjects of the ancient Kingdom of Shu. When their beloved king gave up his throne and went into hiding in the West Mountains, they sent the bird to search for him in vain. Legend has it that the dots on the azalea petals were the imprints of tears from the bird. The flower represents enduring loyalty and friendship.

The "Tu Chuan Flower" song was a popular tune during the Second World War. The song described a young girl who took a red azalea from her hair and put it on her boy-friend's chest to send him into the battlefield. My uncle joined the "New Youth Army" at that time. He was sent to rescue the British in Burma, never to return.

In my father's generation, the Chinese witnessed the fall of the last Dynasty, the founding of the first Republic, the war among the warlords and the Northern Expedition, the Second World War, and the Communist takeover. In my time, the saga of chaos continued into the Cultural Revolution, which denied ten years of formal education for a whole generation. How lucky can a modern Chinese be, to grow up in the Orient in peace and receive the benefit of a full education?

During the last days of my military basic training, the "Old Man" (an affectionate nickname among my peer group for our late President) came to give a talk. Under the scorching sun, the troop stood in dead silence. Suddenly, I noticed my platoon leader's shoulders had started shaking. When he turned around to dismiss our group, the "Iron man's" face was completely soaked in tears. That night, after dinner, I asked him how he felt. "Our old man is showing signs of aging." He started sobbing uncontrollably again.

It was the will of this stubborn old man, who decided to make a last stand on a tiny island, that enabled a generation of youngsters to grow up in peace. Many of them were given the opportunity to further their education in the United States. Their children are taught to treasure the value of their education in this land of opportunity.

Our Old Man, we miss you.

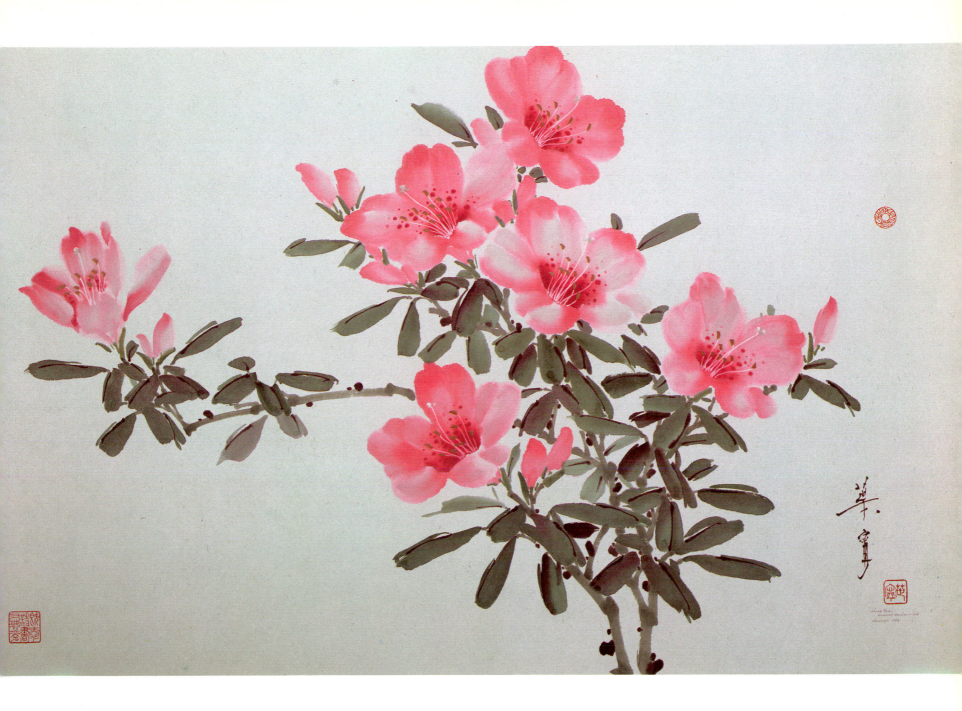

149

The Summer Palace

Collection of Paul and Gwen Dent

22"x36"
Paper: Jen Ho
Brushes: "Landscape" (line), "Big Idea" (tree, color), "Wash" (shade).
Colors: vermillion, manganese blue, purple madder, vermillion with white (structure); Winsor green with charcoal gray, vermillion, red, crimson lake, purple madder (tree); Prussian green with charcoal gray, Winsor violet, vermillion, yellow, manganese blue (sky, water).

Seal: Harmony of Nature

Yi Ho Yuan (頤和園 , Beijing 北京)

The Summer Palace is called Yi Ho Yuan — the Garden of Harmonious Unity. It was developed first by Chien Lung (乾隆 1735-95), the fourth emperor of Ching (1644-1911, the last dynasty of China). Chien Lung was a man of exquisite taste and the Ching dynasty reached its peak in wealth and strength during his reign. It also started its downhill trend. The Summer Palace shared the fate of Ching, and like a mirror, it told the story of modern China.

The Garden was destroyed twice by foreign troops. First, in 1860, it was burned by British and French forces. The Palace was rebuilt in 1888 by the Empress Dowager Ci Xi, (慈禧太后) the notorious woman who held supreme power during the last phase of the dynasty. Ci Xi instigated the "Boxer Rebellion" and declared war against all foreign devils. In 1900, the combined forces of eight foreign powers plundered the city of Beijing and again burned down the Garden. Rebuilt in 1903, the Garden was opened to the public in 1924 after the overthrow of the dynasty by the Nationalist's Republic.

When Ci Xi rebuilt the Palace, she did so under the pretext of developing a navy training site and spent the funds which were to have been used for building a Chinese navy. The only navy training session held in the Garden took place some 80 years later by a foreign adviser named Bob Hope. He did a comedy sketch dressed up as a Chinese general. The only boat built was an immovable, marble one. In a way, this boat turned out to be the right thing, for when the new Chinese fleet was eventually built, Japan sunk all the ships in one single battle. Since the marble boat could not move, it could not sink either.

I like to see notorious tyrants engage their energy in building things that last. The tyrants come and go, but eventually common folks can enjoy the monuments these tyrants built for themselves.

The Summer Palace consists of Kunming Lake (昆明湖) and Wan Shou Shan (萬壽山 Longevity Hill). The garden was designed to incorporate the poetic mood depicted in Chinese landscape paintings. It is a classic example of Chinese imperial gardens.

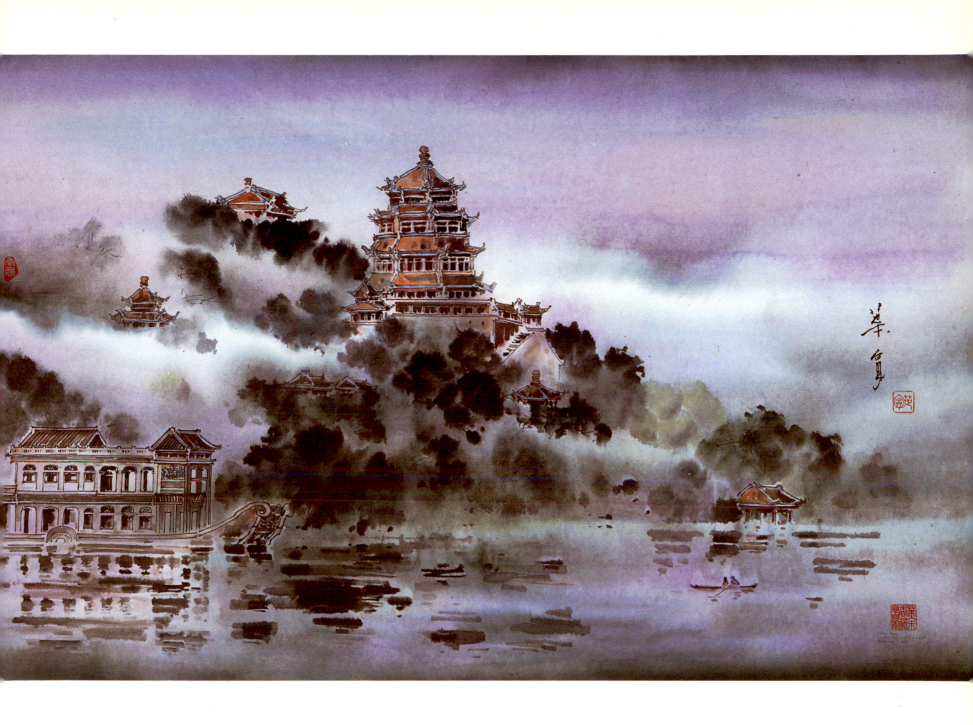

151

The Summer Palace in Winter

Collection of John and Joanna Duffy

22"x36"
Paper: Double Ma
Brush: "Landscape" (line), "Flower and Bird" (color), "Wash" (shading).
Color: brown madder, purple madder (structure); burnt sienna with ink (figure); neutral tint, Winsor violet, ink (background); silver, poster white (snow flakes).

Between the Hall of Fame and the Pagoda of Learning

Let me reveal the story of what has gone on during the process of making this painting. Note, I call it a story. I am prepared to deny its validity.

I was practicing plum trunks on "Ma" paper. The day before, I had used this paper to do some figures and found the paper had a remarkable way of showing strength and texture in all the line works. Painting one trunk after another, I grouped them into host and guest, and they began to look very good together. I decided to make them into a forest of plums.

The phone rang, and my brush rolled out of my hand. A patch of gray now existed between these trunks. It became necessary to shade all the background in order to hide this gray patch. At this point, the idea of the "Summer Palace in Winter" was born.

The idea was not new. I had seen a picture in a magazine showing dry branches covered with snow and surrounding a building in the distance. I had tried to compose a painting with this idea late last year. I used wax to prevent background moisture from seeping into the space intended for my "snow." (the traditional Chinese view is that using poster white in landscape is a crime. I could not bear the guilt of using white for snow.) The wax proved to be very messy; It involved cooking and ironing. I could not turn my classroom into a restaurant or a laundromat when I shared this with my students. So I decided to painstakingly block each individual area without resorting to a foreign substance.

The whole thing worked fairly well, except in the lower right corner, where I had started with too much moisture. There the background shading got into my snowy tree, and I used ink to develop a few blobs in this area. The contrast actually forced the space to show more white. I have learned in the field of art that the best way to fix a "mistake" is to add a couple of similar mistakes elsewhere, sort of a "host boo-boo and guest boo-boos." This way, invariably people will say the artist really intended to do this in the first place. I proceeded to add a few more ink blobs on other trees in the foreground.

I thought it would be nice to accent the front trees with darker outlines to push the building further back. The idea was great, but once started I realized it had the makings of a disaster. I simply did not know how to do them right. The only way out was to pray for more snow to cover these "feet of a serpent" (畫蛇添足 a common Chinese slang, if one paints a serpent, why bother to add feet?) I begged my ancestor for forgiveness, took out my poster white and silver cake. With a tooth brush, I frantically dropped in millions of tiny snow flakes.

The painting looked all right, and I went to bed with a sense of relief. All of a sudden, a terrifying thought emerged. I just realized the plum, our national flower, blossoms in winter. I woke up in cold sweat.

I went back to the painting again. There was no way I could add even one blossom to the painting. "The snow came too early this year," I said to myself, and went back to bed.

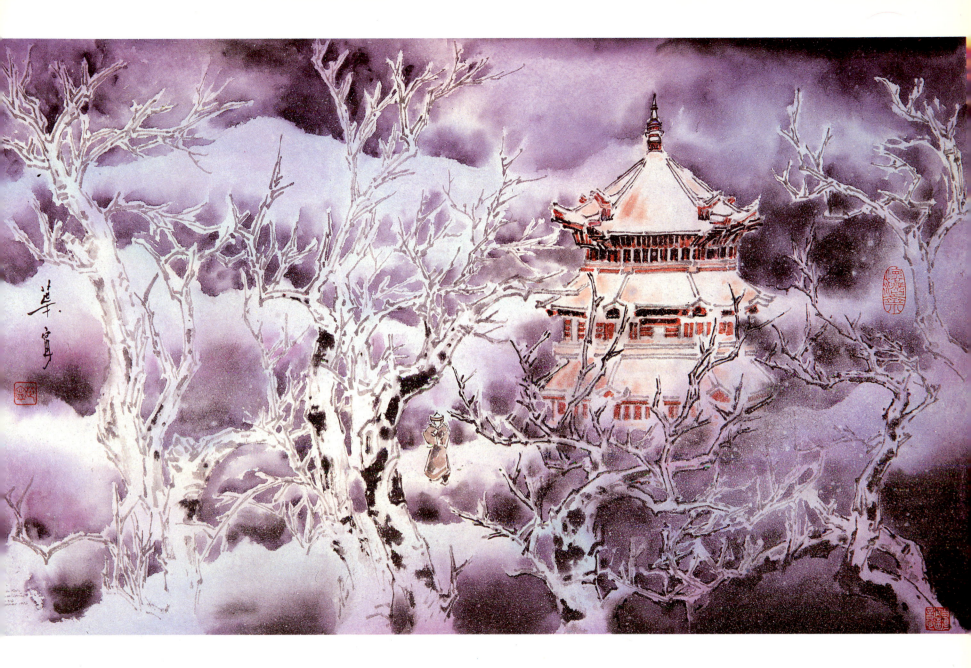

Seal: Like Silk:
Depicting a Bright Future;
Note of Optimism

153

Pearls (Grape)

23"x35"
Paper: Double Shuen
Brushes: "Large Flow" (leaf), "Big Idea" (fruit, vine, vein, dct).
Colors: green mixed by blending yellow and indigo, indigo, ink (leaf, branch, stem); brown madder with neutral tint, purple madder with charcoal gray (fruit); ink (vein, dot).

Pu Tao 葡萄

The grape is called "Pu Tao" in China "Pu" implies "crawling," and "Tao" renders the spirit of culture, cultivation, joy and happiness. It is a great name for a fruit which provides so many moments of inspiration for poets and artists throughout the world.

The best grape in China comes from the Turpan Basin (吐魯番) in northwest Xin Jiang (新疆) Province. Turpan is the hottest place in China. Its temperature reaches 120 degrees F. in July. About 154 meters below sea level, Turpan is also the lowest point in China. The topography is so unique that even when thunderstorms occur high in the sky, the moisture evaporates completely before it reaches the earth. Turpan is known as "The Oven."

The Turpan Basin is surrounded by snow-caped Tianshan (天山) Mountains. Ample runoff from the melting snow seeps into the ground. Over the centuries, folks have built an extensive underground system of channels and wells. The Basin is marked by 3,000 hours of sunlight and 250 frost-free days a year, plus a sharp contrast in temperature between day and night; all these factors produce happy grapes.

Artistic Ego

I once watched a movie with Burt Reynolds and Jill Clayburgh in it. When Burt barely approached the lady by touching her on the arm, the lady started moaning. "I am good, but not that good," Burt said.

I really rarely consider myself a professional artist. Whenever fortune strikes and a decent painting comes out of my hand, I am usually the one who is in the most shock. Still, my family has been occasionally criticized as having too much artistic ego. I thought it would be a good idea to make clear whenever I made a gesture of humility in this book by putting a * at the end of the remark. But it proved to be artistically unpleasant. I will leave this important task to my viewers. Please identify the subtle hints of humility which permeate this book and make as many * marks as you find appropriate for me. Thank you.

All artists have ego. Without ego, the artist could not be creative. I do feel what I do is unique, and I encourage my students to think this way, too. I tell them, "Feel positive about yourself and express yourself. Be honest and truthful." Brush painting is a subjective experience. If one does not admit a mistake, one can never make one. But I do not claim that my work is the best. In the field of Chinese painting, there are endless layers of mountains to climb. As one arrives at the peak of one mountain, one starts to notice other, higher mountains ahead. I do set standards for myself and compare my own works to those from the past.

I do not have one master as my teacher. I treat all other artists who do things differently than me as someone I can learn from. * (I cannot help it.)

Seal: Unique

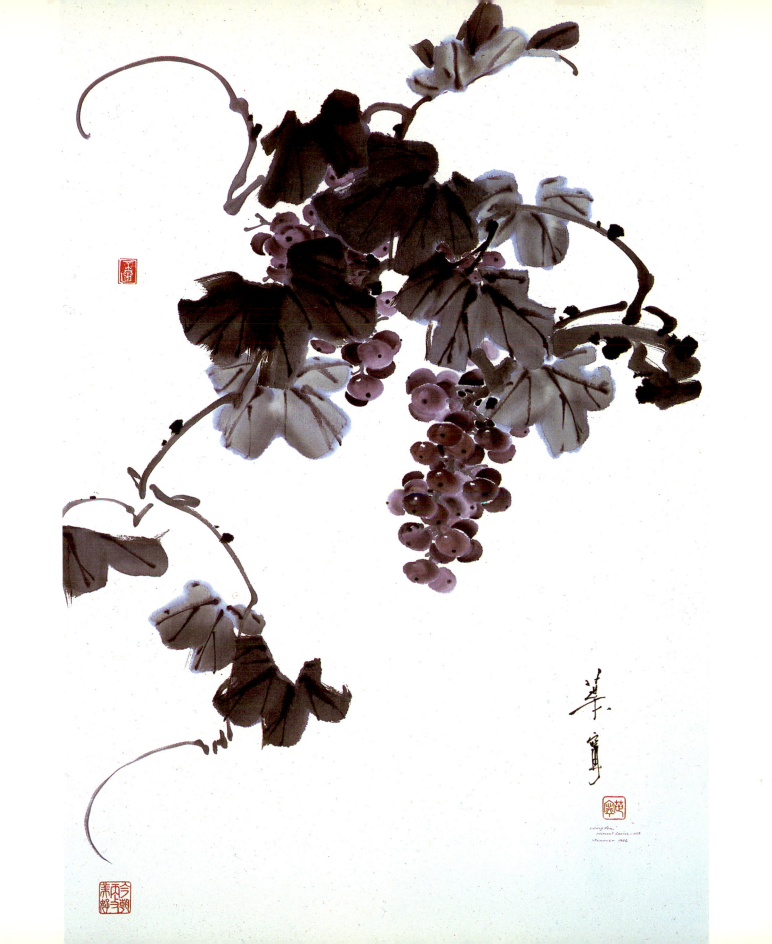

Pink Magnolia

18"x26"
Paper: Double Shuen
Brushes: "Big Idea" (flower, calyx, branch), "Idea" (vein).
Colors: permanent magenta, crimson lake, purple madder (petal outside); poster white, vermllion, crimson lake (petal inside); burnt sienna with ink (calyx, branch); permanent magenta, crimson lake (vein); ink (dot).

Muh Lan 木蘭

In early spring, clusters of pink and purple appear on the bare branches of the magnolia trees along the banks of the Suchow River (蘇州河). Young ladies clothed in blue go by rowing boats, passing through the white walled dwellings on both sides of the river. One can feel the good earth.

Muh Lan is the smaller sister of the white magnolia. It is also called Shin Yi (辛夷), but I like the name Muh Lan better. It is the name of China's legendary heroine.

Hwa Muh Lan was the daughter of Wei (魏) in Northern Chou Dynasty (北周 557-580 A.D.). When China was threatened by the barbarians--"Tu-chueh" (突厥) — from the north, the emperor called upon each family to enroll at least one man into the army. Muh Lan volunteered herself in place of her aging father. Disguised as a young man, she changed her last name to Hwa (花 meaning flower), and entered the army as the Wei family's adopted "son." In the course of 12 years, she won the respect and admiration of her comrades and was promoted to the rank of a general. In the most decisive battle, she captured the Khan of the barbarians and caused the collapse of the Tu-chueh nation.

Muh Lan's identity as a woman was never discovered during her military career. She finally revealed herself in front of her comrades-in-arms when she retired and got ready to return home. Her chief-of-staff promptly asked for her hand in marriage. They lived happily ever after.

The story of Muh Lan is similar to the "Butterfly Lovers." However, Muh Lan has a much happier ending. Why? I come to this conclusion: because the lady is the boss. Anytime a lady is the boss, there will be a happy ending.

The showy size, sturdy stem, and the torch shape of the magnolia flower remind the Chinese of the strength of the feminine spirit. Like Hwa Muh Lan, the flower wears shining armor outside but still keeps a pure and gentle heart inside.

Seal: Heart of Flower

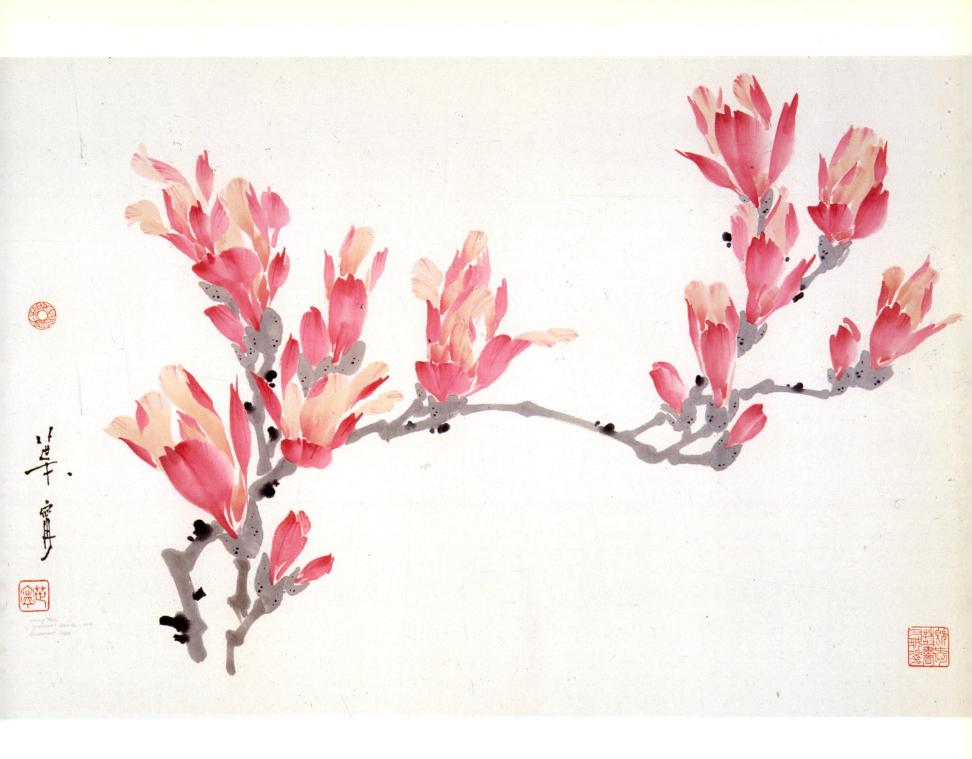

157

78 蕙

Grass Orchid (Whei)

16"x20"
Paper: Double Shuen
Brush: "Idea"
Colors: dark green mixed by blending yellow and indigo (leaf); green with crimson lake (petal, stem); crimson lake (stamen).
For detailed, step-by-step instruction on the orchid, see Lesson 2-3 in the Study Guide.

Extra Incentive

An artist friend from China brought a scroll of his work to show me. When he opened the scroll, a little silverfish jumped out. A delightful artistic exchange then turned into a frantic chase scene. I may have suggested that we should be kind to little creatures before, but this does not apply to silverfish. Artists all secretly wish their works could become immortal, and a silverfish considers rice paper as its gourmet food. One should not be nice to silverfish.

The chase ended in vain, and the silverfish found its way into the attic, where tons of rice paper were stored.

The Chin Emperor, the one who built the Great Wall, was a notorious tyrant. Many tried to assasinate him, but failed because no one could get near him with any weapon. Jing Ko (荆軻), a loyalist of the neighboring state, devised a plan to get close to the tyrant by offering something the tyrant really wanted — a map of the neighboring state. Jing Ko hid a knife in the center of the scroll. When the Emperor rolled the map open, Jing Ko grabbed the knife and made an attempt to end the tyrant's life.

I thought of this story when the silverfish appeared.

When my "friend" left, I went back to the attic and stared at the pile of rice paper, feeling depressed. Silverfish never die; they just fade away. I knew the race was on. It is a question of who would get to this pile of rice paper first — me or the silverfish. I needed to comsume these papers, and the fastest way I knew how was to practice the grass orchid.

The grass orchid was my first subject when I started to paint. In seconds, I completed my first orchid. I recall I then said to myself, "This is like rowing a boat downstream (順水推舟), or raising my head to see the moon (擡頭望月)" (These Chinese expressions are our way of saying, "It is a piece of cake"). Later, as I learned better, the grass orchid became one of the toughest cookies. There were times that I could consume in one afternoon several used telephone books and have the pages cover the entire house so that my mother could not even enter the room. It was one way to let her know that I did my practice. Still, good orchids rarely came. People always associate painting the orchid with the expression of joy. I have shed many tears of frustration trying to show happiness.

I did use up all the papers before the silverfish could get to them.

Jing ko failed to assasinate the Chin Emperor and the Emperor use the map to conquer the neighboring state.

I must say I only used this silverfish from China as an added incentive to paint. Being so close to the beach, my attic had silverfish long before my artist friend's visit. I wonder how the silverfish from China is getting along with the Americans?

Seal: Clear, Delicate, Pure Fragrance

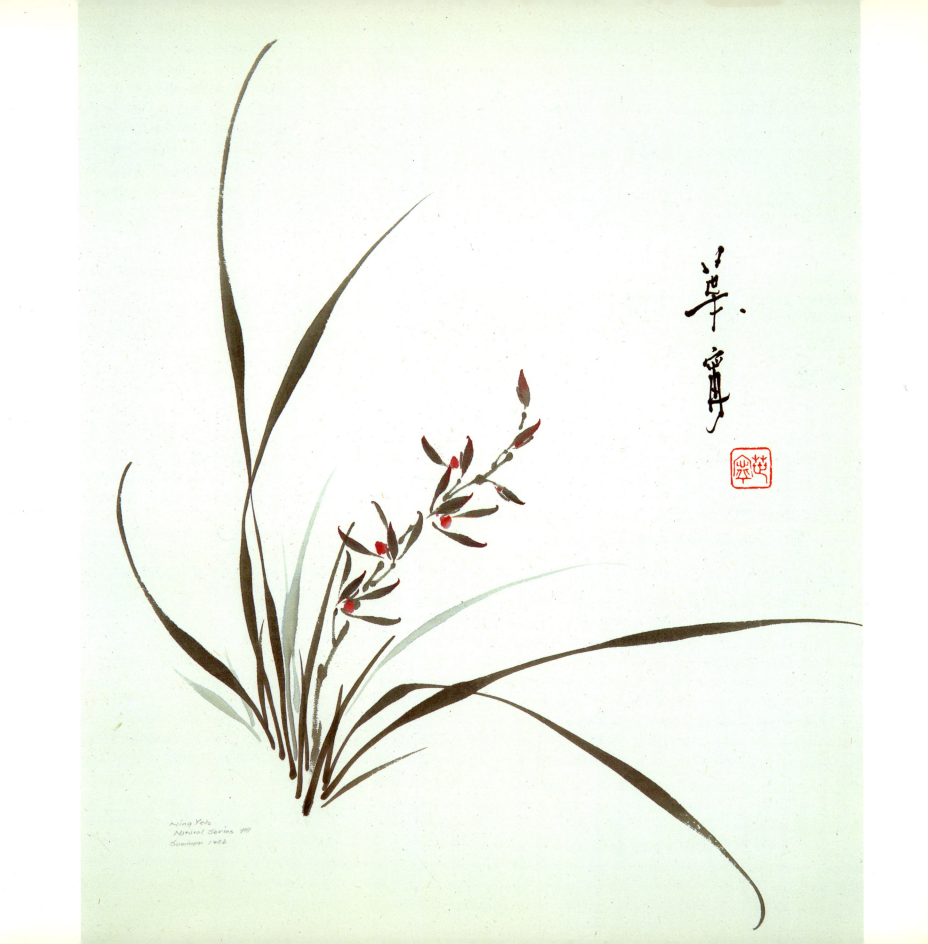

Ning Yeh
Natural Series 118
Summer 1986

Mood of Spring (Foreign Orchid)

Collection of Eva Webb

17"x27"
Paper: Double Shuen
Brushes: "Large Flow" (flower, bud, stem, stalk), "Lan" (leaf).
Colors: poster white, permanent magenta, crimson lake, purple madder, green mixed by blending yellow and indigo, vermillion (flower, bud); dark green, indigo, ink (stem, leaf), green mixed with burnt sienna (stalk).

Yang Lan 洋蘭

Since the mass invasion of foreign influences came to China by crossing the ocean, the Chinese have made a habit of adding the word ocean (Yang) to foreign things: foreign orchid — Yang Lan; crimson lake — Yang Hung (洋紅 foreign red); foreign doll — Yang Wa-wa (洋娃娃).

Seal: Quiet Companion outside
the Window of Green

Positive Thinking

In my evening class, there is a shy Vietnamese girl who does very well but never feels good about her works. One night when the class was doing a bamboo painting, I passed by her. I was impressed with her work and paid a compliment. "Ning, I have struck gold!" I heard her say repeatedly. I could not believe her tone of confidence. I held her painting up to let the whole class see. Everyone was happy for her. "This is eleven!" she exclaimed. If ten is the best, what more can you expect out of the spirit of a student when she claims her work is eleven? Through the rest of the class, I emphasized the virtue of positive thinking. Eventually, she produced a true "masterpiece."

As students were getting ready to leave, she came to me. "Ning, I appreciate very, very much. I have struggled so hard, I used up eleven pieces of paper." It finally occured to me that all the time she was saying "struggled," I heard her saying, "struck gold." I ruined her humble image, but I did help her to paint a superb painting.

All artists are conditioned by their time and their environment. An individual can take these conditions with either a positive or a negative attitude. I tend to interpret most challenges I face in a positive way. I choose to express vitality and energy in my animal/figure paintings, a sense of celebration and joy in my floral works, and a feeling of tranquility in my landscapes. I am not always in these moods, but when I am, I express them. When I am not, I try to use my painting exercises to arrive at these moods.

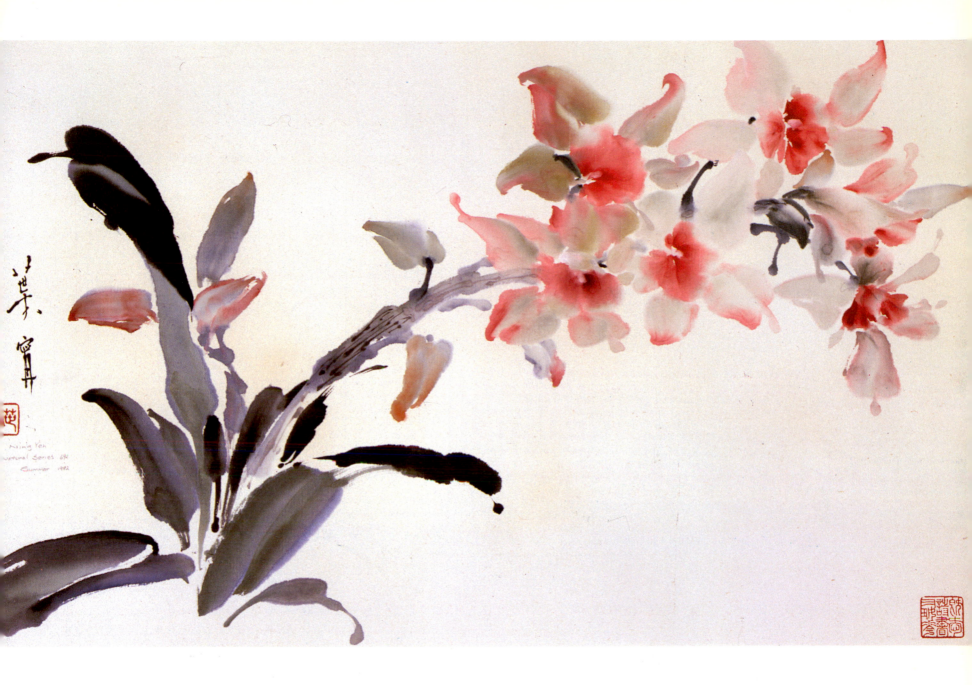

Ning Yeh
Natural Series 6N
Summer 1982

Family Togetherness (Panda)

Private Collection

22"x36"
Paper: Double Shuen
Brushes: "Large Flow" or "Flower & Bird" (ink spot), "Big Idea" (line)
Colors: ink, vermillion
For detailed, step-by-step instruction on the panda, see Lesson 7 in the Study Guide.

Seal: What a Lovely Way to
 Enjoy Life

Ambassador of Good Will 親善大使

The Giant Panda is found only in China.

Although the panda has moments of "losing its cool," especially, for example, when the Japanese zoo keeper decided to conduct those untimely match making sessions, it is generally considered a peace-loving animal. Its every act — sitting, climbing, reclining, gazing, rolling — demonstrates its playful attitude. Every pose is entertaining and inspirational to a throw ink brush painter.

The panda has no predators. Although it appears awkward, it can turn and flee in a twinkling of time, climbing up a tall pine with surprising agility or swimming across a river. Its size and powerful claws also are duly noticed by the common predators. Most animals tend to leave pandas alone.

China's changing attitude towards the West in recent years has made the panda a symbol for goodwill. What better image can the new China seek?

Except in captivity, pandas do not like to share space with each other. But wouldn't it be nice to see all the pandas in one picture, having a good time together?

In my college days, Envoy Yang (楊酒昆) came back from Africa and gave a talk to use on the meaning of "diplomacy." Taiwan had sent teams of agricultural experts to many African nations to help them grow crops. Envoy Yang frequently rolled up his own sleeves and joined the folks in the fields. "Diplomacy," he said, "is the art of offering your country's best to another country."

What a beautiful idea to conclude this book.

Ning Yeh
natural series #6
Summer 1986

Concluding Remarks

In the days of Early Sung (420-477), the artist Ku Chun-chih (顧駿之) designed a studio for himself in the attic of his house. Once he got up into the attic, he withdrew the ladder so that no one else would be able to go up there. He sang poems and studied paintings and painted only when the weather was nice and he was in a good mood.

Most of us do not have the luxury of leisure or the guilt-free conscience to pursue painting this way. I, for one, do have to use the restroom from time to time, and passing a family member with just casual greetings is not quite the Confucian way.

The bulk of the writing of this book took place in the Summer of 1986. I had just completed an instructional book on Chinese brush painting to be used as a study guide for my television course. The study guide dealt with detailed information on individual strokes, how to use the equipment, moisture, color . . . It is indeed one of the hardest books to write.

With most of the paintings already done, this album proceeded like a breeze, and I had a real good time doing it.

Someone said: "If you want to lose a friend, encourage him to write a book." I once heard the husband of one of the foremost lady writers in China being interviewed. "She was so consumed that sometimes she could not recall my name," he said of his wife.

In the months of this self-imposed imprisonment of both body and mind, I was surrounded with warmth and encouragement. I was left alone but never allowed to feel alone.

As with previous major writing projects, my doctoral dissertation and my first art album, my wife Lingchi decided the best way to help me was to leave me alone. She took my little girl, Jashin, back to Taiwan to visit our folks, and left plenty of "seal-a-meals" in the refrigerator. Unlike with my previous project, my teenage boy, Evan, decided not to go with his mom. However, he was extremely co-operative in not disturbing me while I was working, except for occasionally poking his head through the studio door to remind me to eat. Kids of his age really wish parents would leave them alone anyway.

Students who called always began with "I know I should not bother you at a time like this . . . By the way, when is the book going to be made available?" (It is so American, I love it.)

I have many good friends and patrons in Orange County. They knew this was the first vacation I had given to myself for years and respected my privacy. It is wonderful to know that there are people out there anxiously waiting to see my works and that people care and understand the need for the solitude of an artist.

My doctoral dissertation took seven years to complete. Eventually, my chairman, Dr. Blair called me. "Ning, I know you are a perfectionist, but I hope this will not be the only book you ever write. If you need to say more, you can write another book. Get it done, and move on with your life."

Later, working on my first art album The Art of Chinese Brush Painting, I again was very serious, as if everything was on the line. I needed to prove my worth to the world. The album was published in 1982, and I felt completely drained for months afterwards.

This time my seriousness wore out during the writing process of the study guide for the television course. I have really used this book to unwind, to relax myself. Many of my friends have observed that I am at my best when circumstances are spontaneous. I agree to this assessment. I wrote continuously for days, laughing and crying along the way. The momentum seemed never to cease, and all the stories which I had shared with my students and friends came together with ease. I was constantly eager to get going. When it comes to Chinese brush painting, I have thousands of tales to tell.

Several themes thread through the independent essays which accompany each of the paintings: the characteristics of my Hsieh-I style of Chinese brush painting; the background and the spirit of the florals, animals, and landscapes; my experiences in pursuing an art career.

There are many books and albums in the libraries on Chinese brush painting. People can find information readily available on important artists, examples of their works, and the historical development of Chinese brush painting. I feel what I can best offer here are things which have affected my mentality and provided me with the motivation to paint.

I am honored when artists like my style and follow my teachings, but I also encourage them to learn from other teachers. If my efforts have sparked someone's interest in art or added another dimension for someone's artistic pursuit, I shall be more than satisfied.

Appendix

Chinese Dynasties

黃帝	Huang Ti (The Yellow Emperor)	2700 B.C.
夏	Hsia	2205-1766 B.C.
商	Shang	1766-1122 B.C.
周	Chou	1028-221 B.C.
西周	Western Chou	1028-770 B.C.
東周	Eastern Chou	770-221 B.C.
春秋	Spring and Autumn Period	770-476 B.C.
戰國	Warring States	476-221 B.C.
秦	Chin	221-206 B.C.
漢	Han	206 B.C.-A.D. 220
三國	Three Kingdoms	220-265
晉	Tsin	265-419
南北朝	Northern and Southern Dynasties	317-580
隋	Sui	581-618
唐	Tang	618-907
五代	Five Dynasties	907-960
宋	Sung	960-1279
北宋	Northern Sung	960-1127
南宋	Southern Sung	1127-1279
元	Yuan	1271-1368
明	Ming	1368-1644
清	Ching	1644-1911
民國	Republic	1911-

Map of China

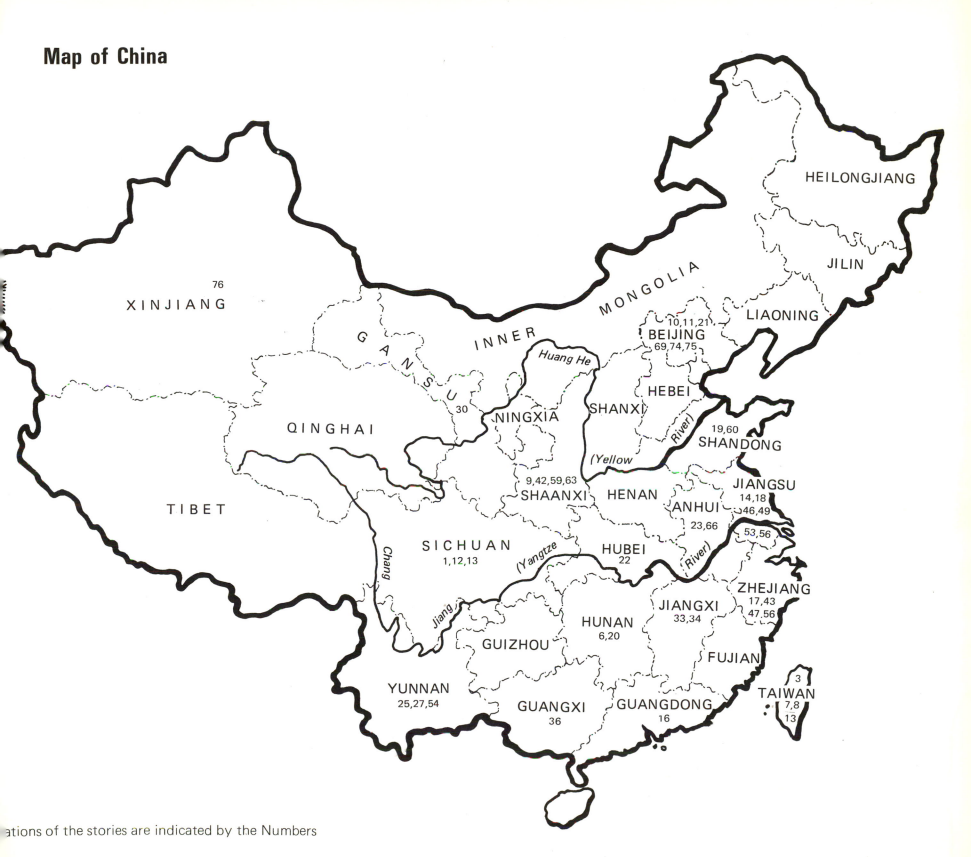

HEILONGJIANG

JILIN

XINJIANG 76

INNER MONGOLIA

LIAONING

G A N S U

Huang He

BEIJING 10,11,21
69,74,75

QINGHAI

NINGXIA 30

SHANXI

HEBEI

SHANDONG 19,60

(Yellow

SHAANXI 9,42,59,63

HENAN

ANHUI 23,66

JIANGSU 14,18
46,49

TIBET

53,56

SICHUAN 1,12,13

HUBEI 22

River)

Chang

(Yangtze

ZHEJIANG 17,43
47,56

JIANGXI 33,34

HUNAN 6,20

Jiang

GUIZHOU

FUJIAN

TAIWAN 3
7,8
13

YUNNAN 25,27,54

GUANGXI 36

GUANGDONG 16

ations of the stories are indicated by the Numbers

167

Signature and Seals

Using the signature, calligraphy and seals as integral parts of composition in painting is uniquely Chinese. To authenticate and to show approval of his work, the artist uses a personal seal in red along with his signature in ink.

I feel it is my privilege to give a Chinese name to my students to use in their "masterpieces".

I usually try to choose Chinese characters which share the sound of the first names of my students. The Chinese words are monotone, that is, one character for one sound. Since most popular Chinese names are 2 to 3 characters, I tend to urge students whose names are more than 3 sylablles to use a shortened version. Names like E-li-za-be-th would be 5 characters. Not only is this name too long to be used in painting composition, but also it would take a whole semester just for Elizabeth to learn how to write her name.

There are more than 60,000 characters in the Chinese language, but only about 2,000 sounds. There are, therefore, a wide range of choices for selecting words which sound alike to represent your name. It really comes down to how much I like my students. So far, I have not assigned a name which has bad connotations to any of my students.

Chinese seals are carved in two basic ways. The positive seal refers to the seal characters which are shown in red with the spaces around them. The negative seal refers to the seal characters which are carved out with the space around them shown in red. The positive seal is light and airy; it represents heaven. The negative seal is more weighty and substantial; it represents earth. Should the two types be the same size, they can be used in pairs, aligned vertically. The positive seal usually goes above the negative seal.

Positive

Negative

One seal which represents the artist is always used with the signature. This is the identification seal of the artist. Often, it is the artist's name seal. The artist may choose his full name, first or last name, or his art name. Many artists use a set of identically sized seals in positive and negative types to add interest to their signatures, Besides names, art names, studios, residences, and birthplaces are also often used as identification seals. Most artists' identification seals are square-shaped. Since most of the time the seal script is done in a different style than the artist's signature, the image of the personal seal and signature can be totally different. Therefore, although the same characters are shown in both the signature and the seal, there is no need to worry about repetition.

In addition, the artist uses a number of different seals to enhance his composition. These seals are referred to as the side seals or mood seals. They depict the general or specific qualities of the artist, his works, or the virtue of the subject matter.

The meanings of mood seals can be of a infinite variety. Among the seals I have ordered for my students, there are meanings such as "Grandmother of Three from Texas," and "Chinese Brush Painters Do It with the Four Gentlemen".... I do try to inject as much poetic quality as possible when I translate these deep thoughts into Chinese characters. Sometimes, though, I feel quite inadequate in capturing the essence of the creative American students of mine.

The seals can be many sizes and shapes. The square, large, and weighty ones are more commonly used at the lower corners of the painting. The rectangular, round, or vertical oval-shaped ones are used typically along the sides of the painting.

In the old days, collectors were allowed to put their seals on the paintings they acquired. The Imperial courts practiced this tradition quite excessively. Some of the old paintings were blanketed by seals of the different Emperors with no respect paid to the consideration of composition. Some placed their seals right at the center of the painting to show their importance. Today, such practice is generally discouraged by both artists and art patrons.

One of the most treasured activities among the Chinese painters and connoisseurs is the collecting of seals. The value of the seal is determined by its antiquity, artistry, and the nature of the raw material from which it is carved.

For detailed, step-by-step instruction on placement of seals, see Lesson 19 in the Study Guide.

1 Seal: The Proud Children of Nature

2 Seal: Notes of Learning in the Misty Mountain

3 Seal: The Ancient Moon that Once Shone on the Glory of the Chin Dynasty is Still Hanging at Dawn on the Peak of the Emerald Mountain

4 Seal: Painting

5 Seal: Ning Yeh Signature & Personal Seal

6 Seal: Studio Blessed with Potential

7 Seal: A Mood Like This Shall Be Forever Cherished in My Heart

8 Seal: Seasoned Memory

9 Seal: When One Loves Poetry and Writing, One Shall Find Time to Enjoy the Flowers

10 Seal: A Journey of Heart

11 Seal: A Journey into Art

12 Seal: Pure

13 Seal: A Gift of Love

14 Seal: Hidden Beauty

15 Seal: I Like to Spend My Entire Life Preparing Ink

16 Seal: Much Can Be Accomplished in the Decade of the 80's

17 Seal: Elegance

18 Seal: The Yeh Family from Ching-tien, Chekiang

19 Seal: Acquiring the Idea beyond the Image

20 Seal: Heart-felt Sharing of Inspiration Transcends beyond Time and Space

21 Seal: A Thousand Miles' of Scenery in a Day's Journey

22 Seal: Fulfillment of An Everlasting Wish

23 Seal: Sky Shore: Spirit reaching the shore of sky; sky has no shore, hence the spirit is free

24 Seal: Mountain Afloat

25 Seal: Subtle Glow of Jade

26 Seal: Noble Elegance

27 Seal: Love

28 Seal: The Spirit of Stroke, The Taste of Ink

29 Seal: Longevity

30 Seal: Quiet Companion outside the Window of Green

31 Seal: Clear, Delicate, Pure Fragrance

32 Seal: Heart of Flower

33 Seal: Unique

34 Seal: Like Silk: Depicting a bright future; note of optimism

35 Seal: Chi-ling: Imaginery Creature of Vitality

36 Seal: Celestial Horse

37 Seal: Fragrant Shadow

38 Seal: Idea of a carefree spirit acquired through serendipity.

39 Seal: Pleasing Thoughts of Beauty

40 Seals: Dancing Poise (top),
Lady Yee (Below)

41 Seal: Dancing Posie

42 Seal: Ascending to Another
Level

43 Seal: In Harmony with the
Spring Breeze

44 Seal: Every Blade of Grass,
Every Branch of Tree, Shares
the Essence of the Vital
Spirit of the Universe

45 Seal: The Dawn of S

46 Seal: Everything is Even More
Beautiful This Morning

47 Seal: Integrity through
Humility

48 Seal: Calligraphy: Painting
from the Heart

49 Seal: A Mood of Cool Elegance
as Soaring Geese Sing along
with the Frosty Morning Moon

50 Seal: There is No End to
Learning

51 Seal: Grand Prospec

52 Seal: Taste of Spring

53 Seal: The Essence of Misty
Mountain

54 Seal: Enjoying Nature at Ease
(While Picking Chrysanthemum
by My Fence, I Feel Nan
Mountain's Leisure)

55 Seal: Flower, Not Flower

56 Seal: Essence of Heart

57 Seal: Everlasting Treas

58 Seal: Harmony of Nature

59 Seal: Face to Face
with Words Forgotten

60 Seal: A Multitude of Colors
in Celebration

61 Seal: Warmed with the
Lingering Fragrance of Tea,
One Paints for One's Own
Enjoyment

62 Seal: The Passing Cloud Brings
a Caring Message from Her
Wandering Son

63 Seal: Ten Thousand Layers of
Green Mountains in My
Homeland: Reminiscent o
Beauty of the Old Country

64 Seal: Poetic Song

65 Seal: A Psalm of Nature

66 Seal: Subtle Mood Accompanied by Delightful Rhythm

67 Seal: Dream of A Butterfly: Chun-tze dreamt of himself as a butterfly. Upon awakening, he wondered whether he was a man in the dream of a butterfly

68 Seal: Not Wishing to be Awakened from the Dream of Spring

69 Seal: Fulfillment of an Everlasting Wish

: There are Still Some Splendid Arts and Genuine Elegant Spirits that Exist Today

71 Seal: Home is Where My Heart is at Peace

72 Seal: Song of a Wandering Soul

73 Seal: Journey of Heart

74 Seal: Holding a Glass in Hand, Long Awaiting, to Greet Whoever Appreciates

75 Seal: Everlasting Beauty

eal: Playing with Ink

77 Seal: Grace

78 Seal: A Lovely Time with Beautiful Scenery

79 Seal: Resourceful, Never Ending Vitality and Energy

80 Seal: Constant Change and Adjustment

81 Seal: Whispering Waves: Sight and Sound of Wind in the Forest

Seal: What a Lovely Way to Enjoy Life

83 Seal: The Realm of Creation

84 Seal: A Script: The Age of Innocence

85 Seal: Delicate

86 Seal: Happy Dot, Clever Idea

87 Seal: Living at Ease with Tranquil Mind

EXCERPTS FROM OAS CATALOG

INTRODUCING TWO COMPLETE SETS FOR BEGINNERS IN CHINESE BRUSH PAINTING

For the convenience of beginning students, two sets of equipment for Chinese brush painting have been selected specifically by artist Ning Yeh.

Each set contains all the necessary materials for Chinese brush painting (as shown in Ning Yeh's television series).

The materials are designed so that students can use either set to start their practice. Some students may wish to begin with the Students' Set and later advance to the Artists' Set.

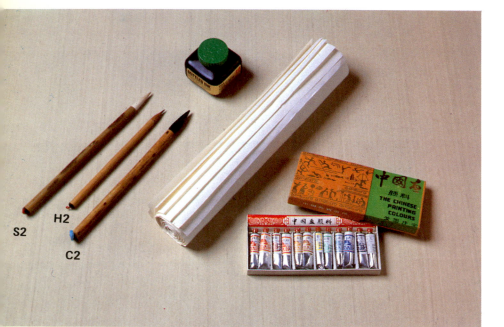

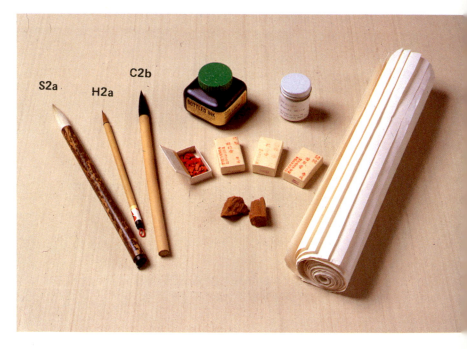

The Students' Set

Contains a complete set of basic materials for Chinese brush painting; developed as an introductory set for low cost, student practice purposes:

S2 "Basic-Soft" brush
H2 "Basic-Hard" brush
C2 "Basic-Comb" brush
Bi Oas Bottled Ink
 Set of "Guta" Chinese painting colors: 12 tubes
R2a Small roll of rice paper

THE ARTISTS' SET

Contains the following fine materials:

S2a "Large Soft" brush
H2a "Idea" hard brush
C2b "Flower/Bird" (L) combination brush
BI OAS Bottled Ink
4 boxes of Chinese color chips:
 red, vermillion, indigo, burnt sienna
1 package of Chinese yellow chunks
1 jar of OAS Artists' Poster White
R2a Small roll rice paper

174

NOTES ON CHINESE BRUSH PAINTING
SUPPLIES AND EQUIPMENT
by Ning Yeh, Ph.D.

BRUSHES

The brushes are labeled as follows:

S: Soft brush 1: Small-size
H: Hard brush 2: Average-size
C: Combination brush 3: Oversize

The soft brushes are usually made of goat hair, mostly with white bristles. They are used mainly in Chinese calligraphy. I use the larger soft brushes for bamboo trunk studies and smaller soft brushes for bird paintings and for painting on ceramics.

The hard brushes are usually made of wolf hair with brown bristles. These brushes are valued for their sharp tips and bouncing resiliency. I use hard brushes for all the line work and for slender shapes which come to a point. The "Idea" and the "Orchid Bamboo" series are among the very best hard brushes.

The combination brushes are usually made of mixed hair with hard bristles inside and soft bristles outside. Combination brushes are used mostly to develop fuller shapes in floral and animal studies. The "Flower and Bird" and the "Flow" series are among the best combination brushes.

BRUSHES IN THE SETS

The Students' Set

S2 **"Basic-Soft"** 1/2" x 1-5/8" (diameter x hair length)
The brush has a full body and even-length white goat hair, it has good absorption and is great for bamboo trunk practice.

H2 **"Basic-Hard"** 3/8" x 1-1/8"
The best among the most reasonably priced wolf hair brushes.

C2 **"Basic-Comb"** 1/2" x 1-3/4"
The brush has good size for floral and animal studies.

The Artists' Set

S2a **"Large Soft"** 5/8" x 2"
Larger, fuller, and more stable than 'Basic-Soft."

H2a **"Idea"** 5/16" x 1-1/16"
See next discussion on the best brushes.

C2a **"Flower and Bird" (L)** 1/2" x 2"
See next discussion on the best brushes.

BEST BRUSHES: the soft brushes included in our set are among the best in their category. There are several series of hard and combination brushes which are among the treasures in Chinese brush painting. For more advanced work, I recommend the following brushes:

Hard Brushes

The "Idea" series
The "Idea" series of hard brushes are excellent line brushes with sharp points and bouncing resilience. They are the most versatile brushes for all purposes.

H2a **"Idea"** 5/16" x 1-1/16" (Included in the Artists' Set)
One of the best hard brushes produced in China. Used for "Four Gentlemen" studies — orchid, bamboo, mum, plum; small flower petals and line work for all subjects, especially veins and twigs. The brush has a fine tip to handle details such as pollen dots and stamen.

H2b **"Big Idea"** 3/8" x 1-3/16"
This brush handles all the tasks of the "Idea" brush. With its fuller body, it is able to produce larger shapes with more color variations. The "Big Idea" brush is used for leaves, branches, and petals.

The "Orchid Bamboo" series
The name "Orchid Bamboo" is given to this series of brushes because of their incomparable ability to deliver the blade-like leaves which grace the orchid and bamboo.

H2c **"Orchid Bamboo"** 3/8" x 1-3/8"
The ulimate hard brush for branches and blade-shaped florals.

H2d **"Large Orchid Bamboo"** 7/16" x 1-7/16"
This brush functions like a larger size "Big Idea."

Combination Brushes

The "Flower and Bird" series

C2a **"Flower and Bird"** 3/8" x 1-1/2"
Developed specially for producing full shapes in floral and bird studies, also great for painting animals.

C2b **"Flower and Bird" (L)** 1/2" x 2"
The combination brush for the Artists' Set. The brush has longer bristles to handle fuller shapes in floral, bird, and animal paintings.

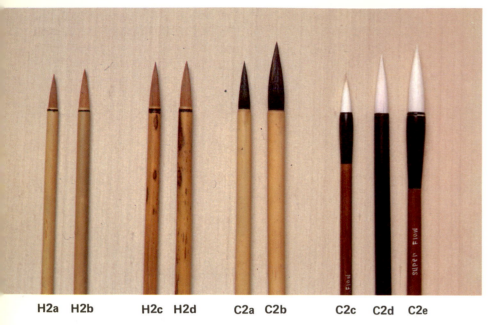

H2a H2b H2c H2d C2a C2b C2c C2d C2e

The "Flow" series

C2c "Flow" 3/8" x 1-3/16"

An exquisite brush for line, dot, and calligraphy. Its flexibility allows more variety of shapes. I call it a "Lady Idea" brush. The tip of this brush seems to have a spirit of its own. It adds character to all the lines and dots.

C2d "Large Flow" 7/16" x 1-3/4"

One of my favorite brushes for floral and animal studies (horse, panda, petal, leaf). This brush offers wider range and better flexibility than the "Flower and Bird."

C2e Super Flow (Extra Large Flow) 9/16" x 2"

It is the largest brush in the Flow series. It was called the Extra Large Flow. Because the improvement made to the handle of the brush (a horn socket is now added to prevent the splitting of the bamboo hàndle), the name has been changed to Super Flow. I use the Large Flow and Super Flow to do many similar subjects.

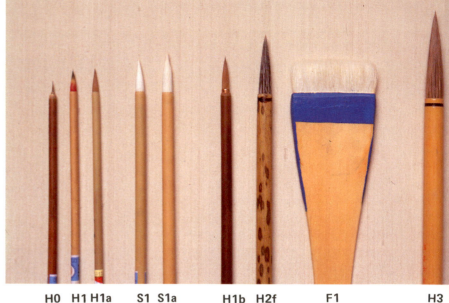

HO H1 H1a S1 S1a H1b H2f F1 H3

Specialty Brushes:

HO "Super Fine"
1/32" x 5/16"
The smallest brush for hair-like line work.

H1 "Little Hero"
3/16" x 3/4"
Inexpensive but a good detail brush. Recommended for pottery or ceramics.

H1a "Best Detail"
3/16" x 13/16"
The finest detail brush; good for delicate line work, such as stamens, pine needles, bird beaks and eyes, tiny pollen dots.

S1 "Small Soft"
5/16" x 1-1/16"
A brush for small birds, tree dots, landscape shading, reasonable for pottery use.

S1a "Medium Soft"
3/8" x 1-3/8"
A little larger than "Small Soft," similar usage.

H1b "Landscape"
1/4" x 1-1/16"
The best brush for fine lines with variation, such as trees and rocks. It is a tough brush for withstanding the torturing exercises in landscape.

H2f "Mountain Horse"
7/16" x 2"
A "punk hair"-like brush made with the toughest bristles, for texture work in landscape, tree trunks, dots.

F1 "Wash"
2-1/2" wide
A flat wide brush made with goat hair, essential for large areas of shading; for cloud, mist, and background coloring.

H3 "Lan"
9/16" x 2-1/2"
A oversized brush for large leaves. Excellent.

A CHART FOR BRUSH SELECTION

STUDENTS' (Good)	ARTISTS'* (Better)	FINEST* (Best)
Soft: "Basic-Soft"	"Large Soft"	"Large Soft"
Hard: "Basic-Hard"	"Idea"	"Orchid Bamboo"
	"Big Idea"	"L. Orchid Bamboo"
Comb: "Basic-Comb"	"Flower/Bird"	"Large Flow"

* Brushes used on television by Ning Yeh

For finest detail, add "Super Fine."
For fine detail work, add the "Best Detail."
For landscape line, add the "Landscape."
For landscape texture, add the "Mountain Horse."
For background shading and mist, add the "Wash" brush.
For extra large strokes, add the oversized "Lan."

For inexpensive brushes to teach young children, or to do pottery, or China painting. . . use "Basic-Hard," "Small Soft," "Medium Soft," or "Little Hero."

BRUSH PREPARATION AND CARE

A new brush comes with a cap to protect the bristle. This cap is useless after you have put the brush to use.

Soak the bristle portion of a new brush in cold water until the hairs become unglued. Usually, the soft and combination brushes take a longer time (several hours); the hard brush takes just a few minutes.

Rinse the brush with water after painting, wipe off the excess water with a paper towel, and regroup the tip back to a fine point. When the brush is dried, store it in a holder wrap it with a bamboo screen, or hang it up if the handle comes with a loop.

PAPER

Rice Paper

In general, rice paper can be divided into two groups: raw paper and sized paper.

Raw Paper: Most artists prefer using raw paper for floral and animal paintings, for it captures the most dynamic qualities of color blending and ink storkes in their original state.

Raw 1 **"Double Shuen"**

This paper has been caled "the most honest" paper. It has fine absorption and is capable of reflecting the maximum range of color variations. It is best suited for the spontaneous style of brush work. Most floral and animal paintings are done with this paper. Double Shuen comes in a large sheet (27" x 54"); a wholesale package of 100 sheets is also available.

For convenience, Double Shuen is cut into 1/4 and 1/3 of its regular size and put into a roll.

Raw 2a **"Double Shuen Small Roll"** 13-1/2" x 27", 12 sheets.

Raw 2b **"Double Shuen Large Roll"** 18" x 27", 12 sheets.

Raw 3 **"Colored Shuen"** 18" x 27", 12 sheets.
Single-layered Shuen paper dyed into various colors (brown, rose, olive, and jade). This paper offers exciting contrast to light-colored florals, or a more muted background for dark-colored florals.

Raw 4 **"Practice Roll"** 18" x 600"
This is machine-pressed paper which has an absorbent nature similar to Double Shuen, convenient to use for practice.

Sized Paper: Usually sizing is done to reduce the absorbent nature of the raw paper and allow the repeated application of colors and strokes. Sized paper is used most effectively for landscape and floral subjects with shaded backgrounds.

Sized 1 **"Jen Ho"** 24" x 40"
The primary paper in landscape exercises.

Sized 2 **"Ma"** 23" x 40"
A hemp paper, Ma shows exciting texture for line work and subjects with shaded backgrounds.

Mounting Paper 26" x 40"
I prefer to mount the finished painting onto a type of paper similar to the paper used in watercolor paintings and then frame it with glass.

PAPER PREPARATION AND CARE

Uncut large sheets should be rolled up and protected with wrapping paper. Paper should not be folded,

INK

Chinese brush painting begins with black and white studies. Even in color studies, ink remains a vital feature. Ink gives the substance to a painting and develops the volume of contrast.

Good ink produces the darkest black. It is smooth and blends with water without any residue. It has a velvety shine and can be fully absorbed into rice paper. When it dries, it becomes permanent; rewetting and mounting will not cause ink to run. Blended with water, good ink can present a great range of shades. Except for the darkest shade, the shades of ink are transparent, and it blends easily with other colors.

INK PREPARATION AND CARE

To make ink, put 2 or 3 teaspoons of water into the well of the ink stone. Hold the ink stick vertically and grind the stick slowly with a circular motion for 3 to 5 minutes. The ink is ready when the water becomes thick and turns to the darkest color. Test the ink with a dry brush. If the ink still runs on the rice paper, more grinding is needed. Prepare fresh ink for each painting exercise. After grinding, wipe off the ink on all sides of the ink stick with a paper towel.

After practice, wash the ink stone thoroughly. Old ink or dry ink loses its ability to mix with water.

Ink Stick

Traditionally, ink was produced by grinding an ink stick with water onto a ink stone. The ink stick is the source of ink, and it is made of pine soot or lamp black, then mixed with glue into a stick.

Ink Stone

The ink stone is often made of slate. For painting purposes, the best-shaped slate is a square one with a deep circular well and a drainage spout for letting out excess water or ready-made ink. The stone comes with a cover to prevent ink from evaporating. The cover is also sometimes used to grind a small amount of thick ink.

Bottled Ink

The ready-made bottled ink is easy to use and convenient to carry and it has replaced the ink stick and stone to a large extent. It is favored by both painters and calligraphers.

Black Ink

BI **OAS Bottled Ink:** Included in Students' and Artists' Sets.
BB **Brown Bottle:** The finest ready-made ink.
BC **Ceramic Jar:** The ultimate.

Vermillion Ink

Vermillion colored ink is used in calligraphy and also used as an alternative to black ink exercises. Chinese like the color for more cheerful occasions.

COLOR

CHINESE CHIP COLORS: the best colors to work with rice paper.

Chunks: **yellow** (included in the Artists' Set)
Box of chips: **burnt sienna, indigo, red, vermillion**
(the above four are included in the Artists' Set), and
sky blue.

All of these colors work with water just as watercolors do. They are not good for human or animal consumption. One really should keep them away from small children or pets.

THE "GUTA" CHINESE PAINTING COLORS (12 watercolor tubes)

A student may use the following tubes from the set as substitutes for the traditional chips and chunks: Gamboge Tint (yellow), Ochre (burnt sienna), Cyanine (indigo), Bright Red (red), Vermillion Tine (vermillion), Sky Blue (sky blue). In addition, Peony Red, Rouge Tint, and Cinnabar Tint, are good supplements to red; the Azurite and Mineral Green are very useful in landscape painting. The set also includes a tube of White. The tubes are factory-sealed. Use a thin nail to push a hole at the top of the tube to let the color out.

CHINESE CHIP COLOR PREPARATION AND CARE

To prepare these colors, pour the entire contents of the color package into individual dishes. Separate the yellow pieces, with more in one dish (clean yellow) and less in the other (to mix with indigo to produce green). Shightly tilt the dish so the color chips can gather to one side. Put 3 or 4 drops of water onto the color chips and gently shake the dish until all the chips are touched by water. When they are dry, all of the chips will be glued onto the dish.

Before each painting session, put 2 to 4 drops of water into each dish to soften the colors according to needs. Colors will be softened in 2 minutes.

After use, allow the colors to dry before stacking these dishes. This will help prevent the growth of fungus. Should fungus appear, rinse it off so people do not know that you have not been practicing. An odor may develop, but the color is still good.

POSTER WHITE

OAS Artists Poster White is bottled specially for Chinese brush painting. A student may also use **Dr. Martin's Flo 2** and/or **Pelikan's concentrated designers color 730/50.** The white is kept in the original jar.

WESTERN WATERCOLORS

Besides the Chinese colors, a number of **Winsor & Newton's watercolors** have been successfully adopted. Among them are **crimson lake, purple madder, permanent magenta, brown madder,** which can be used to supplement red; and **French ultramarine, Winsor violet, neutral tint** used for blue-purple. In landscape, **yellow ochre** is used for land, **cerulean blue** for sky and water, **Winsor emerald** and **Prussian green** for green, **manganese blue** for bright blue, and **charcoal gray** for shading.

It is best to use all the watercolors fresh from the tube.

PORCELAIN ACCESSORIES

The set of color dishes, the flower-shaped plates, and the divided water containers are among the most useful accessories for Chinese brush painting. Two sizes are available in each category.

Color Dishes (Set of 5 with cover):

Each of these Chinese colors needs an individual container so it can stay clean for repeated use. The porcelain "Color Dishes" in a set of five are the best containers. It is a good idea to order extra dishes so the yellow chunks can be separated into two containers: One is used to mix with indigo to produce green; the other stays clean.

P1 Small set (3'' wide)
P2 Large set (3.5'' wide)

P1a Individual Small dish
P1b Individual Large dish

Flower-shaped Plate (with 7 divisions)

The porcelain **Flower-shaped Plate** is best suited for handling watercolors. Its weight keeps it from shifting, and it is deep, which prevents different colors from mixing together.

P3 Small Flower Plate (6'' wide)
P4 Large Flower Plate (7.25'' wide)

Water Container (with 3 divisions)

P5 Small Water Container (5.25'' wide)
P6 Large Water Container (6'' wide)

OTHER EQUIPMENT AND MATERIALS NEEDED

Water Containers

One container for rinsing ink and one for other colors are needed. Do not use a tall container. One should be able to see the water in the container and examine how deeply the brush is dipping into the water. The porcelain Water Container with 3 divisions is ideal.

Saucers

Four or more white saucers for mixing.

Felt

A piece of felt, cut to cover the entire painting area of the table, is the ideal material to place under the rice paper to prevent the excess moisture from forming a stain on the painting. Felt material is available at most fabric stores.

Paper Towel

A roll of paper towels is needed for wiping off the excess water or color on the brush, for testing the color and moisture, and for grouping the brush tip.

Other accessories may include:

Paper weights
A pair of scissors or a **paper cutter**
Masking tape
A notebook and **pencils** to record new findings
A brush stand to rest brushes on
A book stand to rest study material on

For more information on Chinese brush painting instructional books and art albums, material and supplies, signature and seals, please request the "OAS Catalog" from Ning Yeh's Art Studio.

STUDIO SETUP

Chinese brush painting is done with the paper laid flat on the table. Holding the brush vertically, the artist may sit or stand to paint.

You should have a surface at least as big as a card table or a larger rectangular table. Spread your felt in the painting area. Place the equipment alongside your painting hand. Set the water container at the top, so that it is reachable and you can see the brush tip working with water. Place your ink stone or ink dish and your set of Chinese colors below the water container. Next place the saucers for mixing and/or a plate for watercolors. Fold two or three sheets of paper towels and tuck them underneath the saucer. Place your brushes on top of the towels.

It is conceivable that you may be sometimes watching T.V. while you paint (It is beyond my imagination that I will give this instruction to my students). I suggest you position your T.V. to the side of your painting equipment. Have the art album on a book stand above the painting area and the study guide and a small notebook right next to you.

Seal

the Celestial Horse

The symbol on the left side of the seal is the character for heaven (a man with arms and legs stretched and a line above him); the symbol on the right is the character for the horse. My buddy Lin carved this seal for me. He is a gifted sculptor with a weird sense of humor. I chose this seal as the logo for all the materials I select for Chinese brush painting.

181

About Ning Yeh

Ning Yeh was born in Mainland China in 1946. .He was given the name Ning, meaning tranquility, to celebrate the ending of the war. The Yeh family has been famed in the field of brush painting for four generations. His father, a general in the Chinese army, is internationally renowned for his horse painting.

Ning Yeh's art training started when he was seven, after the family moved to Taiwan in 1949. His daily practice included the Four Gentlemen (plum, orchid, bamboo, and mum) and calligraphy. At the age of fifteen, the focus of his training turned to horse painting, his family tradition. Two years later, he won the highest honor for his horse painting at the Chinese Youth Art Festival. He proceeded with floral and landscape paintings and gradually developed his own style.

Ning Yeh was elected to represent his country as a cultural delegate and ambassador of good will to many international youth conferences. In 1969, the United States Deputy Secretary of State visited Taiwan. Greatly impressed with Ning Yeh's talent, he invited the young artist to come to the United States for an exhibition tour. Ning Yeh accepted scholarships offered by the California State Universities and by the Pearl McManus Foundation and subsequently received his Ph.D. degree with honors, in the field of Asian Studies/Government, at Claremont Graduate School.

In the past sixteen years, Ning Yeh's efforts have generated an unprecedented response in Southern California. His lectures, demonstrations, classes, and exhibitions are in constant demand, and a large, sophisticated audience follows his work. A new generation of American artists and teachers of Chinese brush painting exists because of his teaching.

In 1978, a special merit award was presented to him by the mayor of Los Angeles and the California State Museum Board for his outstanding contribution to the art community. In 1978, 1980, and 1984, he accepted the invitation of the prestigious Pacific Cultural Foundation of the Republic of China and organized exhibition tours to the Orient for his students. His native country responded by bestowing its highest honors and praise upon him and his students.

In 1981, Ning and his wife, Lingchi, founded the American Artists of Chinese Brush Painting (AACBP). This non-profit organization is open to all people interested in Chinese brush painting.

Ning Yeh has been featured in many television programs. In 1982, the NBC television network produced a half-hour special on his works. In this documentary, entitled "Arts of Asia," his segment was nominated for an Emmy award. The same year, he published his first art album, The Art of Chinese Brush Painting.

Along with their family and friends, Ning and Lingchi established OAS, Inc. (Oriental Art Supply). Over the past fifteen years, Ning Yeh's OAS has developed an impeccable reputation as supplier of the finest material for Chinese brush painting through direct mail and as a wholesale distributor in the United States.

Ning Yeh is a founding faculty and full-time art professor at Coastline Community College in Fountain Valley, California.

In 1987, Ning Yeh becomes the first Chinese brush painter to air an instructional television series in the United States. Through Coastline Community College, the television series of 20 half-hour programs is made available nationwide through educational as well as cable networks. The television program "Chinese Brush Painting with Ning Yeh" is accompanied by:

1) a comprehensive step-by-step instructional book, <u>A Study Guide of Chinese Brush Painting</u>

2) the finest Chinese Brush Painting equipment kits

3) a resource book, <u>An Album of Chinese Brush Painting</u> <u>(Eighty Paintings and Ideas)</u>.

Ning Yeh travels extensively throughout the United States, lecturing and conducting workshops on Chinese brush painting, recruiting instructors, and developing Chinese brush painting programs in various art and educational institutions.

For further information on Ning Yeh's Television Series on Chinese Brush Painting:

Please Write to:

Telecourse

Coastline Community College

11460 Warner Ave

Fountain Valley. California 92708

For Ning Yeh's

● Exhibition announcements

● Class/Lecture/Demonstration/Workshop announcements

● Brush painting supplies and books catalog

Please write or call:

NING YEH ART STUDIO

10181 CRAILET DR., HUNTINGTON BEACH, CA 92646
(714) 962-5189 ● (714) 963-5429

Photo by N. Prasad

Printed in Taiwan